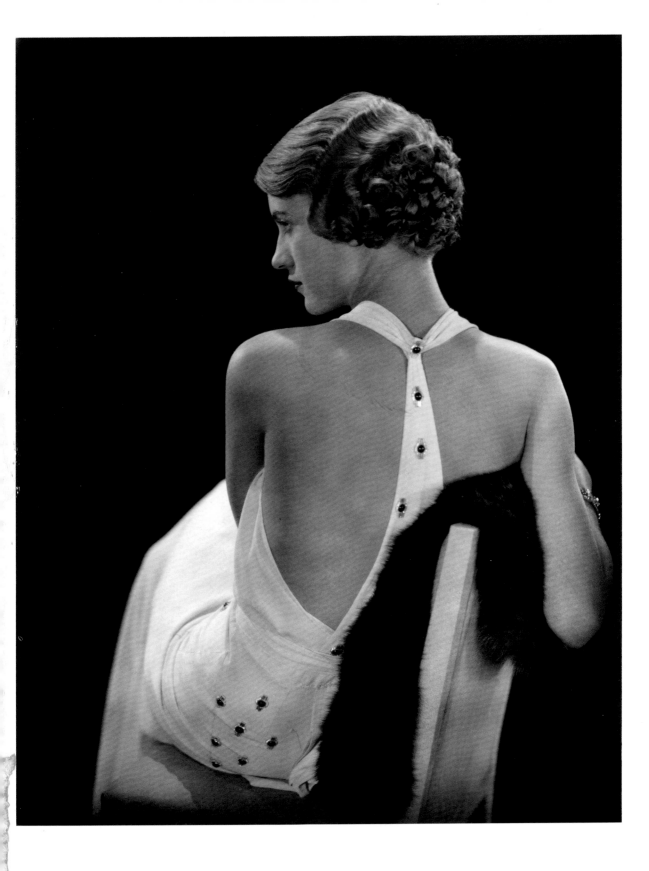

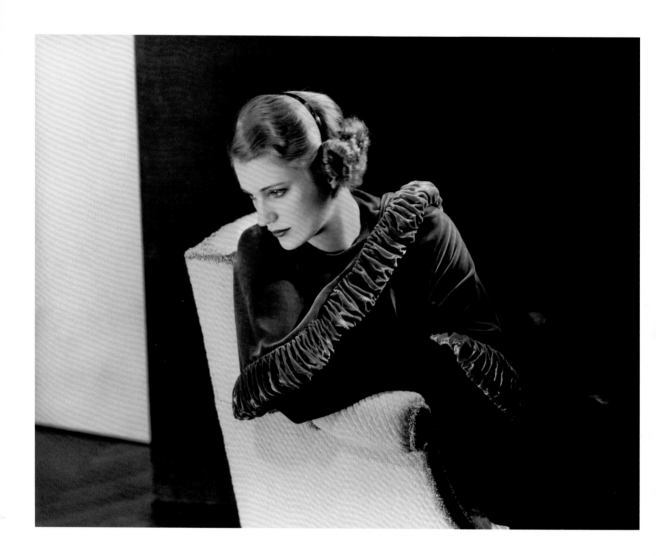

BECKY E. CONEKIN

Lee Miller in Fashion

The Monacelli Press

For Edie with love

Jacket front: **LEE MILLER AND AGNETA FISCHER**
Photograph by George Hoyningen-Huene, 1932
© R. J. Horst
Jacket back: **'FUR BEARERS', BRITISH VOGUE**
Photograph by Lee Miller, London, November 1941
© Lee Miller Archives, England 2013. All rights reserved.
Page 1 **LEE MILLER MODELING CHANEL**
Photograph by George Hoyningen-Huene, Paris, 1930
Page 2 **SELF-PORTRAIT** Photograph by Lee Miller,
New York, 1932

The author gratefully acknowledges the assistance
of the Frederick W. Hilles Publication Fund of
Yale University.

First published simultaneously in 2013 in the United
Kingdom by Thames & Hudson Ltd, London, and by
The Monacelli Press, New York.

Library of Congress Control Number: 2013937369

ISBN 978-58093-376-6

Designed by Anna Perotti

www.monacellipress.com

Printed in China

CONTENTS

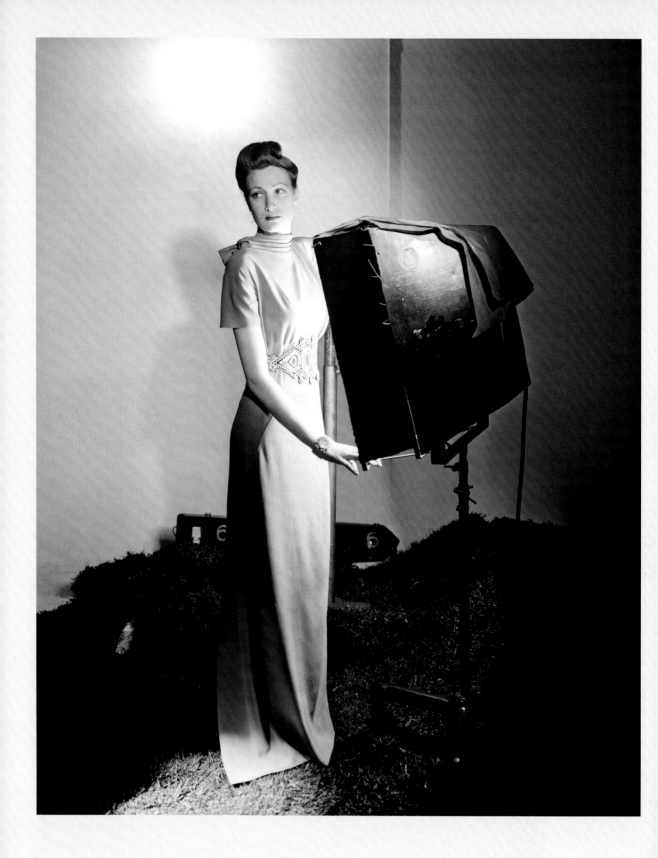

Opposite **UNPUBLISHED PHOTOGRAPH FOR BRITISH *VOGUE***

Photograph by Lee Miller, London, March 1942

Below **UNPUBLISHED PHOTOGRAPH FOR BRITISH *VOGUE***

Photograph by Lee Miller, London, October 1941

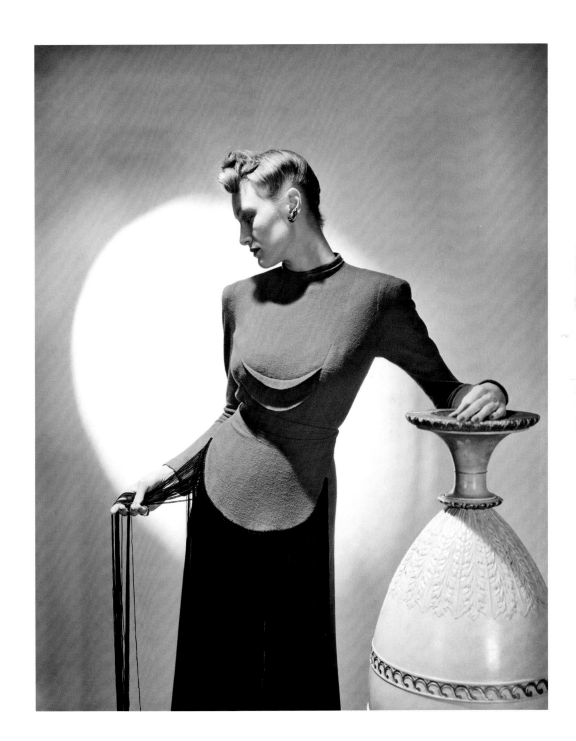

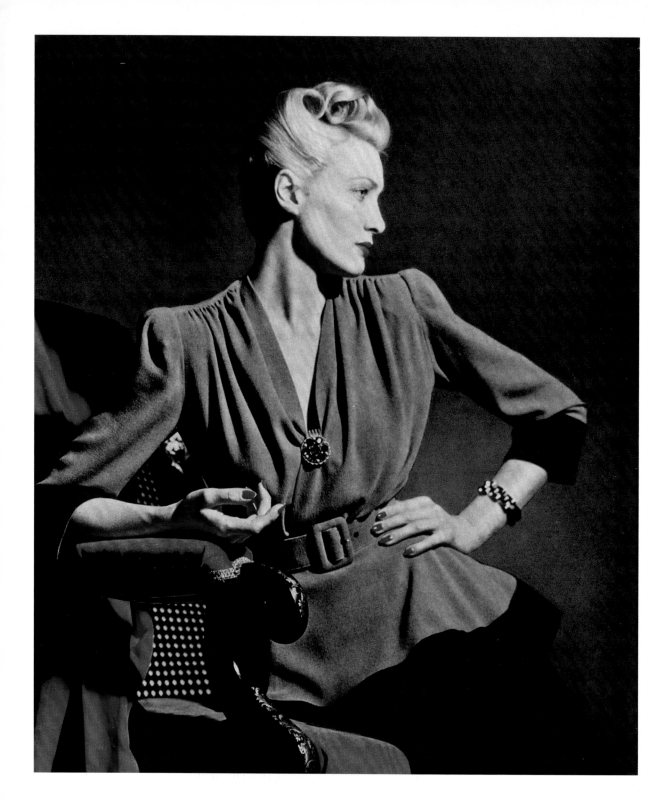

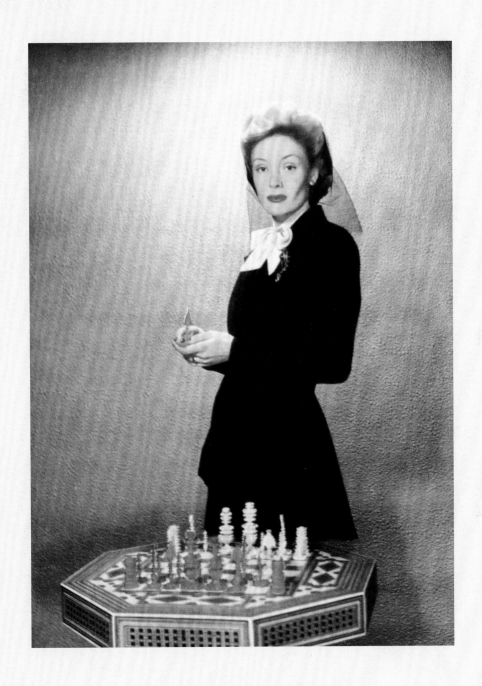

Above **"CUT-AWAY COAT,"** BRITISH *VOGUE*

Photograph by Lee Miller, London, February 1944

Opposite **"PETERSHAM ON WOOL,"** BRITISH *VOGUE*

Photograph by Lee Miller, London, October 1944

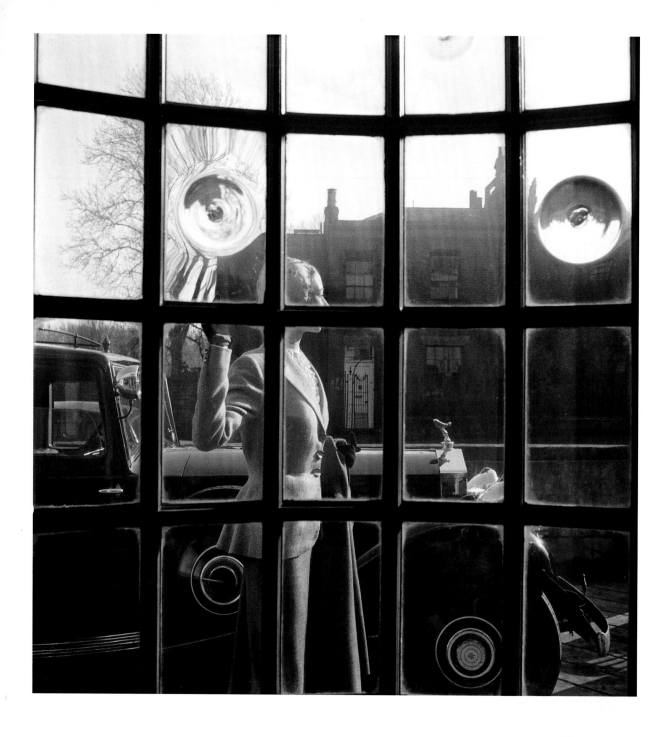

Above and opposite **DELLA OAKE IN "FASHION FOR TRAVEL,"** *GLAMOUR*

Photographs by Lee Miller, London, February 1949

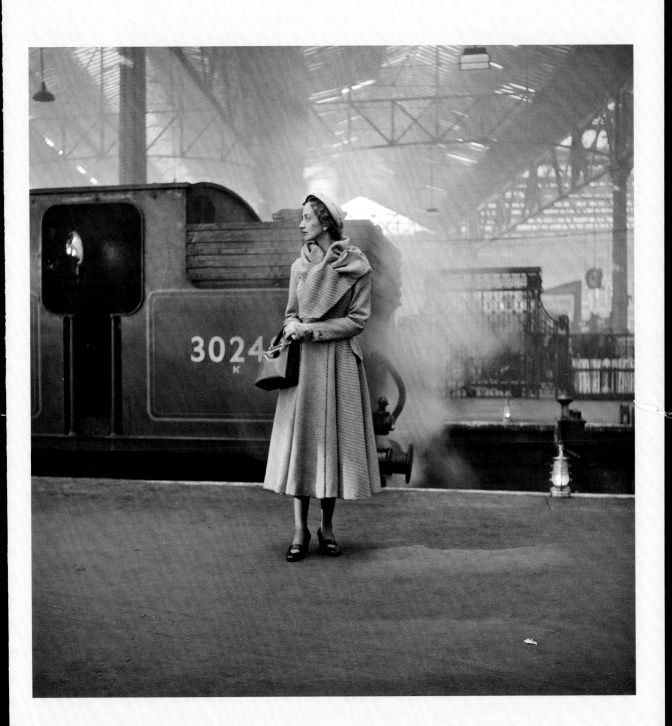

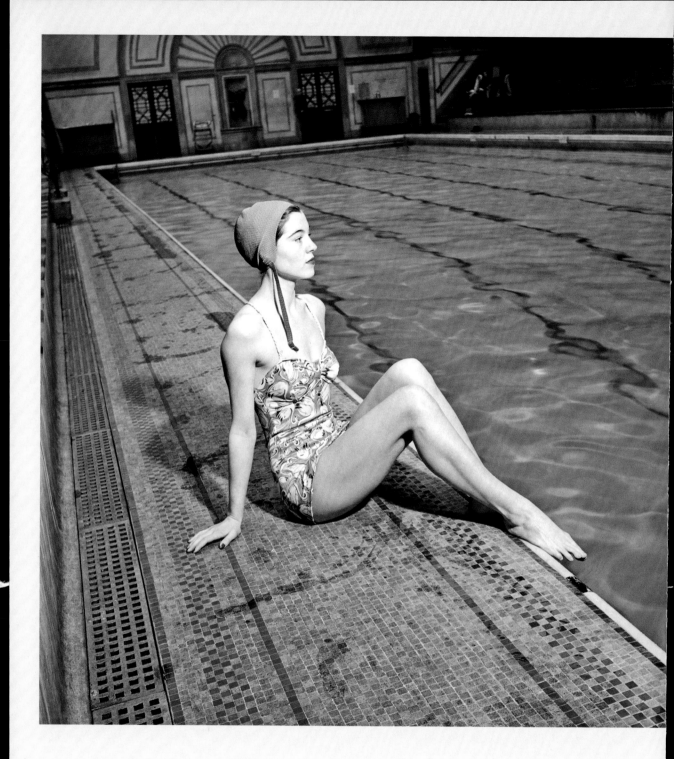

Opposite **UNPUBLISHED PHOTOGRAPH FOR BRITISH *VOGUE***

Photograph by Lee Miller, London, March 1949

Below **UNPUBLISHED PHOTOGRAPH FOR BRITISH *VOGUE***

Photograph by Lee Miller, London, August 1950

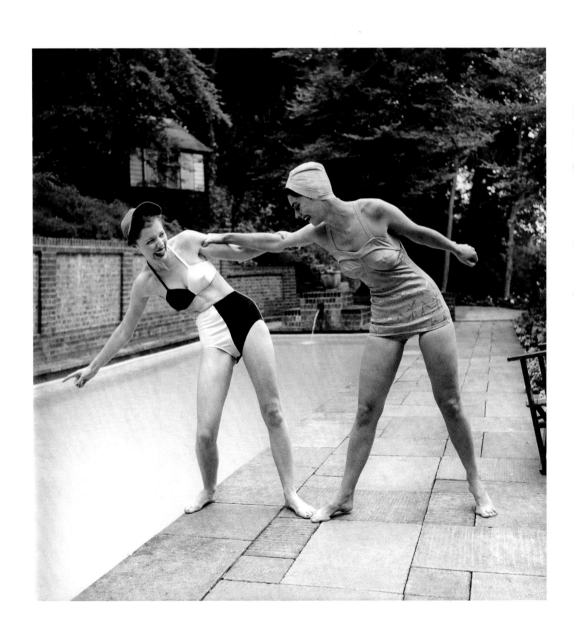

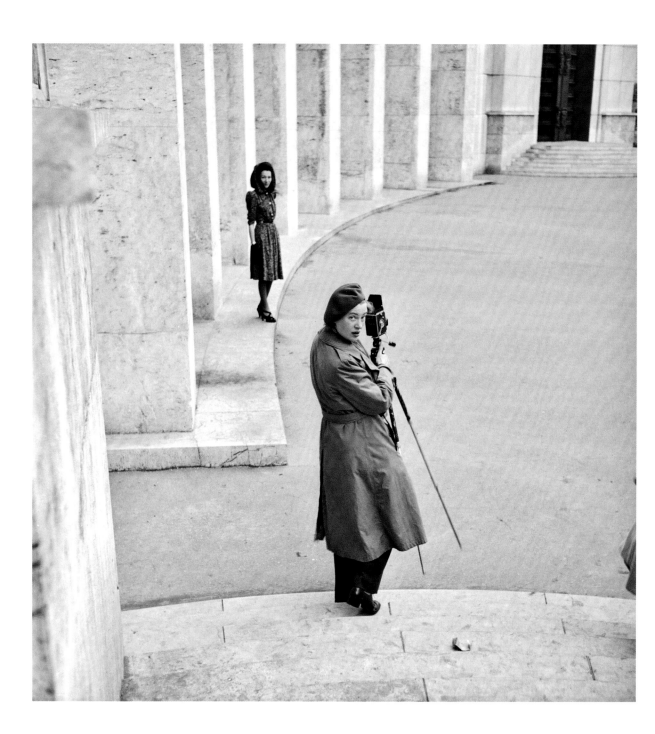

LEE MILLER ON LOCATION

Paris, March 1945

PREFACE

Lee Miller was one of the most important photographers of the twentieth century. A war photographer and a fashion model, a Surrealist and a witness with a camera at the liberation of the Dachau and Buchenwald concentration camps, Miller was unique in her day, and perhaps in ours too. Moving effortlessly from one side of the camera to the other, she was both the consummate professional fashion model *and* a highly successful fashion photographer. *Vogue* was the primary vehicle for her talents, not only in New York and Paris during the 1920s and 1930s, but also in London during the 1940s and 1950s, where she did significant but, until now, little-recognized work. For as Miller has been posthumously recuperated as an artist, her relationship with *Vogue* and her fashion photography have slipped from view. Yet for a full assessment of her career, fashion is vital.

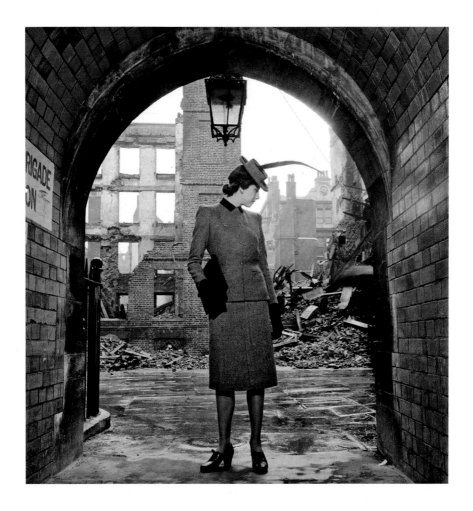

This book is the first to turn the spotlight on Miller's work in fashion—as realized in the pages of the American, British, and French editions of *Vogue*—and to identify it as the backbone of an already impressive life and career. Against the fast-changing landscapes of New York, Paris, and London, this stunning, shocking woman broke boundaries in her photography for the century's leading fashion magazine. Thousands of previously unseen photographs and contact sheets were recovered by her son, Antony Penrose, from *Vogue*'s London offices and these have been painstakingly sorted and restored at the Lee Miller Archives, housed at Farley Farm, her former home, in East Sussex, England. Those photographs most evocative of her talent, humor, beauty, and courage are reproduced here. Miller's photographic technique combined wit, high art, and a modernist edge, and was honed under the guidance of the great photographers of her day, including Man Ray, her lover during

Opposite **AMONG THE RUINS OF THE BLITZ**

Photograph by Lee Miller, London, 1941

Below **OUTSIDE THE ROYAL ACADEMY OF ARTS**

Photograph by Lee Miller, London, April 1940

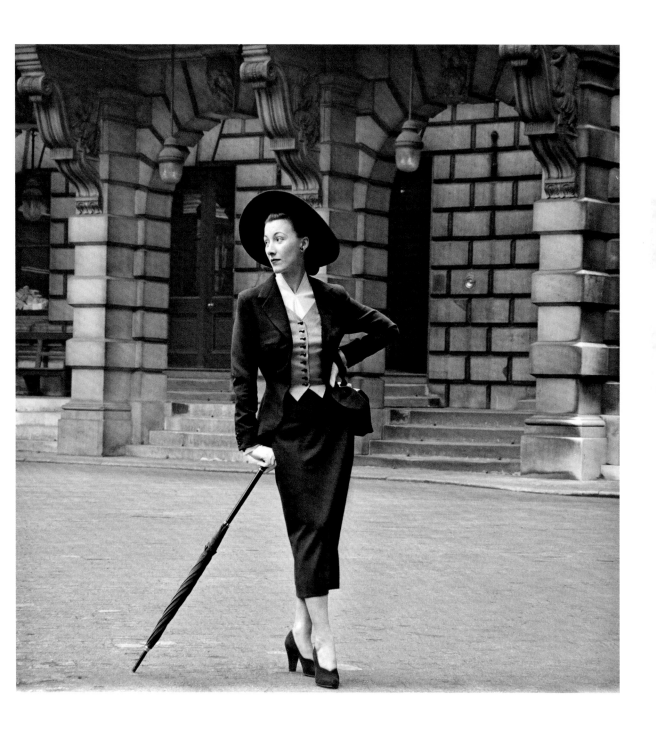

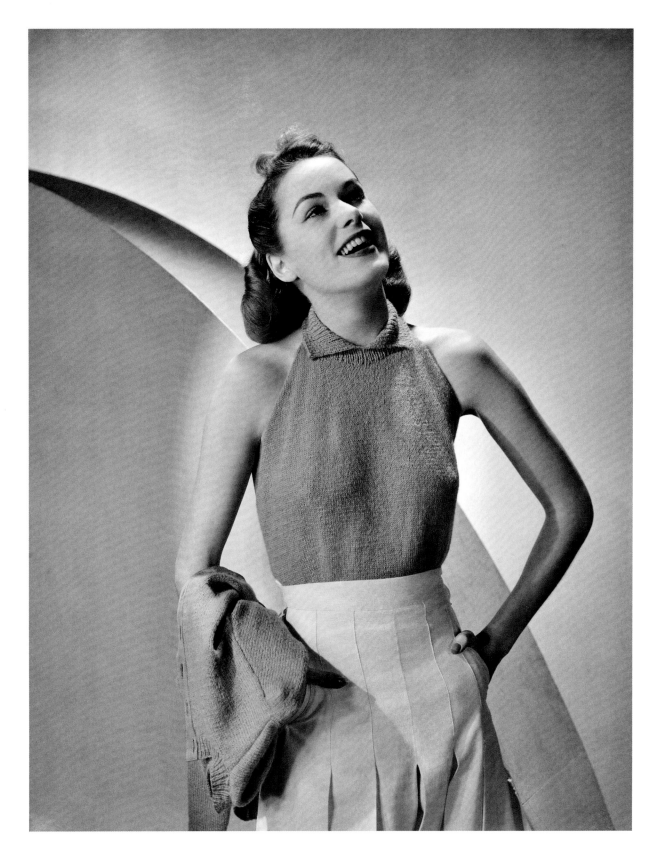

the late 1920s and early 1930s, Edward Steichen, known for his modern formalism at American *Vogue*, and George Hoyningen-Huene, acclaimed for his staged classicism at French *Vogue*. Retracing Miller's output as a fashion photographer offers new insights into her fascinating life, as well as illuminating the history of fashion at critical junctures.

Unlike many twentieth-century beauties and women artists of her caliber, Lee Miller is not, as one would expect, a household name. What is it about this woman that is so compelling yet so elusive? Carolyn Burke, one of her biographers, blames this relative obscurity on Miller's beauty. She has argued that because Miller was "one of the most beautiful women of the twentieth century" it has been "difficult to evaluate her work in its own right." "For many," Burke believes, "her beauty is at war with her accomplishment, as if the mind resists the thought of a dazzling woman who is a first-rate photographer."[1] There is something to this: very beautiful women, even now, often elicit distrust and dismissal. But we must also acknowledge that Miller had turned her back on her photographic career by the mid-1950s, at a point when other people involved in the world of fashion—Edna Woolman Chase, American V*ogue*'s seasoned editor-in-chief, H. W. "Harry" Yoxall, managing director of British *Vogue* for over forty years, and even Man Ray—were contemplating their memoirs.[2] By the 1960s and 1970s, Miller was telling anyone requesting her photographs for exhibitions or books that they had all been destroyed during the war, adding that they were of "no interest anyway and best forgotten." As Antony Penrose has written, "Her disparagement of her own achievements was so intense that everyone was convinced that she had done little or no work of significance."[3]

Penrose chose *The Lives of Lee Miller* as the title of his moving biography of his mother. And, as we will see, Miller did indeed live many lives. She was, in the words of her best friend, fellow American expatriate Bettina McNulty, "a genuine original."[4] Penrose wrote in the opening paragraph of his book, "In all her different worlds she moved with freedom. In all her roles she was her own bold self."[5] According to her sometime lover, *Life* photographer David E. Scherman, across all those worlds Lee Miller was "the nearest thing I knew to a mid-twentieth-century renaissance woman."[6] And a renaissance is what her career in fashion deserves.

Opposite **UNPUBLISHED PHOTOGRAPH FOR BRITISH *VOGUE***

Photograph by Lee Miller, London, December 1941

VOGUE

SPRING SHOPPING NUMBER

"That intangible quality of chic"

EARLY LIFE & MODELING, 1907–29

I n a rented brownstone apartment on West Forty-Eighth Street near Fifth Avenue, Miss Lee Miller, aged nineteen, listened to the radio as she brushed her blond bob and donned a smart ensemble bought in Paris the previous year. Perhaps it was the bad weather, or perhaps it was the late hours she had been keeping socializing throughout the city, but that afternoon Miller headed out into the bustling New York streets, stepped off the curb, and failed to see the car heading straight for her. Luckily for her, amid the hooting horns and screaming cabbies, she fell into the arms of the renowned publisher Condé Nast. Even for a man surrounded by beautiful women, Nast was taken aback by Miller's big blue eyes, shining cropped hair, perfect red lips, and lithe figure clothed in fashions just arrived in New York. To add to the confusion, although clearly American, this beauty was speaking in French.

Condé Nast was a man known to appreciate women who had both intelligence and "that intangible quality of chic" that he thought epitomized his magazines.[2] Instantly, he knew that Lee Miller was that sort of woman. He invited her then and there to come to his headquarters. *Vogue*'s editor-in-chief, Edna Woolman Chase, had been tasked before with featuring the young ingenues whom Nast fancied in the pages of her magazine. (Nast is said to have been sex-obsessed, his offices described as "both an escort service and a feudal village."[3]) But Miller was not naive. She later told a friend that Nast was "a harmless old goat" and remarked to another friend in Poughkeepsie, "you had to keep the desk between yourself and Mr. Nast."[4] And, for once, Woolman Chase was actually looking for a new model to represent that still-emerging type, the "Modern Girl." Only months later, Miller, sporting a vivid blue cloche hat that set off the rich blue of her eyes, would appear on the covers of American *Vogue* and British *Vogue*, all of Manhattan's glittering skyline as her backdrop (page 20).

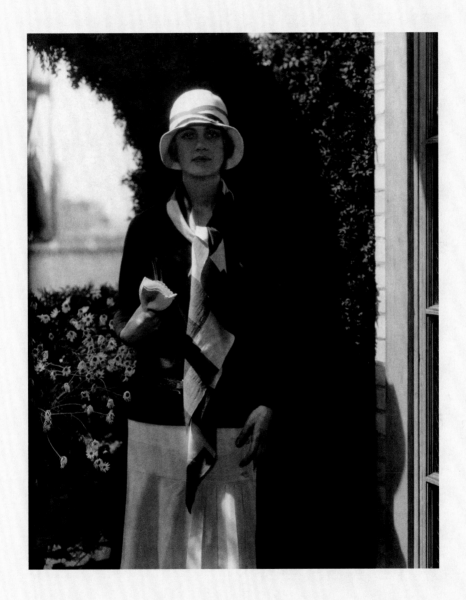

Above LEE MILLER MODELING CHANEL DAYWEAR

Photograph by Edward Steichen, New York, *c.* July 1928

Page 20 LEE MILLER ON THE COVER OF BRITISH *VOGUE*

Illustration by Georges Lepape, late March 1927

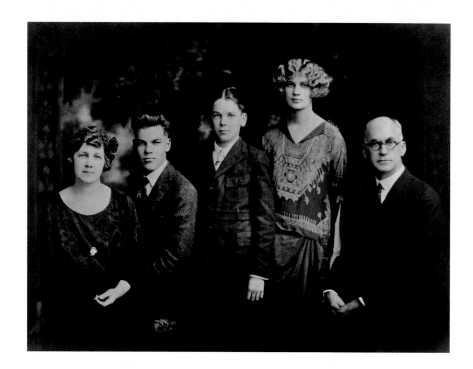

None of Miller's extraordinary career would have happened the way it did if Condé Nast had not scooped her up that fateful day in 1927. But if little in her life had so far indicated a career in fashion, even at the age of nineteen Miller was far from ordinary. Born Elizabeth Miller on April 23, 1907, Miller was called first Liz, then Li-Li, and finally Lee.[5] She was the middle child and only daughter of Florence and Theodore Miller. Her father was an amateur inventor and photographer, and, by 1910, Works Manager of the DeLaval Separator Company in Poughkeepsie, New York. The Millers settled on a 165-acre farm just outside of town. According to her son, Lee inherited from her father "willfulness, an insatiable curiosity about all things mechanical and scientific, and a completely unabashed manner of asking questions."[6]

Yet what should have been an idyllic childhood was marred by almost unspeakable horror. At the age of seven, Miller was sent to family friends in Brooklyn to be cared for because her mother had taken ill. There she was raped and infected with a venereal disease. For the next two years her symptoms were treated both at the Poughkeepsie Hospital and at home by her mother, who had trained as a nurse. Prior to the invention of penicillin, her treatment entailed excruciating douches of dichloride of mercury. The disease would plague Miller on and off until antibiotics became available but, miraculously, she was not left sterile. Her forward-thinking parents also employed a New York psychiatrist who, in the hope of staving off any feelings of guilt, encouraged the young girl to believe that sex was merely a physical act and not linked to love.

Opposite **THE MILLER FAMILY** Poughkeepsie, New York, 1923

Below **LEE MILLER** Photograph by Theodore Miller, Grand Hotel, Stockholm, 1930

Unsurprisingly, as a result of this tragedy, Florence and Theodore were extremely lenient and indulgent toward their prankster daughter. More surprisingly, two weeks before her eighth birthday, Theodore began to regularly photograph Lee in the nude, and continued to do so into her early twenties (page 25).[7] Curator and author Jane Livingston has written of this "closeness between" father and daughter, observing that Lee "may have had a troubled relationship with him—while he was a direct source of strength and a powerful mentor, he became for a time a somewhat obsessed photographer of her, and she a compliant model."[8]

As a teenager Miller was expelled from a number of schools in and around Poughkeepsie for insolent comments and practical jokes. She finally completed her high-school career in May 1925 as a day girl at Putnam Hall, a Vassar prep school.[9] Like so many other creative Americans during the 1920s, she dreamed of the bohemian life in Paris, inspired by Anita Loos's novel *Gentlemen Prefer Blondes*, published that spring, and its protagonist, Lorelei Lee.[10] Miller managed to convince her parents that in order to "finish" her education she should be sent to Europe in the company of two older female chaperones, Madame Kohoszynska, an impoverished Polish countess who had been her French teacher at Putnam Hall, and her companion. They were traveling to Nice where Kohoszynska had been hired by a finishing school, which Miller was to attend.

On May 30, 1925, Lee said goodbye to her parents and her brother Erik and boarded the SS *Minnehaha* bound for France. With her family looking on, she waved from the deck wearing a paisley dress, calf-length coat, and cloche hat (opposite). When Miller and her chaperones arrived in Paris it quickly became apparent that Kohoszynska possessed neither enough French to order a taxi nor to recognize that the hotel she had chosen was a *maison de passe*, a hotel used for prostitution.[11] Miller later remembered, "It took my chaperones five days to catch on but I thought it was divine. I was either hanging out the window watching the clients or watching the shoes being changed in the corridor with amazing frequency."[12] Of that first trip to Paris, she said, "I loved everything; I felt everything opening up in front of me."[13]

Miller informed Kohoszynska that she would not be coming to Nice after all. She promptly found herself a maid's room to rent and wired her father to confirm that she planned to remain in Paris and continue her studies at the L'École Medgyes pour la Technique du Théâtre, where she would study theater lighting, costume, and design.[14] Theodore Miller, ever indulgent, agreed to the new arrangement and granted her an increased allowance, which included what he had been paying the useless chaperones. Miller made a bit of extra money by playing tour guide to visiting Americans who

LEE MILLER ONBOARD THE SS *MINNEHAHA*

Photograph by Theodore Miller, New York, 1925

wanted to see bohemian Paris. They usually threw in a good restaurant meal as a thank you.

Ladislas Medgyes, founder and director of L'École Medgyes, was a revolutionary Hungarian painter and furniture and set designer. According to the dapper Frank Crowninshield, editor of *Vanity Fair*, he was also very much a "play-boy."[15] (Crowninshield and Miller met for the first time at the school that fall.) Florence Miller arrived unexpectedly in Paris on October 5, 1925. Shortly after, she cabled her husband to come as quickly as possible, concluding "Elizabeth unaware." What exactly alarmed Florence we cannot be certain but there is some evidence that Lee was having an affair with the much older Medgyes—she referred to him in her diary as "Maestro"; he called her "*souris*" (mouse).[16] The Millers and Medgyes were introduced at a tea dance and, according to one of Miller's biographers, "as men of the world, the Maestro and Theodore understood each other."[17] All three Millers had also come to an understanding. Theodore departed Paris to visit his DeLaval colleagues in Stockholm and, with her mother now installed as chaperone, Lee completed her studies. When not in class or sneaking off to see the "Maestro," she spent the remainder of her time in Paris with her mother, behaving like any other respectable, upper-middle-class American women—they attended the theater, shopped at the couturiers, and dined in fine restaurants. They sailed for home on the SS *Suffren*, arriving in New York on January 23, 1926, where they were greeted by Theodore.

Back in Poughkeepsie, Lee was suddenly so ill that she could not get out of bed. Feverish, she was diagnosed with congested lungs and remained ill and bedridden for a month.[18] By the end of February, Theodore recorded in his diary that "Elizabeth has so far recovered as to be up and around the house."[19] The following month she was well enough to enroll as a special student in Vassar's new Dramatic Production Program. Vassar, one of the prestigious Seven Sisters colleges matched with the then men-only colleges of the Ivy League, was conveniently located in her hometown. For one particularly successful production, Miller researched Medieval set designs, directed the lighting, and managed a crew of two electricians and six Vassar seniors. Her work caught the attention of Frank and Helen Stout, directors of the Poughkeepsie Community Theater, who invited her to design the lighting for their next play.

Secretly, Miller was undergoing treatment for her recurrent venereal disease, which caused fever, cramps, and nausea.[20] In her diary she wrote about her "virgin life," which included an erotic friendship with a female friend, M. E. Clifford, from Vassar, and telephone sex with a beau named Harold Baker. But even with these distractions,

Poughkeepsie and Vassar could not hold her attention. Everyday that she did not have classes, she took the train to Manhattan, often accompanied by her mother. That winter and spring, she saw fifteen theater and opera productions, with Eugene O'Neill's *Desire Under the Elms* topping the list of her favorites.[21] By April she had convinced Theodore to pay for dance lessons in the city; by May she had landed a place in the chorus of George White's Scandals, a revue "known to be faster and livelier than the Ziegfeld Follies, since the Scandals girls performed the latest steps in costumes that stopped just short of nudity."[22]

In June, Lee once again fell ill, and Theodore and two friends argued that she must quit the Scandals and return home to Poughkeepsie. Possibly too weak to refuse, and certainly too ill to care for herself in her rented Manhattan hotel room, she relented. A few weeks of rest did the trick. In the high summer of 1926, however, Lee experienced a shocking loss. She had once again taken up with her local admirer, Harold, and, seeking some escape from a heat wave then sweeping the east coast, the two of them had driven thirteen miles upstate to take a rowboat out on Upton Lake. It is thought that the young man was showing off for Lee when he dove off the side of the boat. He never resurfaced. The authorities were called, and Lee stood in shock on the beach with her family while they dragged the lake to recover the youth's lifeless body.[23]

Poughkeepsie was no longer a comforting home for Miller, who moved to New York City permanently.[24] She convinced her father to rent a brownstone apartment for her and her brother John, who was studying at the Pratt Institute, and she began to work as a lingerie model at Stewart & Company on Fifth Avenue, while continuing her studies, primarily in painting and drawing, at the Arts Students League.[25] These were not ordinary pursuits for a young woman from a respectable family in Poughkeepsie. But, of course, as we know, Miller was no ordinary young woman. In her diary from that year, she hints at the disturbing experiences of her early years: "Of my dark and supposedly lurid past, I will say almost nothing.... I will content myself this time in saying that anything you hear about me is probably true." She goes on to call herself "sordidly experienced"[26] and, in the parlance of the day, "damaged goods."[27]

More lighthearted thoughts and reflections also populate her diary, including mentions of her Hollywood heroes, the onscreen flappers Louise Brooks and Colleen Moore.[28] It was, after all, the 1920s, a heady time for young men and women prepared to throw themselves into life. And Miller was more than ready to put her past behind her. Brooks and Moore perfectly embodied the "Modern Girl" of 1920s America. Their flapper style, historian Kathy Peiss notes, had been "pioneered" by young

working-class women as they entered the waged workforce "in factories, offices, and department stores … declaring their autonomy and, for immigrant daughters, their American identity." Young middle-class women soon "picked up the style in schools, movies, and magazines" and further popularized it.[29] They bobbed their hair, wore cloche hats, and donned the low-waisted straight chemise dresses that made it possible to kick up their heels and dance the Charleston.[30] Such flappers and "Modern Millies" were ubiquitous in Manhattan by the time Miller moved to the city. In the fall of 1925, Bruce Bliven had written an article entitled "Flapper Jane" for the rather highbrow *New Republic* magazine. There he described the very pretty but heavily made-up "Flapper Jane," aged nineteen, who resides on the Eastern Seaboard, hails from the suburbs, drives fast cars, sports a bob, and wears—what he considered— very little: "one dress, one step-in, two stockings, two shoes." (Bliven explained to his readers that a "step-in, if you are 99 and 44/100ths percent ignorant, is underwear— one piece, light, exceedingly brief but roomy."[31])

A couple of months later, real-life flapper Miss Ellin Mackay, a twenty-two-year-old Manhattan socialite, reinforced the stereotype with her article "Why We Go to Cabarets: A Post-Debutante Explains," published in *The New Yorker*.[32] Mackay was already notorious in New York society for cavorting with the widowed composer Irving Berlin, fifteen years her senior and of Russian Jewish extraction. (They later married.) Her article further scandalized Manhattan's elite families. It declared the "dizzy twenties" an improvement on the "dull old days" and cabaret nightlife much more fun than the Junior League or boring society parties—populated as they were with boring young society men.[33] In a second article, published the following month, Mackay expanded on her message:

> Modern girls are conscious of their identity and they marry whom they
> choose, satisfied to satisfy themselves…. They have found out that their
> own individual charm is of more importance than the badge of social
> respectability that must be worn through the torment of boredom.[34]

Not only did Mackay shock New York society with her article, she also saved the fledgling *New Yorker* by providing it with the voice and purpose it had been sorely lacking. The magazine followed up the tone set by Mackay in its regular feature— first entitled "When Nights are Bold," then "Table for Two"—that reported on the cabarets, nightclubs, and speakeasies, along with their proprietors and clientele, in allegedly "dry" Prohibition-era Manhattan. As the feature's first columnist, Charles Baskerville, announced: "This town is night club mad."[35] At the time, New

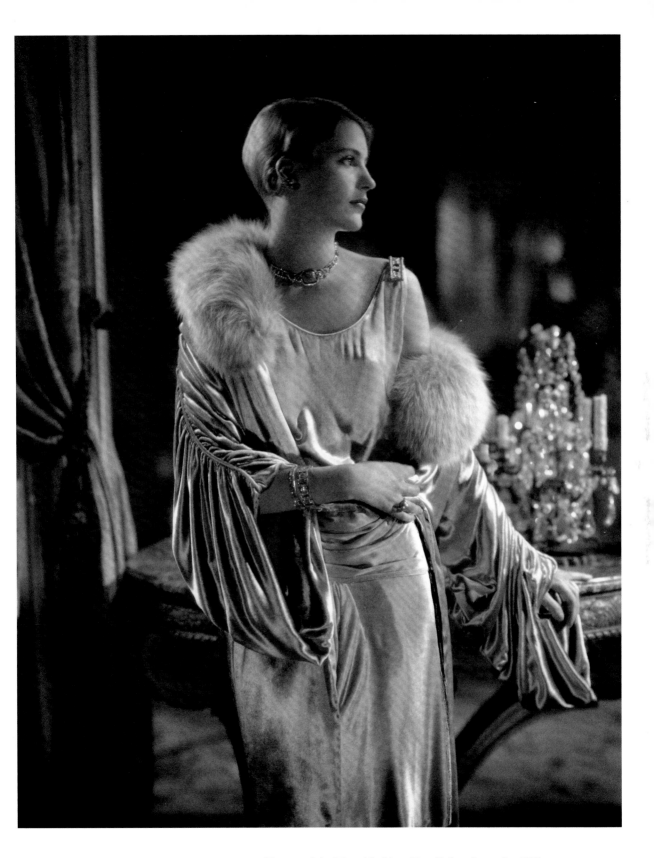

LEE MILLER MODELING EVENINGWEAR Photograph by Edward Steichen, New York, *c*. September 1928

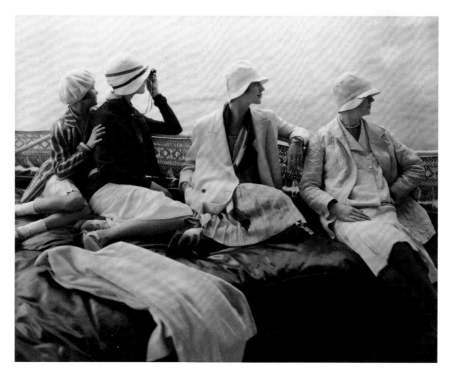

LEE MILLER (THIRD FROM LEFT), "THE MODE PUTS OUT TO SEA," AMERICAN *VOGUE*
Photograph by Edward Steichen, New York, July 15, 1928

York housed thirty thousand nightclubs and speakeasies.[36] Diana Vreeland dubbed the decade "the martini era."[37]

Another distinct sign of the times, in 1927 the Barbizon Hotel for Women opened its doors at 140 East Sixty-Third Street "hoping to attract the single, stylish, and thoroughly modern Millies pouring into New York during the Jazz Age to chase their dreams: stardom, independence, a husband."[38] (One assumes those dreams were to be lived out in that order.) This was the world Lee Miller intended to join when she moved from Poughkeepsie to Manhattan, and to which, after that chance encounter with Condé Nast, she almost immediately gained access.

From that first *Vogue* cover, drawn by the famous Georges Lepape, Miller slid easily into this thrilling and glamorous world—in life and in photographs. To be drawn by Lepape was in itself no small thing. He had made his name in Paris as the illustrator of couturier Paul Poiret's fashion albums and was now earning up to $1,000 per drawing.[39] Other artists were giving up the easel and drawing board for the camera. Just shy of her twentieth birthday, Miller quickly became one of the favorite

models of Edward Steichen, Condé Nast's chief photographer and by far the wealthiest artist in America. On top of an annual salary from *Vogue* and *Vanity Fair* worth $35,000, he earned an additional $20,000 as art director of the J. Walter Thompson advertising firm (equivalent to an annual income of about $7 million today). Steichen often shot his fashion photographs in Nast's thirty-room Park Avenue penthouse. Its gilt-framed mirrors and French antiques created the perfect setting to photograph Miller draped in satin and jewels, and sporting a fur-collared evening coat (page 31). For another Steichen photograph, shot the same year in the penthouse, she modeled a black tulle evening dress by the Paris couturier Lucien Lelong, Delman black satin pumps, and jewels by Marcus.[40]

The financier George Baker's yacht offered the gorgeous locale for a summer leisurewear feature. Published in the July 15, 1928, issue of American *Vogue*, this photograph depicts Miller sitting elegantly alongside fellow models June Cox, E. Vogt, and Hanna-Lee Sherman on a leather sofa (opposite). All four look out to sea, with one model peering through a set of small binoculars. In the center, Miller wears a menswear coat over a dress by Mae and Hattie Green and a long Chanel scarf. Vogt, on her left, models clothes by Chanel and a hat by Reboux. In yet another stunning fashion shoot from 1929, Miller posed with the great fashion model Marion Morehouse of Choctaw American Indian ancestry (later the wife of poet E. E. Cummings). In one photograph, the two women wear the same chemise evening dress, all smoky eyes, dark lips, and thin diamond-braceleted wrists, gracefully languid in the door frame of an expensive drawing room.

In front of the camera, Miller never appears self-conscious. She possessed that rare ability of looking not only beautiful and feminine but also remote and unattainable—almost not quite human. Her disturbing childhood experiences almost certainly contributed to this talent. Her father's obsessive, intrusive photographing, combined with her horrendous rape as a child, seem to have enabled Miller to expunge any evidence of her own thoughts and feelings when modeling—a personalized interpretation of her psychiatrist's advice.[41] Carolyn Burke has argued that when photographed nude by her father, Miller "coped with the situation by dissociating," or distancing, "herself from the use of her body."[42] Thus early on she became equipped with the very thing that a photographic fashion model needs most—a sense of detachment that reads in the resulting image as an attractive aloofness.

In the two years that followed her accidental meeting with Condé Nast, Miller flitted between his parties for the glitterati—his guest lists often included the Vanderbilts, Josephine Baker, George Gershwin, Charlie Chaplin, Cecil Beaton, and

"*It has women's enthusiastic approval!*"

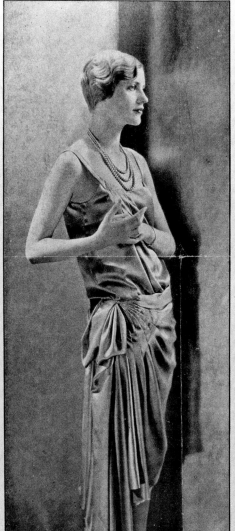

The
IMPROVED
KOTEX

combining correct appearance and hygienic comfort

HOW many times you hear women say—indeed, how many times you, yourself, say: "What did we ever do without Kotex?"

This famous sanitary convenience is now presented with truly amazing perfections. And already women are expressing delighted approval.

"It is cut so that you can wear it under the sheerest, most clinging frocks," they tell one another. "The corners are rounded, the pad fits snugly—it doesn't reveal any awkward bulkiness. You can have complete peace of mind now."

The downy filler is even softer than before. The gauze is finer and smoother. Chafing and binding no longer cause annoyance and discomfort.

Positively Deodorizes While Worn

Kotex is now deodorized by a patented process (U. S. Patent 1,670,587). . . the only sanitary pad using a patented treatment to assure absolutely safe deodorization. Ten layers of filler in each pad are treated by a perfect neutralizer to end all your fear of offending in this way again.

Women like the fact that they can adjust Kotex filler—add or remove layers as needed. And they like all the other special advantages, none of which has been altered: disposability is instant; protective area is just as large; absorption quick and thorough.

Buy a box today and you will realize why doctors and nurses endorse it so heartily—45c for a box of twelve. On sale at all drug, dry goods, and department stores; supplied, also, in rest-rooms, by West Disinfecting Co. Kotex Company, 180 N. Michigan Avenue, Chicago, Illinois.

KOTEX

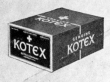

Fred Astaire—and the Upper West Side bohemian set's bootleg gin bashes where Dorothy Parker, the queen of quip, held court. Diana Vreeland fondly remembered the former in her quirky memoir, *D.V.*:

> Everybody who was invited to a Condé Nast party stood for something.
> He was the man who created the kind of social world that was then called
> Café Society: a carefully chosen mélange—no such thing as an overcrowded
> room, mind you—mingling people who up to that time would never have
> been seen at the same social gathering. Condé picked his guests for talent,
> whatever it was—literature, the theatre, *big* business. Sharp, chic society.[43]

Miller and her Norwegian-American friend Tanja Ramm, a fellow model, were included on Nast's guest list as beautiful "young things."[44]

Miller was not short of suitors; they took her to dance, sail, watch polo, and fly in their two-seater planes. Above all, this was the age of aviation—in May 1927, Charles Lindbergh had made his momentous flight from New York to Paris. Miller's many dates included Grover Loening, an aeronautical engineer almost twenty years older than her, the more age-appropriate Alfred de Liagre Jr., better known as "Delly" and later a successful Broadway director, and his friend Argylle, a Canadian aviator who enjoyed having Miller as his co-pilot. Frank Crowninshield, said to know "more-celebrities-than-anyone-else-in-New-York," and Charlie Chaplin also served as chaperones to Miss Miller.[45]

Despite taking Manhattan by storm, by the time she was twenty-two Miller was obsessed with returning to Paris. Her desire may have been fueled by her dubious distinction of being the first live model featured in a Kotex advertising campaign, after a photograph of her was reproduced without her consent (opposite). Understandably, she was embarrassed. Yet, true to form, when the advertisement actually appeared in print, Miller decided to relish the shock it caused. A more likely motivation for her move lies in her announcement that after two years of modeling and studying Steichen's approach to fashion photography she now intended to become a photographer herself. Steichen had introduced her to the innovative work of the American photographer Man Ray, who lived in Paris and was a frequent contributor to *Vogue* and *Vanity Fair*. She now believed that Paris was where she must head to pursue her dream. Armed with letters of introduction from Condé Nast to Man Ray and George Hoyningen-Huene, French *Vogue*'s chief photographer, Miller set sail for Europe on May 10, 1929.

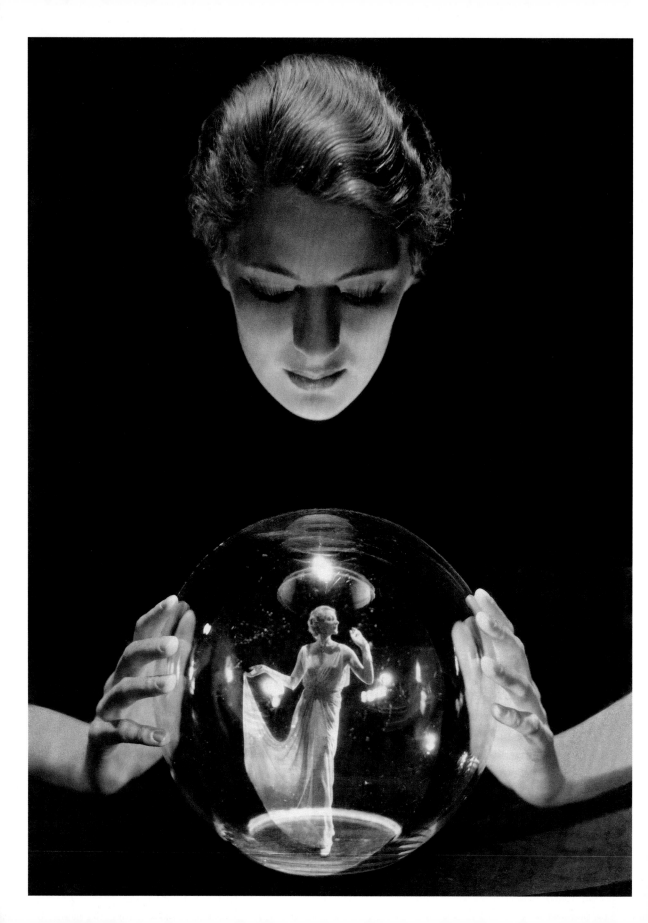

"With strong-willed girls you let them do it"

A PARISIAN APPRENTICESHIP, 1929–32

L ee Miller arrived in Paris with her friend Tanja Ramm in late May 1929. From there, they traveled on to Florence with letters of introduction to resident expatriates in hand. Miller had a small job with a New York fashion designer who had hired her to make drawings of fashion details in Renaissance paintings—lace, belts, cuffs, and buckles—in the hopes of reproducing these in current fashion designs. Miller found the work tedious and decided to photograph the details instead. Using her folding Kodak, a portable tripod, and what little light was available, she managed to make photographs that pleased her employer. With that job accomplished, she returned to Paris in June, while Ramm went to visit friends in Germany.[2]

Well aware of how rude it sounded, Miller proclaimed that she now intended "to enter photography by the back end."[3] After being photographed all her life, she would take up the camera herself. Decades after the event, Miller told an interviewer how she had been "chasing" Man Ray one warm early summer afternoon in 1929 when she found him in the Bateau Ivre bar near his studio on the rue Campagne Première. She was sitting upstairs, chatting and drinking wine with the Russian patron, when Man Ray emerged from "a very turny iron staircase," first his signature black beret appearing, then his head and shoulders, followed by his body. He looked like "a bull," she remembered, with his "extraordinary torso, very dark eyebrows and dark hair." She boldly announced herself: "My name is Lee Miller and I'm your new student." Man Ray replied that he did not take on students and, anyway, he was leaving for Biarritz the next day for his summer vacation. "So am I," Miller retorted.[4]

For the next three years, Miller would be his lover, his apprentice, and his muse. He was almost seventeen years her senior and so successful an artist at this point

Above **LEE MILLER AND MAN RAY IN A SHOOTING GALLERY**

Photographer unknown, Paris, 1930

Page 36 **LEE MILLER LOOKING DOWN AT AGNETA FISCHER**

Photograph by George Hoyningen-Huene, Paris, 1932

that he could afford to drive a sports car and wear custom suits. Though Miller was much taller than he, this seems not to have mattered to her. She recalled, "If he took your hand or touched you, you felt almost a magnetic heat."[5] Man Ray shot hundreds of photographs of "Madame Man Ray," as some called Miller, over the next three years. In the process, he taught her everything, from "fashion pictures to portraits." Impatient by nature, Miller loved photography because "you have something in your hand when you're finished—every fifteen seconds you've made something."[6]

Man Ray was at the cutting edge of this young art form. For indoor photographs, he used a Graflex camera, a small studio camera with glass plates measuring four by five inches, which "had to be unpacked very carefully and loaded into the chassis."[7] Plate cameras were difficult and awkward—the lens was focused by moving it along a track—and about to become outmoded as technology changed. But the large negatives they produced were ideal for Man Ray's photographs, especially his portraits, and allowed for meticulous retouching. In a 1975 interview, Miller discussed how Man Ray's retouching technique differed from that of magazine editors during the interwar period, who crudely retouched photographs using an airbrush. Man Ray preferred to retouch prints with a Jenner, "a tiny triangular blade that went into a penholder.... [It was] originally invented by Dr Jenner who invented vaccination and that's what he used to scratch people with." The Jenner had to be very sharp and when used on eggshell paper, as Man Ray did, "you could very carefully scrape out a wrinkle with a very light touch, and get rid of the dark things."[8]

Mark Haworth-Booth, author of *The Art of Lee Miller*, uncovered three photographs from around 1930 that show Miller retouching prints in her Montparnasse apartment at 12 rue Victor-Considérant, only a few minutes walk from Man Ray's studio. "In one, Man Ray watches over his pupil as the proud master, his arm circling her back, and is rewarded by a flashing smile. In another he looks down at her work as if advising, one hand on her shoulder."[9] The third photograph shows Miller at her desk, lit by an architect's lamp, working alone at the retouching of a pile of photographs. Man Ray also taught Miller printing techniques in his darkroom, which was up a narrow staircase from his apartment and "wasn't as big as a bathroom rug." Inside, the darkroom was fitted with "a wooden sink lined with acid-proof paint, a big print-developing basin, and a tank above that where the water could run through and rinse." Within this miniscule space Man Ray made "very soft, beautiful enlargements" from glass negatives and cut film using a mercury light.[10] Miller soon began to print his photographs as well as her own, so he could return to his first love—painting. The photography critic Vicki Goldberg has written that "editing is an inescapable

part of" a photographer's craft, and identified Man Ray as one photographer who embraced this process of elimination. He "evidently photographed full figures or wide scenes in order to find and crop down to the telling detail later on, unusual to this extent for a photographer, most unlikely for a painter," which, of course, he also was.[11]

Man Ray is famous for having pronounced photography not an art but a way to paint with light.[12] Thanks to the many lamps in his studio, he could experiment with patterns of light and darkness in his work to create "multiple shadows like overlapping waves of sand."[13] His photo-flood light, created by putting a low-voltage bulb into a higher-voltage circuit, cast "a brilliant, clear light," according to Miller. He also used lightweight lamps that could be easily moved around the studio or arranged into "a whole bank of … long, vertical strips that he could swing around at different angles." Miller learned all these tricks of the trade, as well as the art of photographing silver objects. The misconception, she learned, is that "where you think a silver object is very bright it actually isn't, it's just reflecting what's in the room."[14] Lighting was key here too.

While printing one day in the darkroom, "something crawled" across Miller's foot and she "let out a yell and turned on the light," only to realize, she later recalled, "that the film [had been] totally exposed" in the process. Man Ray was not pleased as a dozen negatives of a nude against a black background had been in the development tanks, but he "put them in the hypo and looked at them" anyway. The result was a revelation. "The unexposed parts of the negative, which had been the black background, had been exposed by this sharp light and had developed right up to the edge of the white, nude body."[15] Man Ray and Miller experimented further with the process, perfecting what is known as the Sabattier effect, but which they called "solarization."[16] Some of their best-known photographs are solarizations.

Man Ray's portraits of socialites, writers, and artists had appeared frequently in the pages of *Vogue* during the 1920s. So admired were these works that to be photographed by Man Ray conferred a certain celebrity status on the sitter.[17] The Wall Street stock market crash of October 23, 1929, had resulted in fewer wealthy sitters turning up at his studio.[18] Still, Man Ray's views on the art of portraiture remained pronounced and they influenced Miller as she developed her own style. As she explained to an interviewer in 1941, "He dislikes the 'candid camera' attitude to portraiture."[19] Decades later, she added that Man Ray was also "very sensitive about the drawing of a face … very much against … the vulgarity of a regular cinema portrait of that time with shiny high cheekbones and an oily look." He avoided that style of portrait by always shooting from "at least ten to twelve feet away," because, as Miller explained,

"when you come close to a face with a lens, the nose is bound to get out of proportion to the ears." Man Ray wanted the image flattened and his technique resulted in "that very fine, delicate drawing that's so Renaissance-looking. It is never bulbous."[20]

Shortly after her arrival in Paris, Miller knocked on the door of *Vogue*'s Paris offices and was enthusiastically taken on as a model. The modeling profession was then in its infancy in Paris. As fashion photographer Horst P. Horst recalled, "We had no hairdressers, makeup people or modeling agencies. Girls just turned up or somebody knew somebody. I have no idea what they were paid, but it was very little."[21] Miller was the exception. She was among the first generation of professional models that emerged as fashion magazines slowly moved away from their earlier reliance on actresses and aristocrats.[22] Rather than taking payment in clothes, as those women did, Miller was paid in cash.[23] She began to appear regularly in the pages of French *Vogue*, affectionately called "*Frogue*" by its staff.[24]

George Hoyningen-Huene was then chief photographer at the magazine. Today, along with Edward Steichen, Adolph de Meyer, and Louise Dahl-Wolfe, he is considered one of the four pioneers of fashion photography.[25] A baron born in Leningrad, Hoyningen-Huene was only seven years Miller's senior and had a reputation for being fierce: fixing his gaze on the nervous model waiting to pose for him, he would disdainfully ask, "Is this what you expect me to photograph?"[26] Miller became his favorite model when she worked in Paris. He treated her with respect, and together they created some fine fashion photographs. In the October 1929 issue of French *Vogue*, which appeared just before the Wall Street crash, Miller features in three photographs wearing tweed and jersey and "consecrating the triumph of the muscular young woman."[27] Like Steichen in New York, whose work he admired, Hoyningen-Huene chose to depict modern women "in their normal surroundings, pausing for a moment during their daily activities."[28]

A flick through the pages of French *Vogue* from this period reveals Miller modeling Yrande and Izod beachwear, Maria Gay summer daywear, and Chanel and Lanvin evening dresses (opposite, pages 44 and 45). Frequently photographed from behind, sometimes seated on a classical pedestal, her lovely back and shoulders epitomized the new elegant but somewhat androgynous modern woman (page 46). As another one of Man Ray's models said of Miller, "her athletic figure made the simplest things seem elegant."[29] Cecil Beaton remembered her in more overtly androgynous terms: "[Lee Miller] cut short her pale hair and looked like a sun-kissed goat boy from the Appian Way. Only sculpture could approximate the beauty of her curling lips, long languid pale eyes, and column neck."[30] Her figure and her style helped to define a generation.

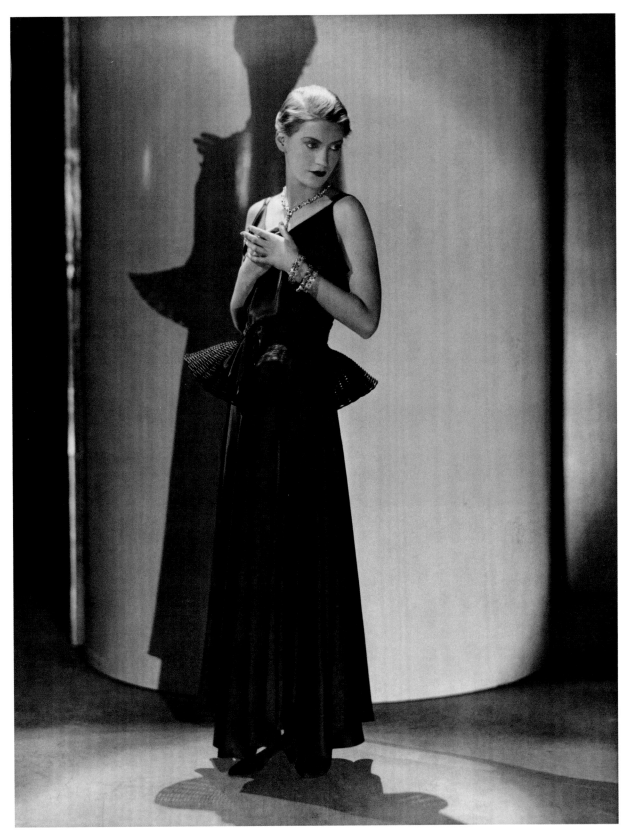

LEE MILLER MODELING LANVIN Photograph by George Hoyningen-Huene, Paris, October 1932

LANVIN

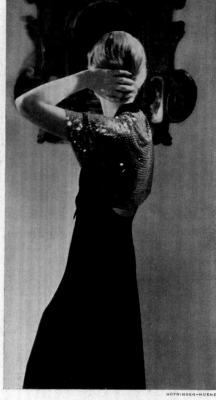

HOYNINGEN-HUENE

près du cou. C'est un des traits les plus caractéristiques de la belle collection de Lanvin que ces robes montantes devant jusqu'au cou, mais largement décolletées dans le dos, voilé plus ou moins partiellement par une pèlerine plissée, une cape s'allongeant en capuchon, ou une collerette de paillettes faisant partie de la robe. Les robes sont en crêpe de couleurs si seyantes : bleu Raphaël, rose amarante, ou rouge flamme, que le visage sera certainement embelli par le reflet du tissu si proche.

Vionnet a développé ses précédents effets d'écharpes, nouées et drapées, de couleur contrastante avec la jupe. Ces écharpes indépendantes de la robe, mais qui lui sont en quelque sorte indispensables, forment de véritables vêtements très courts, qui s'achèvent en ceinture à longs pans : tel un corsage-écharpe en velours noir sur une robe rouge, ou rouge ou vert sur une robe noire, ou orchidée soutenu sur une robe rose-orchidée pâle. De toutes façons, les épaules et l'attache du bras sont toujours couverts. (Suite page 30)

L'emploi des paillettes est entièrement renouvelé par Lanvin. Ici, l'éclat de paillettes d'acier fixées par une turquoise contraste avec la matité d'un crêpe de laine noir. Posé par Miss Lee Miller. Miroir de S. Roche

Le mouvement diagonal du décolleté et du drapé aux hanches est accentué dans cette robe en fleur de soie gris bleu, par une incrustation d'un bleu plus soutenu. Silhouette princesse d'une ligne nouvelle. Bijoux de Van Cleef et Arpels

Le col cape de Jeanne Lanvin
La taille basse de Jean Patou

LEE MILLER MODELING LANVIN, FRENCH *VOGUE* Photographs by George Hoyningen-Huene, Paris, 1932

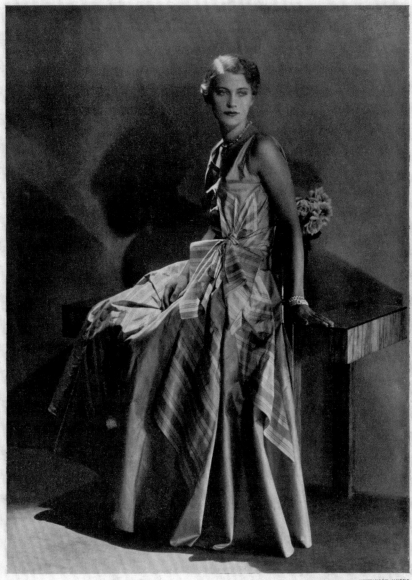

HOYNINGEN-HUENE

CALLOT **JEANNE LANVIN**

ROBE EN TULLE BLANC, MOULÉE ET PERLÉE JUSQU'AUX HANCHES, LARGE CEINTURE DE TAFFETAS PARTIELLEMENT INCRUSTÉE
AU-DESSOUS DESQUELLES LE TULLE MOUSSEUX S'ÉCHAPPE SUR UNE ROBE EN TAFFETAS ROSE. BIJOUX DE BOURDIER

LEE MILLER MODELING LANVIN, FRENCH *VOGUE* Photograph by George Hoyningen-Huene, Paris, October 1930

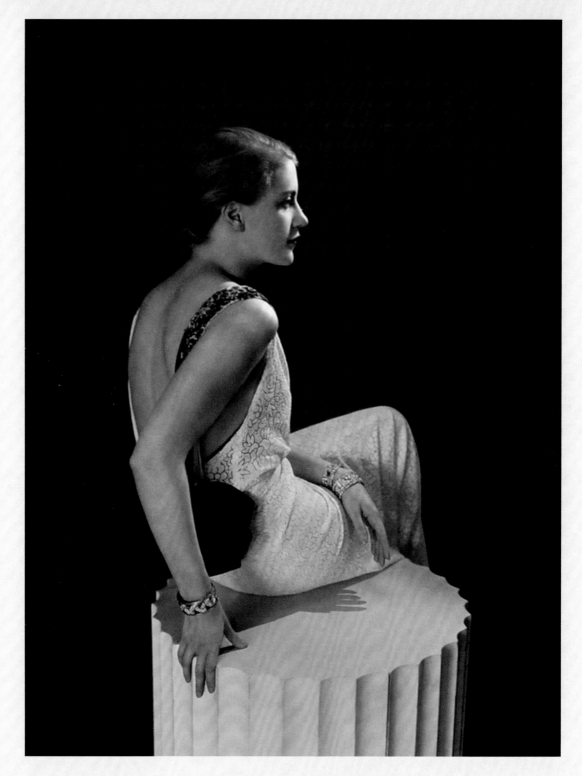

Above **LEE MILLER MODELING LANVIN**

Photograph by George Hoyningen-Huene, Paris, August 1932

Opposite **SELF-PORTRAIT IN THE WINDOW OF THE GUERLAIN BOUTIQUE**

Photograph by Lee Miller, Paris, *c*. 1930

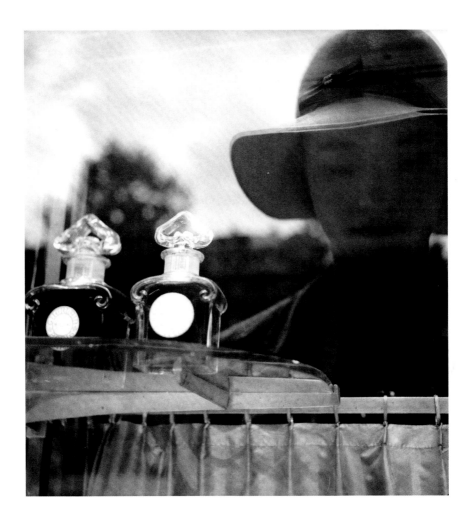

By the early 1930s, Miller was a fixture on the Paris scene and at the center of art, fashion, and high society. She was young and cosmopolitan, fashionable and sexually-liberated, and involved with the Surrealists. Her first forays into art photography occurred under Man Ray's tutelage and resulted in some of her most acclaimed images from this period. In one self-portrait—her reflection captured in the window of the Guerlain perfume boutique—her eyes are closed as if in a dream (above).

Surrealism differed from the formal modernist movements—Post-Impressionism and Cubism—that preceded it in that its proponents were very interested and involved in the world of fashion. In his book *Fashion and Surrealism*, Richard Martin writes, "Fashion became Surrealism's most compelling friction between the ordinary and extraordinary."[31] By 1930 the Surrealists had "entered the realms of fashion, fashion advertising, and window display," and the Surrealist style had become "pervasive ... among the major fashion publications, most especially *Vogue* and *Harper's Bazaar*." Jean Cocteau, Leonor Fini, Hoyningen-Huene, and Man Ray, among others, were

"the unlikely missionaries for the stylistic revolution."[32] As Roland Penrose explained in an interview in 1980, "Surrealism was not just a new school of painting—it was a way of life—it was a way of thinking and a way of living.... A way of thinking that relied very much on spontaneity, the unconscious ... and [a] sort of humanitarian background."[33] Miller fit into this Surrealist milieu perfectly.

When Miller happily joined the French *Vogue* studio, it was not only as a model but also as one of the "slaves" in Hoyningen-Huene's photographic workshop. In her words, she found through him an "entirely different kind of photography" than what she was learning from Man Ray. Hoyningen-Huene was a master of studio lighting and when Miller modeled for him she would coax him into talking about his technique, thus providing her with private tutorials as they worked. She was an excellent student. By the winter of 1930 she had her own apartment and studio in Montparnasse and began to land photographic jobs for leading couturiers Jean Patou, Elsa Schiaparelli, and Gabrielle "Coco" Chanel. *Vogue* published her shadow-laden photographs of new fragrances, featuring chessboards and perfume bottles, along with more typical fashion shots.

A young German art student by the name of Horst Bohrmann joined *Vogue*'s Paris studio in 1930 as an apprentice to Hoyningen-Huene. The two men were lovers, the younger man living in the servant's room above his mentor's apartment.[34] Hoyningen-Huene enjoyed photographing Horst and Miller together as they were the same age and both blond, blue-eyed, and remarkably beautiful. One leisure and beachwear spread for the July 1930 issue reveals Hoyningen-Huene playing with his models' gender roles and sexuality (opposite). In a deck chair sporting mannish tailored trousers and a long-sleeved shirt, Miller reclines confidently while gazing over at a bare-legged and bare-armed Horst, who sits on the ground beside her in a more demure and self-conscious pose. For another shot on the same spread, Hoyningen-Huene photographed Miller from behind wearing masculine sailcloth overalls.

Bohrmann soon changed his name to Horst P. Horst and would become a successful photographer in his own right. On the one occasion that he persuaded Miller to model for him, he posed her holding a sprig of lily of the valley in her hands. She responded to the developed photograph, "Wow! That's a howl!"[35] With his imperfect English, Horst decided that Miller was making fun of him and vowed never to photograph her again, concluding, "With strong-willed girls you let them do it, you don't suggest."[36]

The story of fashion photography has often been told in terms of talented, even genius, photographers and their beautiful models. The photographer is an artistic

TOILE OU FLANELLE

Un vêtement de plage taillé sur le modèle d'une combinaison de mécanicien et traité en grosse toile rouge sombre, est d'une élégante originalité

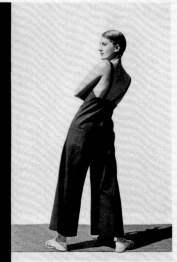

HÉLÈNE YRANDE

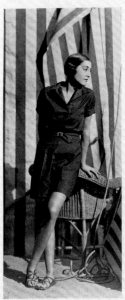

HÉLÈNE YRANDE

HOYNINGEN-HUENE

L'uniforme des boy-scouts est à la base de ce costume de plage en deux pièces qui est fait dans une grosse toile de fil d'un bleu soutenu. L'empiècement de la culotte se transforme en ceinture devant

Pyjama en flanelle, beige pour la blouse étroite à la taille, et bleu pour le pantalon tenu par une ceinture de cuir. Costume de bain deux-pièces en épais lainage crêpé blanc bordé d'une tresse de soie

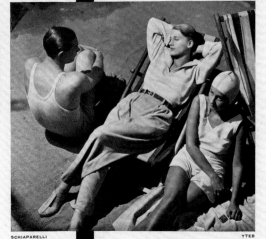

SCHIAPARELLI

YTEB

LEE MILLER MODELING LEISUREWEAR, FRENCH *VOGUE*

Photographs by George Hoyningen-Huene, Paris, July 1930

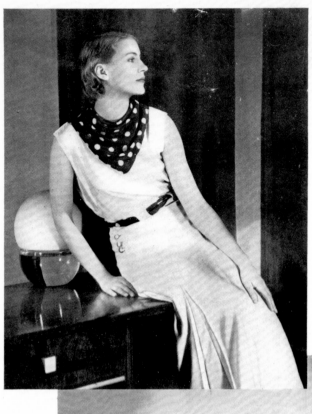

● (Left) Two weights of Rodier's white sinellic are used for this tennis ensemble. The shirt and knickers are in one, and a skirt slips over them. The dark blue and white spotted scarf is attached to the dress to keep it in place. A second dark blue and white spotted scarf ties round the waist. London Trades, Fortnum and Mason. Posed by Miss Lee Miller

● (Below) Long cream flannel trousers and a white loosely knitted wool shirt compose this costume for beach wear. They are worn with a wide red patent leather belt, and red leather sandals to match. A red and white medicine ball matches the costume. Everything from Lillywhites, Piccadilly. Posed by Miss Evelyn Spilsbury

Lee Miller

FASHION SELF-PORTRAIT (TOP), BRITISH *VOGUE*

Photographs by Lee Miller, Paris, June 1931

FASHION SELF-PORTRAIT (RIGHT), BRITISH *VOGUE*
Photographs by Lee Miller, Paris, September 1930

auteur; the model is—at best—his muse. The active male subject creates; the passive female object poses. Never were such simplistic readings less true than in the early days of professional photographic modeling. When the cameras were so slow and the studio lights so hot, successful professional models were real collaborators in the construction of these images. Some designers and photographers have acknowledged this active participation. For example, the couturier Paul Poiret wrote of the "mannequin" Paulette in his 1931 autobiography, "The way in which she gave life to everything I put on her could really be called a collaboration."[37] Jane Livingston has more recently written that many of Man Ray's photographs of Miller "seem created through a process in which the model and photographer have collaborated fully as artists."[38]

Working as both model and photographer gave Miller insight into this collaborative process that few other models could intuit. Two *Vogue* fashion spreads illustrate her unique ability to move with ease from one side of the camera to the other, acting either as model, photographer, or both (opposite and above). The resulting photographs problematize the active–passive, male–female, photographer–model dichotomies that underlie most narratives of fashion photography. Here, we find Miller performing both roles, underscoring her centrality in creating contemporary

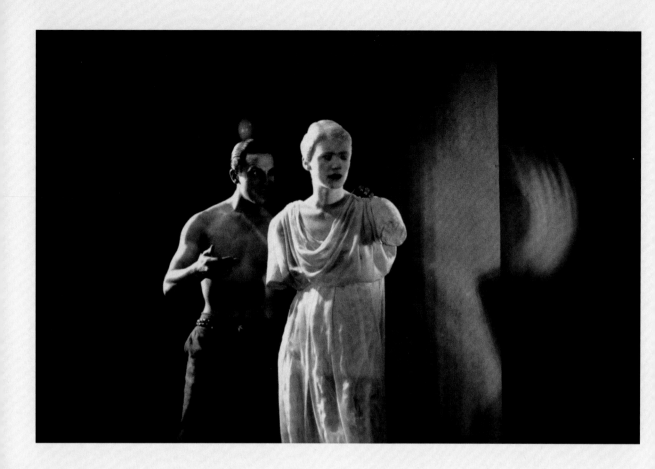

LEE MILLER AND ENRIQUE RIVERO

Still from Jean Cocteau's film *The Blood of a Poet*, Paris, 1930

understandings of the modern woman. Relaxed and sexy, Miller both inhabited and photographed this new representation of womanhood.

Miller and Man Ray continued to make photographs, mischief, and love. In the summer of 1930, they attended the Bal Blanc together, the foremost costume ball of the season. Hosts Count and Countess Pecci-Blunt had instructed all their guests to wear only white, and a white dance floor was constructed in their garden, with the orchestra hidden discreetly behind some bushes. Man Ray recounted in his 1963 auto-biography how he was asked "to think up some added attraction" for the party and so he "hired a movie projector" and projected "an old hand-colored film by the pioneer French filmmaker George Méliès," from a top-floor window onto the revolving white-clad dancers below. He remembered the effect years later as "eerie."[39]

After the film, black-and-white pictures and letters were projected onto the dance floor and guests. Miller thought the evening magical and the projections "absolutely stunning."[40] It was also at times rather risqué, especially when a guest reached up to grab a letter and realized that they were holding a "rude" word. For Man Ray there was an added attraction, or perhaps more accurately, distraction. He had taken Miller with him as an assistant but "she was continually being taken away to dance, leaving me to concentrate alone on my photography." They were both dressed in tennis whites, though hers were "very smart" and "especially designed" by the couturier Madame Vionnet, then at the height of her career.[41] Miller moved gracefully around the party, "a slim figure with blond hair and lovely legs." Her partner was "pleased" by her success "but annoyed at the same time, not because of the added work, but out of jealousy; I was in love with her."[42]

Two months after the Bal Blanc, Miller again raised Man Ray's ire. In a two-page article, the October 1930 issue of French *Vogue* announced Jean Cocteau's first film, *The Blood of a Poet*, and informed readers that "Miss Lee Miller" would be playing the lead female role.[43] Not only did Man Ray consider Cocteau a rival but he had also recently given up filmmaking to spend more time with Miller. In *The Blood of a Poet* Miller was transformed into a classical sculpture (opposite); she was tied up, draped in cloth, and covered in butter and flour that turned rancid under the hot lights. In later scenes her arms are set free and she is allowed to play cards and lead an ox. In the film Miller was, as so often during the late 1920s and early 1930s, simultan-eously active and passive, subject and object. She later recalled how Cocteau "electrified everyone who had anything to do with the film" and described the film as a "poem" made "in a state of grace."[44] The film was well received. Charlie Chaplin claimed it had shown him "that cinema could exist in Europe," not just in Hollywood.[45]

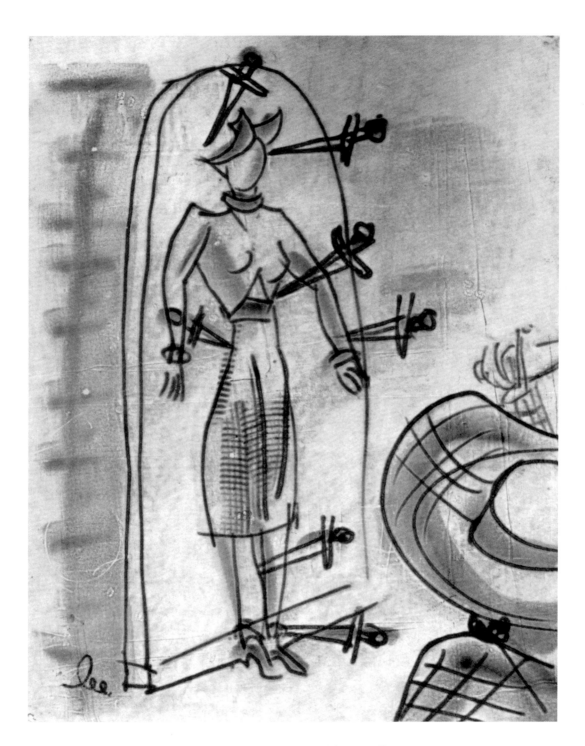

PINNED TO THE WALL BY DAGGERS Sketch by Lee Miller, *c.* 1930

When it was finally screened in New York in May 1933, one reviewer wrote that Miller was "extremely good," giving a performance of "rapt intensity."[46]

One afternoon in Montparnasse, an acquaintance spotted Miller and Man Ray walking together connected by a gold chain: "The woman was taller than the man and strode along in spite of being tethered." From their body language she concluded that "he [was] more attached to her than [she] to him."[47] This was to be the story of their relationship. As Miller took on other work, as well as lovers, Man Ray became increasingly jealous and despondent. He wrote to her: "You are so young and beautiful and free and I hate myself for trying to cramp that in you that I admire most, and find so rare in women."[48]

Miller was living the life of the "modern," sexually-liberated woman, the role that she so often portrayed when modeling. In the spring and summer of 1932, she had taken first a cultivated, wealthy Egyptian businessman, Aziz Eloui Bey, as her lover, before moving on to the New York art dealer Julien Levy.[49] Both men were married. Miller eventually found Man Ray's possessiveness intolerable. Another female artist named Lee, the American Lee Krasner, would later say that the Paris Surrealists treated their women like French poodles.[50] Miller's drawings from this Paris period suggest that she found modeling equally oppressive. One sketch from a series of five shows a fashionably dressed model pinned by daggers to a backboard, while at least one well-dressed woman looks on (opposite).[51]

In October 1932, increasingly exasperated by Man Ray's behavior and enticed by the prospect of her own studio in Manhattan, Miller departed Paris for New York City. She left behind Man Ray, who created angry mementos with bits of her body at their center. He replaced the cut-out photograph of an eye on one of his famous "ready-mades"—in this case, a metronome—with a cut-out photograph of Miller's eye. On the back of a sketch for this object, now known as *Object of Destruction*, he wrote:

> Legend. Cut out the eye from a photograph of one who has been loved but is
> seen no more. Attach the eye to the pendulum of a metronome and regulate
> the weight to suit the tempo desired. Keep going to the limit of endurance.
> With a hammer well-aimed, try to destroy the whole at a single blow.[52]

Man Ray loved Miller, in his own words, "terrifically, jealously."[53] In the two years after they separated, he would obsessively rework his painting *Observatory Time— The Lovers*, in which Miller's red lips float, disembodied in a blue, cloud-filled sky.

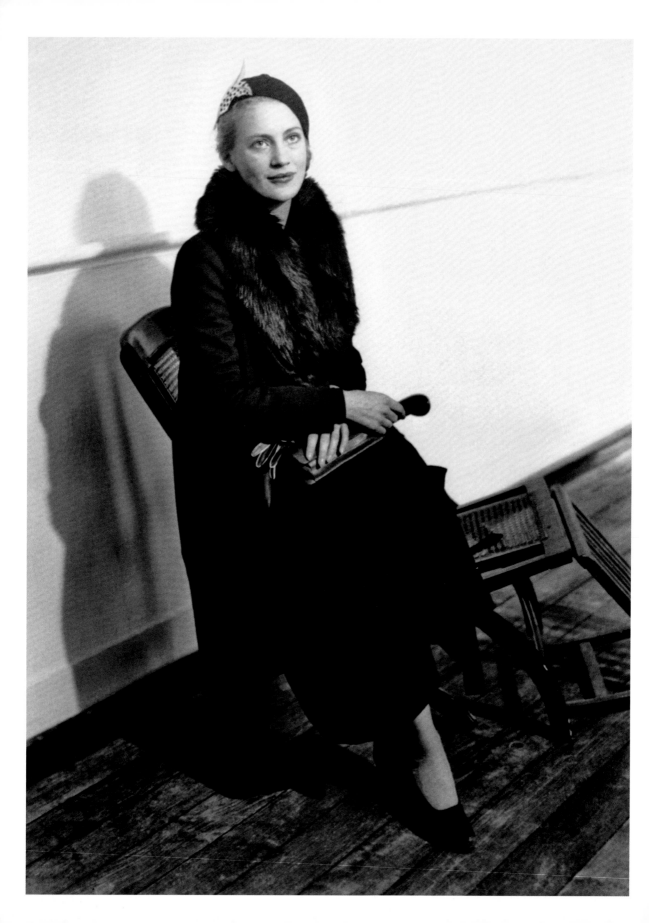

"I'd rather take a picture than be one"

NEW YORK AND EGYPT, 1932-39

I n 1931 the fashion editor Diana Vreeland returned to New York City after two years residing abroad in London. "It was after the Crash," she writes in her memoir, "but it was still a very opulent time in New York." Perfectly evoking the feel of Manhattan during the early 1930s, she describes one evening in the Abbaye "bottle club":

> So, we arrived ... the richest, swellest group—I'm talking about money-in-the-*bank* rich, not stockbrokers—and everyone was beautifully dressed for dinner ... and, of course, there was a certain element of *danger* because we were in a speakeasy doing something that was against the law.... It was chic and amusing.... In there, in this small room, were the best of all worlds and the worst—a delicious balance, if you really like nightlife, as I always have."[2]

This was the New York that Lee Miller—both beautiful blue eyes firmly intact—returned to after her own time abroad. When her ship docked on October 17, 1932, newspaper reporters were there to greet her (page 56). Disembarking in a smart beret and fur-collared coat, she smiled for the journalist from the *New York World Telegram*, who dubbed her the most photogenic of the "cargo of celebrities on board." When he referred to her as "one of the most photographed girls in Manhattan," however, Miller retorted, "I'd rather take a picture than be one."[3] Photography gave her joy and fitted "the tempo and spirit of today."[4] Her brother Erik and her mother awaited her on the pier, as she left behind the throng of reporters. (Her attentive father was traveling on business.[5])

Miller had returned to Manhattan to open her own photographic studio with $10,000 worth of backing from Christian Holmes II, heir to the Fleischmann's Yeast

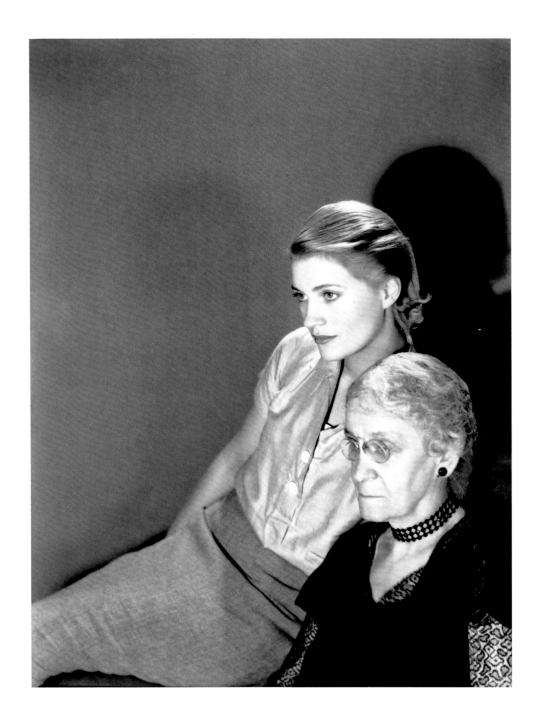

Above **LEE MILLER AND HER AUNT KATE**

Photograph by Erik Miller, New York, 1932

Page 56 **LEE MILLER ONBOARD THE SS *ÎLE DE FRANCE***

New York, October 17, 1932

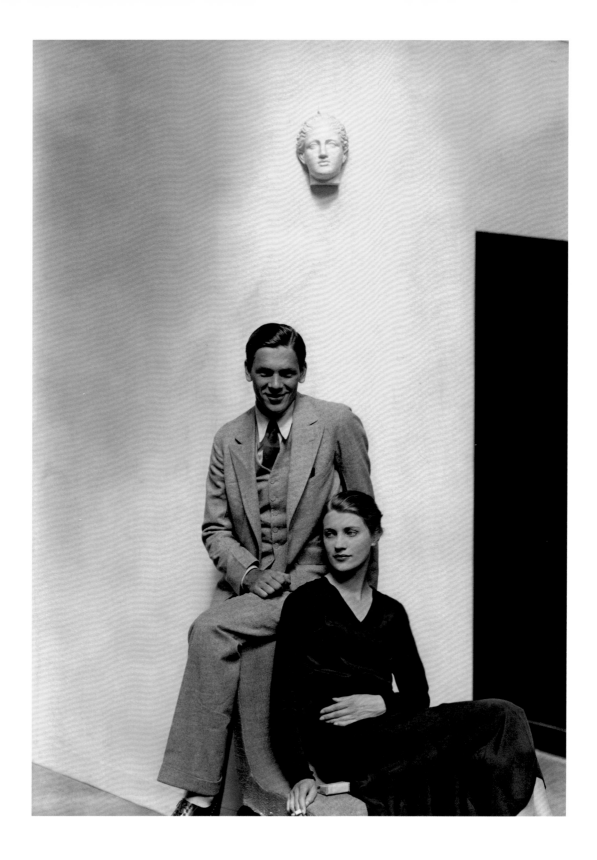

ERIK AND LEE MILLER Photograph by George Hoyningen-Huene, Paris, 1930

fortune and a Wall Street broker, and from Cliff Smith, heir to the Western Union fortune. Holmes's wealth was so great that he commuted to Manhattan across the Long Island Sound by yacht, then was met by a chauffeur who drove him to his office.[6] His grandson Christian R. Holmes IV remarked in 2004, that "of four generations of [my family] … I find them on balance to be creative, artistic, eccentric, funny, driven and restless."[7] One can imagine that Christian Holmes II and Miller were fast friends.

By November Miller had rented two apartments at 8 East Forty-Eighth Street, a six-story building, one block from Radio City Music Hall. The apartments were connected by a small kitchen; one became her home, the other the Lee Miller Studio.[8] Her well-heeled backers and Condé Nast contacts, along with her own self-promotion—she announced her venture as the American branch of "the Man Ray school of photography"—meant that even in the depths of the Great Depression the Lee Miller Studio did tolerably well.[9] Her appearance in the November issue of American *Vogue* must have helped further to publicize her new venture. Modeling a Lanvin dress, she poses above the caption, "smartest worn as Miss Lee Miller wears it in the photograph, without a single ornament."[10] Miller was already a presence on the New York photography scene. Earlier that year her Parisian photographs had been on view in an exhibition of portrait photography at the Julien Levy Gallery, 602 Madison Avenue, alongside works by Berenice Abbott, Arnold Genthe, Alfred Stieglitz, Hoyningen-Huene, Steichen, and Man Ray.[11]

Miller invited her brother Erik to work as her studio assistant (opposite). He was highly qualified as he had been working for the fashion photographer Toni von Horn, whose photographs were regularly appearing in the pages of *Vogue*, *Vanity Fair*, and, by 1932, *Harper's Bazaar*.[12] Miller saw her chance and hired him for $100 a month.[13] Forty-odd years later, Erik told his nephew Antony Penrose that he did most of the printing for the Lee Miller Studio and initially "it was tough":

> Lee was insistent on getting the highest quality. She would come into
> the darkroom to examine the prints and she would grab hold of any that
> were even slightly defective and tear the corners off. I always used to marvel
> at the way she could pick out what was wrong with a print … but when it
> was put right the whole print would be greatly improved.[14]

In addition to his photographic skills, Erik brought to his sister's new enterprise a bundle of engineering skills that their father had shared with him over the years. He supervised the design and construction of a row of cypress tanks, large enough to develop the eight-by-ten-inch plates, and built the darkrooms himself. They installed

lighting, concealing the cables and devising a remote switchboard, and added to the illusion of intimacy with elegant backgrounds and props. Lee decorated "the windows with tubes of chiffon in shades of the spectrum, like a row of Christmas stockings." The French doors continued the effect in the same color scheme but with flat curtains.[15]

The studio was an artfully constructed, exotic yet intimate space. Miller was acutely aware of the psychological challenges of making good portraits. No one was allowed to accompany the sitter as she did not want "an audience complex" or "gallery smile" from her subjects. She explained to Ruth Seinfel, a reporter for the *New York Evening Post*, "It takes a lot of time to do a good portrait, I must talk to the sitter, find out what idea of himself or herself he has in mind."[16] She refused to book more than one sitting a day, and the sitter was treated to a lovely lunch, prepared by her "unflappable" young African American housekeeper, Georgia Belaire.[17]

Miller told another reporter that a good portrait catches the subject "not when he is unaware of it but when he is his most natural self." This meant, Miller felt, that women made ideal portraitists and that photography was "perfectly suited to women as a profession." For "it seems to me," she said, "that women have a bigger chance at success in photography than men.... Women are quicker and more adaptable than men. And I think they have an intuition that helps them understand personalities more quickly than men." She found men more self-conscious sitters than women "because women are used to being looked at."[18] It is worth pausing here to note that the cultural critic John Berger agreed with Miller in his widely-acclaimed book and British television series, *Ways of Seeing*. There Berger argued that "women watch themselves being looked at," or, in other words, women are taught to think of themselves as always on view.[19]

Clients of the Lee Miller Studio included the advertising agencies BBDO and Henry Sell, as well as the fashion and cosmetics companies Elizabeth Arden, Helena Rubinstein, Saks Fifth Avenue, I. Magnin & Co., and Jay Thorpe. Miller also continued to submit work to *Vogue*. Mark Haworth-Booth has written on Miller's innovative advertising photographs from this period, detailing how she was interested in the technical problems of photography and studied three-color photography, the precursor to Kodachrome, with her friend Dr. Walter "Nobby" Clark, Head of Research at Eastman Kodak.[20] Lee and Erik decided to use this color technique for a cosmetics advertisement. Using an eight-by-ten-inch format camera, they made three separate negatives via three separate exposures of the object on black and white film, each with a different color filter, one yellow, one red, and one blue (opposite). They placed the cosmetics on a mirror and surrounded them with heavily scented

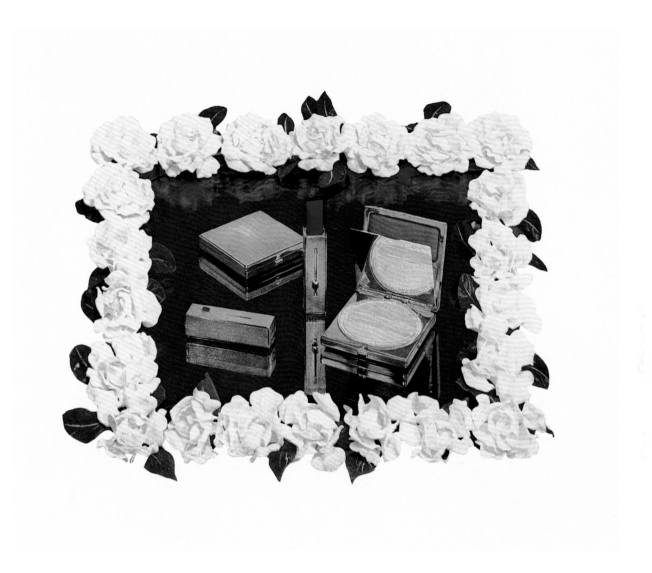

COSMETICS ADVERTISEMENT

Color proof by Lee Miller, New York, 1933–34

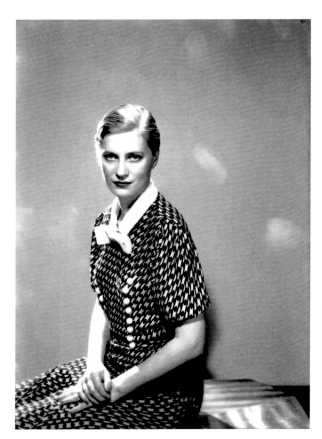 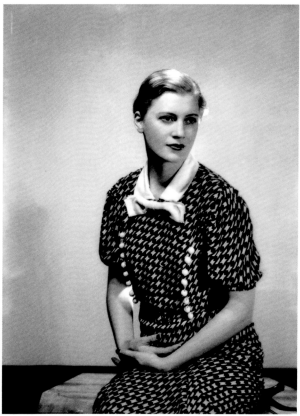

Above and opposite **SELF-PORTRAITS**

Photographs by Lee Miller, New York, 1932

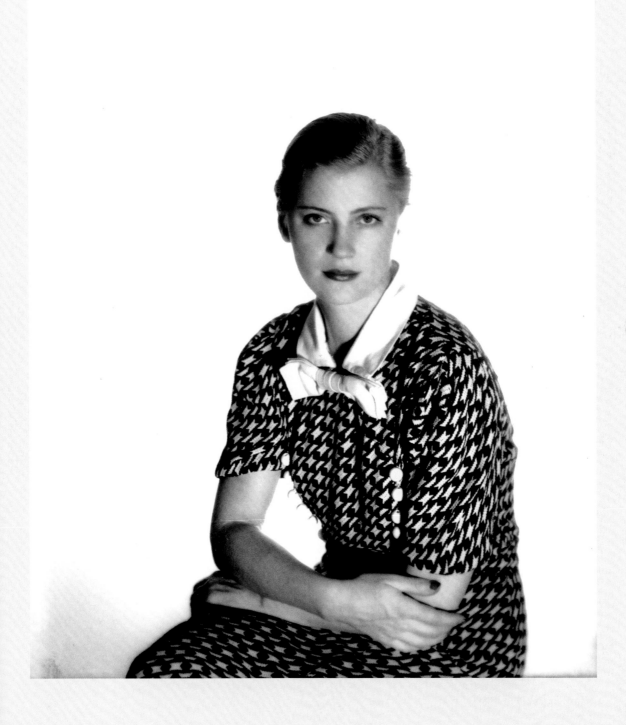

most captivating way. (Decades later her friend Bettina McNulty pointed out that even in the most casual snapshot, Miller knew her best side and arranged herself in the most flattering position possible.) These self-portraits were not merely private exercises in self-reflection; armed with this knowledge, Miller could approach her modeling work with a new sense of empowerment. In March 1933, American *Vogue* published another one of Miller's self-portraits in an article on hats, hairdos, and headbands. As Haworth-Booth has noted, this is an exceptional feature, even by Miller's standards, because not only does she appear in the self-portrait but she is also credited for two of the other photographs as well.[28] An icon of modern beauty, Miller created that role for herself just as much as the men who photographed her; she worked diligently on her craft both behind and in front of the camera.

Returning to New York had meant returning to the lively social life surrounding Nast, Crowninshield, and the rest of the *Vogue* crowd, including Edna Woolman Chase and Henrietta Malkiel. Miller also enjoyed socializing with people from the New York theater world, such as the actresses Lilian Harvey and Gertrude Lawrence, the lyricist Ira Gershwin, brother of George, and the director and producer John Houseman.[29] Houseman regularly turned up at the late-night poker games at Miller's studio, where Georgia served tasty meals all hours of the night and bootleg booze was always on tap. John Rodell, the literary agent, became Miller's most constant companion, making Houseman "bitterly jealous" since he harbored "an unrequited lust" for her.[30]

In May 1933, Jean Cocteau's *The Blood of a Poet* finally screened in America for Julien Levy's New York Film Society. The next fall it would make a two-month run at the Fifth Avenue Playhouse. Miller's photographs graced the foyer and the program proclaimed she had inspired "Monsieur Cocteau." Thanks to Levy and *The Blood of a Poet*, Miller became a regular at Kirk and Constance Askew's "at-homes," a sort of salon that met every Sunday at five o'clock. At their home, drink in hand, Miller met, or became reacquainted with, Aaron Copland, Salvador Dalí, Agnes de Mille, and George Balanchine, among others. The wealthy Askews supported Levy's film society and the Museum of Modern Art, and were just embarking on a new project: the world premiere of composer Virgil Thomson and Gertrude Stein's opera, *Four Saints in Three Acts*. When John Houseman was hired to direct the new opera, he in turn hired Miller as the production's official photographer and Frederick Ashton as choreographer. Thomson and Houseman felt that the voices of African American singers were best suited to the operatic spirituality of the work and with the help of Eva Jessye, a classically trained African American teacher and choir director who had

worked in Hollywood, they hired the top talent of Harlem. With *Four Saints* they were "on fresh ground"; these singers would be singing songs other than the stereotypical "Swanee River" or the offensive "That's Why Darkies are Born."[31]

Miller photographed the entire cast—eighteen principals, twenty choristers, and six dancers—one by one, then as a group. Premiering on February 8, 1934, at the Wadsworth Athenaeum in Hartford, Connecticut, the production made theater history.[32] Less than a fortnight later it transferred to Broadway and became the season's hit. It ran for sixty performances—the longest run of any American opera—and, according to her biographer Carolyn Burke, "guests at cocktail parties debated Stein's libretto, people waved the program at one another in the street, and George Gershwin found inspiration in the opera for *Porgy and Bess*, produced the following year with Jessye as choral director."[33] Miller's photographs of the opera were everywhere.

By May 1934 *Vanity Fair* was listing Miller alongside László Moholy-Nagy, George Hoyningen-Huene, and Cecil Beaton as one of the "most distinguished living photographers."[34] But just as abruptly as it had begun, this phase of Miller's career came to an end. In June 1934, Aziz Eloui Bey, her old beau from Paris, arrived in Manhattan. By July they were married and the Lee Miller Studio had closed. The couple set sail for Cairo on September 1, 1934, leaving behind Erik Miller and other friends and lovers, all shocked by the swift turn of events. We can never know what exactly made Miller choose this path. Burke suggests that studio work was making Miller dissatisfied and restless, that only her social life, the parties at Condé Nast's penthouse and with her new theater friends, had sustained her for much of this period.[35] Perhaps living as an unmarried female artist in New York had also taken its toll. Arthur Penn, the filmmaker and younger brother of fashion photographer Irving Penn, said of the Depression-era art scene: "There was a double standard. The girls were artists but ornamental—intelligent, talented, yet girls first."[36]

Miller's new husband was by all accounts a kind and gentle man, twenty years her senior, good-looking, and fluent in English. He was a wealthy businessman from a notable family and had studied engineering in Liverpool before commencing work for the Egyptian railway. He was part of the Franco-Egyptian elite who considered Cairo home but believed "Paris was the navel of the world," in the words of one contemporary.[37] Throughout the 1920s he and his first wife, Nimet—a highly-strung, demanding beauty, who sometimes posed for Hoyningen-Huene and, indeed, Miller in 1931—had lived half the year in Paris and the other half in Cairo. Eloui Bey was determined to "bring peace" to Miller and wrote to her parents, in the first of many letters, that if she did not enjoy life in Cairo, he would seek a transfer to London.[38]

In Cairo, the "black satin and pearls set," as Miller called them, shopped, gossiped, played tennis, and attended the opera. As a non-Muslim European, Miller was allowed to join the men's parties, unlike the local women, "the harem wives" who "spend their time behind the grillwork on balconies playing brilliant bridge and poker and watching men's parties in the room below." These women had not met a man who was not a relative since they were twelve years old, at least by Miller's account.[39] Even though Eloui Bey hired fifteen servants, including a personal maid and an Italian-trained cook, Miller quickly tired of this life.[40] She may also have had a miscarriage in her first year of marriage, which "colored their life together from then on."[41]

The couple spent the summer of 1935 back in Europe, first in St Moritz for July and August, then Basel, Berlin, and London, where Aziz bought a British car. In the early spring of 1937, back in Egypt, Miller began making expeditions into the desert to explore and take photographs. Many consider her photographs from this period some of her finest. *Portrait of Space*, taken near Siwa in 1937, for instance, is often called her best Surrealist photograph (opposite) and it is said that it so impressed René Magritte when he saw it displayed in London in 1938 that it inspired him to paint his famous *Le Baiser*.[42] But even the Sahara could not keep Miller satisfied; by May 1937 she felt compelled to convince Eloui Bey that it would be best for her to spend the summer in France alone, taking only her maid, Elda, with her.

Arriving in Paris, Miller checked into the Hôtel Prince de Galles, then headed out to a fancy dress ball that very same evening.[43] And so it was that she met the man who would become her second husband, Roland Penrose. Penrose was a British Surrealist and a major collector of modern art who would go on to co-found London's still-important Institute of Contemporary Arts. Oddly, he had fallen for Miller a year earlier, before ever meeting her. In the summer of 1936, he had become mesmerized by her beautiful red lips, hovering in the cloud-filled sky of Man Ray's painting *Observatory Time—The Lovers*. The painting had hung above a doorway at the first International Surrealist Exhibition in London.[44] Penrose was one of the exhibition's organizers, along with Herbert Read. Contributors included Paul Nash, Henry Moore, and Humphrey Jennings from Britain, and Man Ray, André Breton, and Paul Éluard on the French side. Then, at this Surrealist costume ball in Paris, Penrose met those lips in the flesh. Max Ernst was there with his hair dyed blue, dressed as a beggar, when Roland in his own get-up introduced himself to Lee. She was the only guest not in costume, on account of the short notice, and sported a long dark-blue evening dress, which emphasized the blue of her eyes and the blond of her hair. Penrose was wearing trousers covered in paint, his right hand and left foot dyed

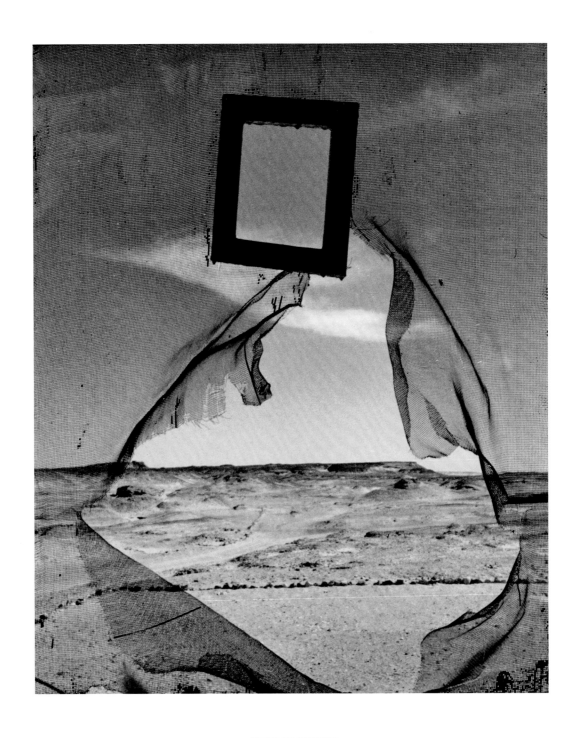

PORTRAIT OF SPACE

Photograph by Lee Miller, near Siwa, Egypt, 1937

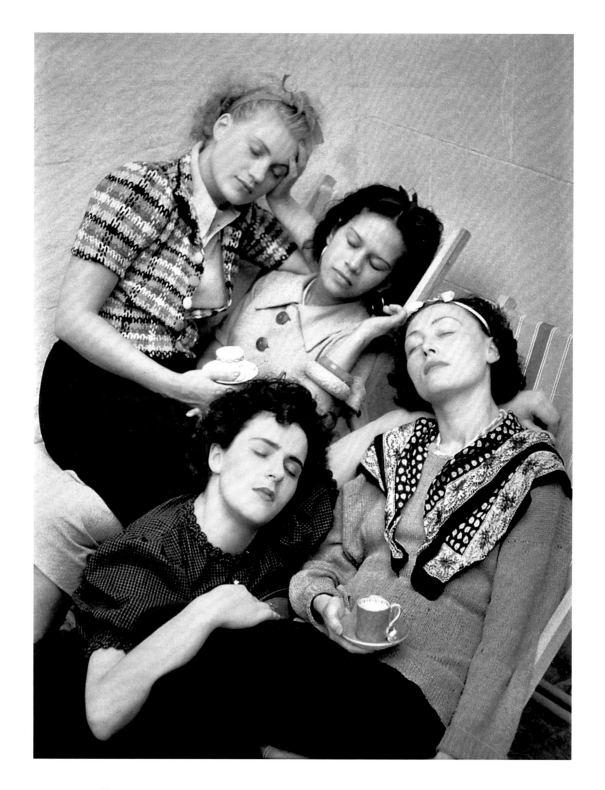

Above **LEE MILLER, ADY FIDELIN, LEONORA CARRINGTON, AND NUSCH ÉLUARD (LEFT TO RIGHT)**

Photograph by Roland Penrose, Cornwall, England, summer 1937

Opposite **LEE MILLER'S COPY OF *THE ROAD IS WIDER THAN LONG***

Handwritten message by Roland Penrose, spring 1939

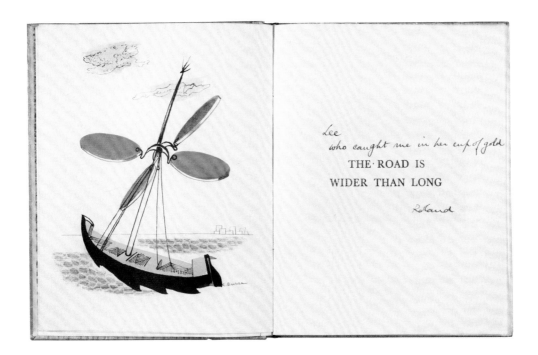

Lee
who caught me in her cup of gold

THE·ROAD IS

WIDER THAN LONG

Roland

bright blue. Decades later Penrose wrote in his memoir that Miller "seemed to enjoy the abysmal contrast between her elegance and my own slumlike horror. And so it was for the second time that the *coup de foudre* struck."[45] The next evening Ernst and Penrose threw a dinner party at Ernst's studio and invited Miller, who was the star of the evening—gorgeous and entertaining with her "outrageous Surrealist wit, strange tales of Egypt and reminiscences of Paris in the 1920s."[46] Returning in the wee hours to his small room at the Hôtel de la Paix, she and Penrose became lovers and were inseparable for the rest of the summer.[47] Together with friends, the pair traveled to Cornwall in south-west England, then on to the south of France (opposite, pages 74–75 and 76). At the end of the summer, however, Miller returned to her loyal, loving husband in Cairo. She continued to find Egyptian society stultifying.

Over the next two years, Penrose and Miller carried on a passionate correspondence and reunited whenever the opportunity arose, such as in the spring of 1939 when he arrived in Asyut, Egypt, where she was staying with friends. There he presented her with a pair of engraved gold Cartier handcuffs and a copy of *The Road is Wider Than Long*, which he described as "an image diary from the Balkans."[48] It charted their journey together through Greece, Bulgaria, and Romania in July and August of the previous year, in his words and photographs (above).[49] He wrote about the adventure four decades later: "Sometimes, almost never, by chance an invitation arrives to explore distant countries with a girl with whom one is in love and, should this occur, one would be an obstinate fool to refuse."[50]

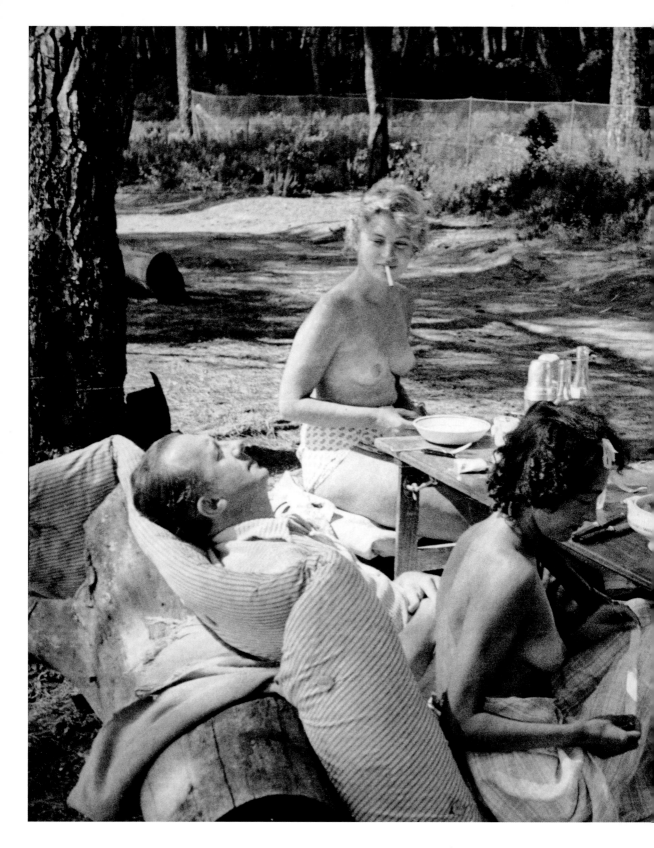

PAUL AND NUSCH ÉLUARD, LEE MILLER, MAN RAY, AND ADY FIDELIN Photograph by Roland Penrose, Île Sainte-Marguerite, France, 1937

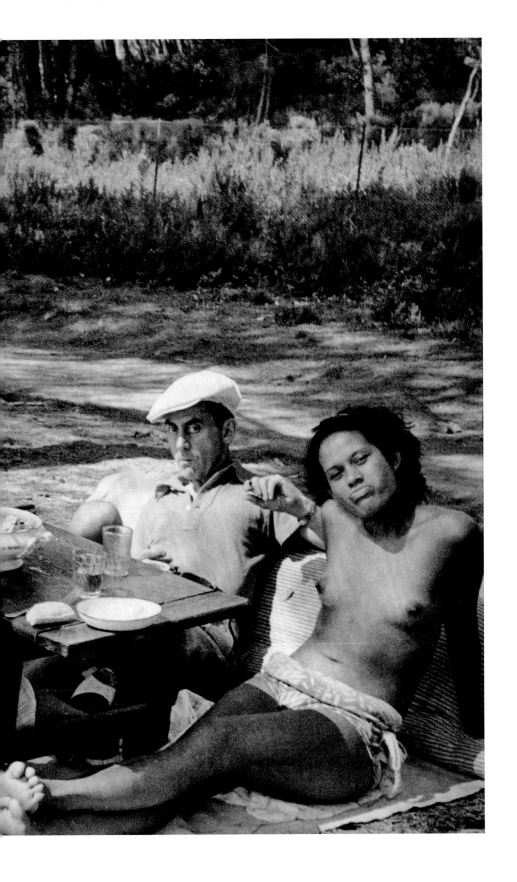

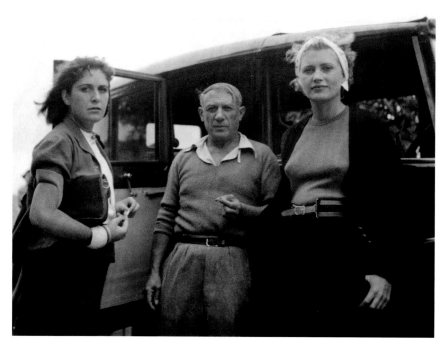

DORA MAAR, PICASSO, AND LEE MILLER

Photograph by Roland Penrose, Mougins, France, summer 1937

In June 1939, Miller boarded a ship from Port Said, Egypt, to England and wrote to Penrose in London that, although she was a "sick muddle of indecision," she knew that she was "never returning to Egypt" and "glad that finally I'm coming back to you."[51] In the high summer of that year, they traveled together to the south of France, first visiting Max Ernst and Leonora Carrington in Saint-Martin d'Ardèche and then Picasso and Dora Maar at Antibes. Hitler invaded Poland on September 1, 1939. Their vacation was cut abruptly short when Britain and France declared war on Germany two days later. Miller and Penrose drove swiftly in his Ford V8 through villages filled with the sound of ringing church bells and people taking their horses to army requisition camps. At Saint-Malo they left the car with the Automotive Association and boarded a passenger ferry to Southampton.[52] They arrived back at Penrose's house in fashionable Hampstead, north London, on September 3, "just in time to hear the first air-raid sirens and watch the silver-gray barrage balloons rise in the sky."[53]

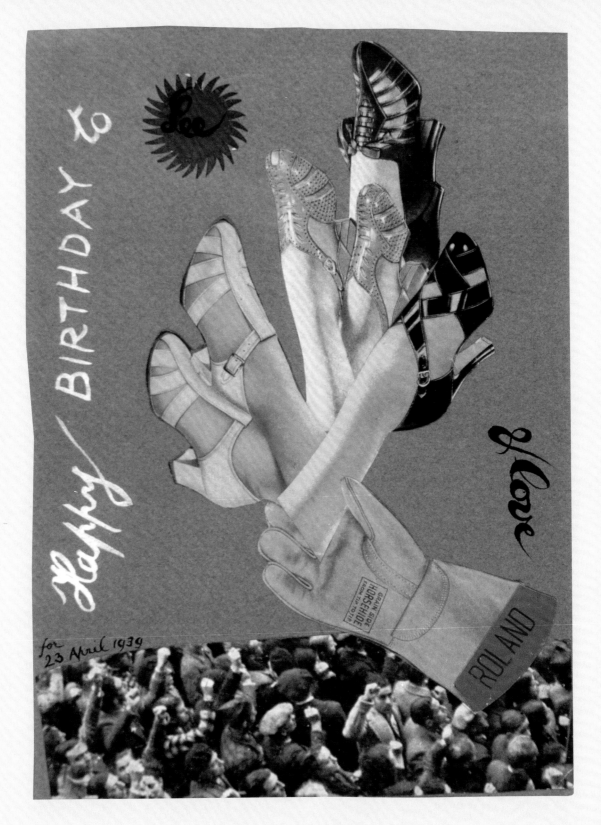

"BOUQUET OF SHOES" BIRTHDAY CARD

Made by Roland Penrose for Lee Miller, April 23, 1939

"Here and now resolve to shop courageously to look your best"

FASHION PHOTOGRAPHY IN LONDON, 1939–44

Above **"THEY HAVE BEEN HERE BEFORE," BRITISH *VOGUE***

Photograph by Lee Miller, London, October 1941

Opposite **POSING WITH A HEADACHE, BRITISH *VOGUE***

Photograph by Lee Miller, London, October 1941

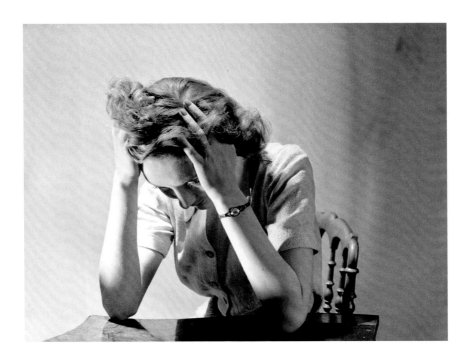

and Economics.[8] When staff began leaving to join the forces, Miller offered her services in January 1940.[9] Mark Haworth-Booth has suggested that the cable Condé Nast sent through that month must have made Miller feel she was "on probation."[10] Nast cabled from New York:

```
DELIGHTED YOUR WANTING TO JOIN US STOP YOUR
INTELLIGENCE FUNDAMENTAL GOOD TASTE SENSITIVENESS ART
VALUE MUST ULTIMATELY MAKE YOU GOOD PHOTOGRAPHER STOP
SENDING CRITICISMS YOUR TRIAL PHOTOGRAPHS.[11]
```

If this was probation, Miller rose to the challenge. Throughout the war she was British *Vogue*'s most consistent and prolific fashion photographer. She regularly photographed the "Bargain of the Month" and "Smart Fashions for Limited Incomes" features, the "*Vogue* Pattern Book" section, printed on uncoated paper in each issue, and, increasingly, the "lead" fashion spread. By 1944 she was even in charge of the prestigious full-page color feature. Photographing in *Vogue* Studios, as well as in museums, art galleries, and outdoors, Miller did the best she could with the practical wartime dresses, hats, shoes, and suits that she was asked to photograph. The talented Miller somehow even made photographs for a feature on headaches visually compelling (above). Often in the studio she used sculptures, vases, and other antique props—a tendency she had picked up from Hoyningen-Huene—with pleasing results, including for an extraordinary self-portrait from 1940 (page 85).

Opposite **UNPUBLISHED FASHION SELF-PORTRAIT FOR BRITISH *VOGUE***

Photograph by Lee Miller, London, 1940

Below **UNPUBLISHED PHOTOGRAPH FOR BRITISH *VOGUE***

Photograph by Lee Miller, London, July 1941

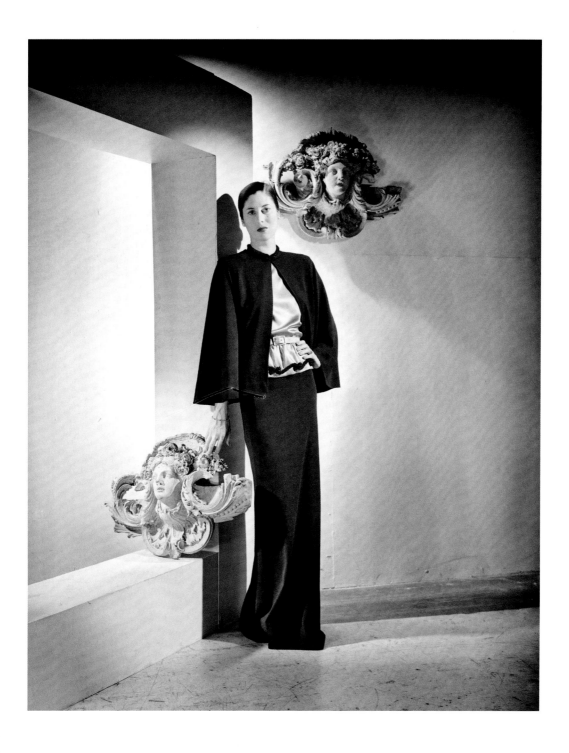

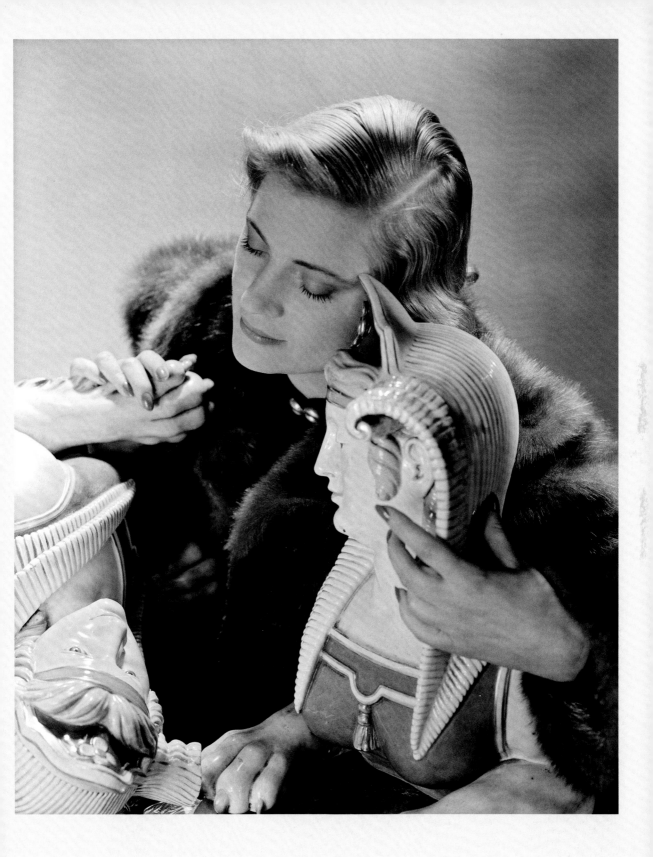

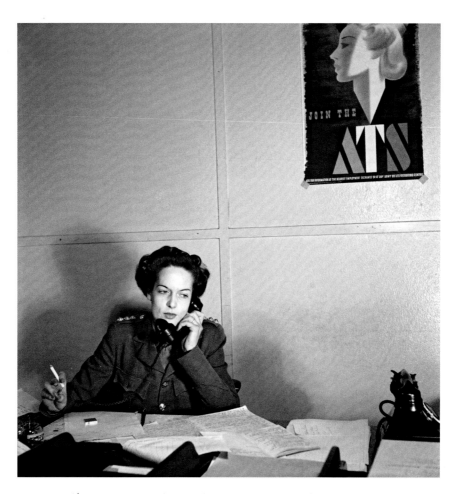

Above **ATS CAPTAIN** Photograph by Lee Miller, England, September 1944

Opposite **ATS SERVICEWOMAN** Photograph by Lee Miller, London, 1941

With so many British women involved in official war work, Miller also frequently photographed women in uniform and other workwear for British *Vogue* (above). For the November 1941 issue, she traveled out to Greenwich in southeast London to photograph members of the Women's Royal Naval Service (WRNS). Features editor Lesley Blanch's accompanying text informs readers that these women always manage to look "pretty and feminine" in uniform. Miller's photographs show them tracking planes and on the bridge of their ship, underscoring their essential war work and competence, and not just their gender-appropriate looks.[12] For another feature that fall—this one on the hairstyles most suitable for enlisted women—Miller photographed one Miss L. M. Stanley in her Auxiliary Territorial Service (ATS) uniform (opposite).

The ATS was the women's branch of the British Army and had sixty-five thousand women between the ages of seventeen and forty-three on its rolls by September 1941.[13] Their jobs ranged from cooks, clerks, and telephonists to orderlies, drivers,

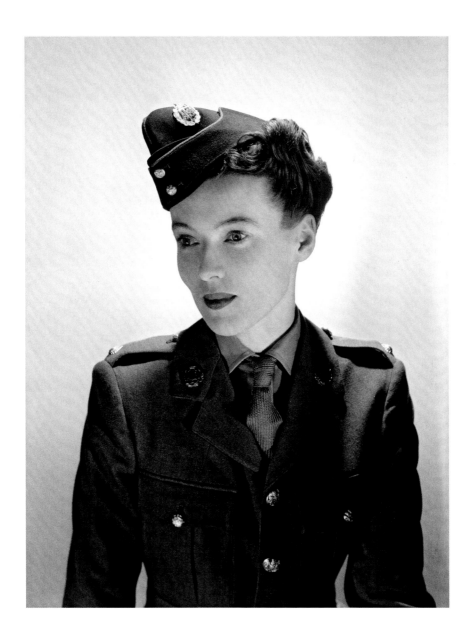

postal workers, and ammunition inspectors. They were the volunteers. In December 1941, when the war with Japan began, Parliament passed the National Service Act, and all unmarried women between the ages of twenty and thirty and in non-essential employment were called up to join one of the auxiliary forces: either the ATS, the WRNS, the Women's Auxiliary Air Force (WAAF), the Women's Transport Service (WTS), the Women's Voluntary Service (WVS), which provided emergency services on the home front, or the Women's Land Army (WLA), which was largely responsible for the running of British farms during the war. Married women were later enlisted too, although those pregnant or with small children at home were exempted.[14]

Bombs began to rain down on London day after day, night after night. On the first day of the Blitz, September 7, 1940, 348 German bombers, escorted by 617 fighter jets, filled the skies over London and the surrounding area, covering an area of some eight hundred square miles. That day alone, 448 people were killed. The city was bombed every single day or night from then until November 2. At its peak, on any one night up to 177,000 people sheltered against the bombs in the London Underground stations. Miller wrote to her parents back in Poughkeepsie of "three solid months of hell at night," and how initially she had felt "like a soft-shelled crab" but, like most Londoners, soon developed what the broadcaster Edward R. Murrow told his listeners was "a quiet acceptance of the situation."[15] The last night of the Blitz was also its deadliest. On May 10, 1941, three thousand Londoners were killed by German bombs. In all, over twenty thousand people were killed in the Blitz and 1.4 million rendered homeless.[16]

Alexander Liberman, art director of American *Vogue*, later praised Miller for the dose of reality she brought to transatlantic relations within the *Vogue* empire, which was otherwise often lacking.[17] Condé Nast had announced from New York that with war raging "we must not allow people to think of *Vogue* as a really frivolous periodical, unaware of the serious challenges that have been going on in the life, interests, and psychology of women."[18] But Miller sensed that some in the New York office were woefully out of touch. She later wrote to Erik and his wife, Mafy:

> I'll never forget wonderful Edna Chase, the doyeness—the goddess—the former of taste, discretion and elegance—sending a memo to us in the bombing, that she noticed we weren't wearing hats and she didn't approve that we dyed our legs and made lines up the backs to simulate stockings— (Britain had no nylons until the US Air Force brought them in as rich presents)—and I happened to be in charge of the office that day though it was none of my affair to answer the boss, I sent a cable in my own name: we have no ration coupons and no nylon stockings anyway. The next week every member of the staff was sent three pairs.[19]

Although the realities of wartime Britain eluded Woolman Chase at times, safe as she was in her Manhattan office, they were squarely addressed in the pages of British *Vogue*. The Blitz and its nightly blackouts were covered in straightforward prose, almost jaunty in its pragmatism. In "Living the Sheltered Life," published in October 1940, Lesley Blanch describes the thriving "subterranean" restaurants of

LEE MILLER

OUTSIDE—on several nights, bombs have spattered within twenty yards. This street below our window now holds a new crater, and another length of the arcade has crashed. We were turned out temporarily for a time bomb

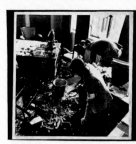

INSIDE—our offices have been strewn with broken glass. (See the freakishness of blast, that leaves a tumbler of water uncracked, unspilled.) Though five storeys up, our floors have been deep in soil and debris flung through the roof

BENEATH—we work on when our roof-watcher sends us down. Our editorial staff plan, lay-out, write. Our studio photograph in their wine-cellar-basement. Our fashion staff continue to comb the shops. Congestedly, unceremoniously but cheerfully, Vogue, like its fellow Londoners, is put to bed in a shelter

19

"HERE IS VOGUE IN SPITE OF IT ALL!" BRITISH *VOGUE* Photographs by Lee Miller, London, November 1940

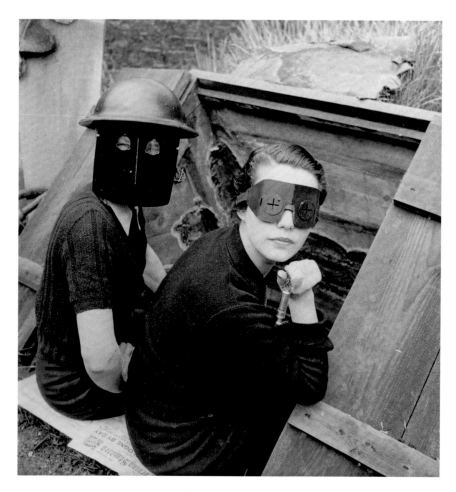

FIRE MASK AND EYE SHIELD Photograph by Lee Miller, Hampstead, May 1941

London, such as Hatchett's where Arthur Young's swing band played, and enumerates the assorted amenities available in the bomb shelters of London's department stores—everything from books and magazines to hairdressing and manicures.[20] The next month, accompanying a more frightening though still upbeat piece (page 89), six of Miller's photographs appeared under the caption, "Here is *Vogue* in spite of it all!" The text reads:

OUTSIDE—on several nights, bombs have spattered within twenty yards. This street below our window now holds a new crater, and another length of the arcade has crashed. We were turned out temporarily for a time bomb INSIDE—our offices have been strewn with broken glass.... Though five storeys up, our floors have been deep in soil and debris flung through the roof BENEATH—we work on when our roof-watcher sends us down. Our

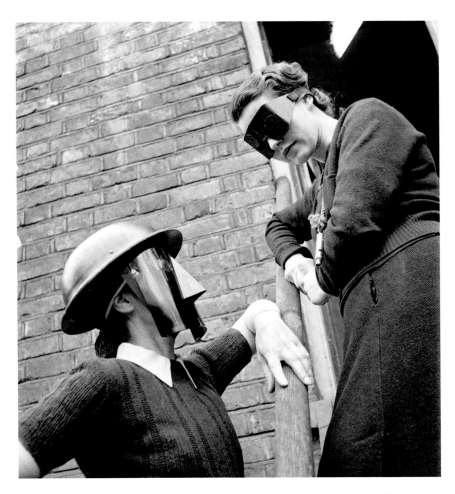

FIRE MASK AND EYE SHIELD Photograph by Lee Miller, Hampstead, May 1941

editorial staff plan, lay-out, write. Our studio photograph in their
wine-cellar-basement. Our fashion staff continue to comb the shops.
Congestedly, unceremoniously but cheerfully, Vogue, like its fellow
Londoners, is put to bed in a shelter.[21]

The seemingly incongruous inclusion of these wartime realities alongside articles
about the latest fashions underscores the complicated nature of the upmarket fashion
magazine. Though generally maligned as merely escapist, these magazines actually
adapt to the world around them, especially in the hands of an astute editor. In spite
of the Blitz, paper rationing, and staff shortages, British *Vogue*'s wartime circulation
would climb to eighty thousand under Withers's editorship. "Despite having little
feeling for fashion," she would transform British *Vogue* over her twenty-year career
at the magazine.[22]

In 1950 Richard Titmuss, historian, civil servant, and Professor at the London School of Economics, wrote of the Blitz: "Between the first and last incident, between 1939 and 1944, the alert was sounded on 1,224 occasions.... It may be said that Londoners were threatened once every thirty-six hours for over five years, threatened ... going about the ordinary business of their lives."[23] *Vogue*'s staff behaved no differently. Miller explained to her parents in a letter how "it became a matter of pride that work went on. The studio never missed a day, bombed once and fired twice—working with the neighbouring buildings still smoldering—the horrid smell of wet charred wood—the stink of cordite—the fire hoses still up the staircases and we had to wade barefoot to get in." Miller and others worked at home in the evenings if they were lucky enough to have what she called "the sacred combination of gas, electricity and water."[24]

In 1941 Miller took a series of photographs of her own air-raid shelter, which Penrose had dug into the front yard of 21 Downshire Hill. One of these shots, although never published in *Vogue*, has frequently been republished (page 90). It features two young women at the entrance to the shelter each modeling a mask or an eye-shield worn as protection against incendiary bombs. In *The Art of Lee Miller*, Mark Haworth-Booth suggests that the insouciant way that one model holds an air-raid warden's whistle is indicative of "the puny defenses in a time of a total war." For him, "no other photograph of the Phoney War and the Blitz seems to have produced an image quite like this portrait of the double deformity of war."[25] Other never-before-seen photographs—one of a model wearing an air-raid warden's lantern clipped to her skirt, and another of two models chatting in equally strange but slightly different face shields (page 91)—are unsettling reminders of how total war was both mundane and completely exceptional. Miller took the opportunity during the shoot to photograph the interior of her air-raid shelter, which was guarded over by a Barbara Hepworth sculpture.[26] Decorated with pink and blue coverlets on the beds, it looks as comfortable as a bomb shelter possibly could.[27]

In other subtler ways Miller brought the war quietly into the pages of British *Vogue*, staging fashion shoots in the middle of salvage drives and other home-front efforts (page 78 and opposite). As early as 1939 she posed models gazing at Europe on a globe and in an office next to a hat stand covered in military officers' hats (pages 81 and 95). In October 1941 she photographed a model in a country field with barrage balloons floating in the sky behind her (page 94). The following year, she took a model to the Holborn Viaduct and positioned her among its historic sculptures.[28] With her keen eye, Miller spotted the symbolic potential of a hat with a large feather and shot the model wearing it in front of one of four winged lions that adorn the viaduct.[29]

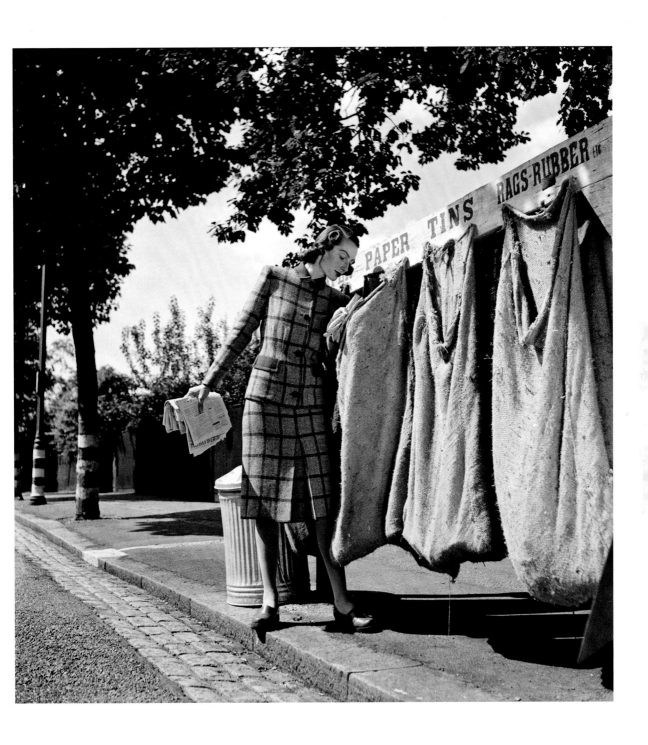

"ALL CHANGED," BRITISH *VOGUE* Photograph by Lee Miller, London, July 1942

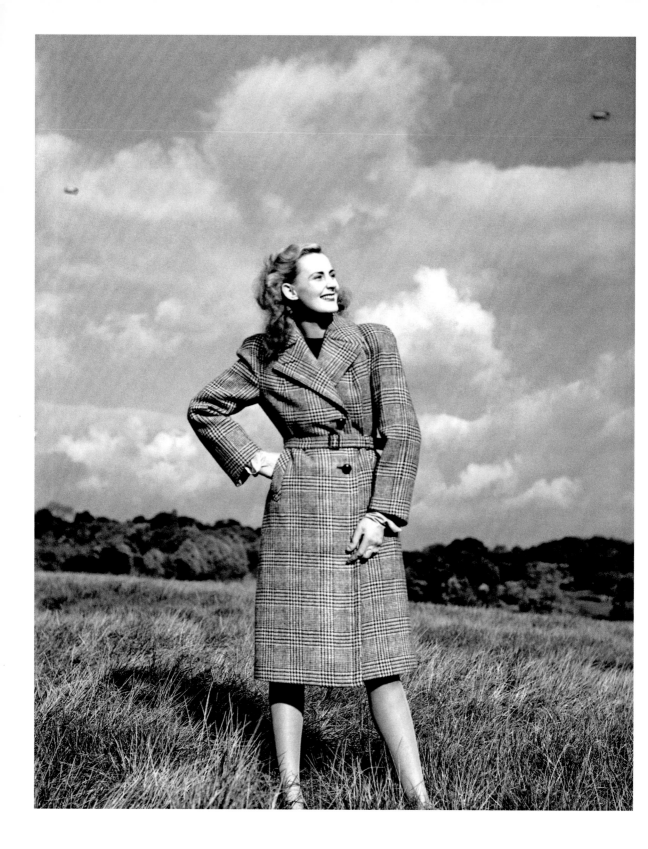

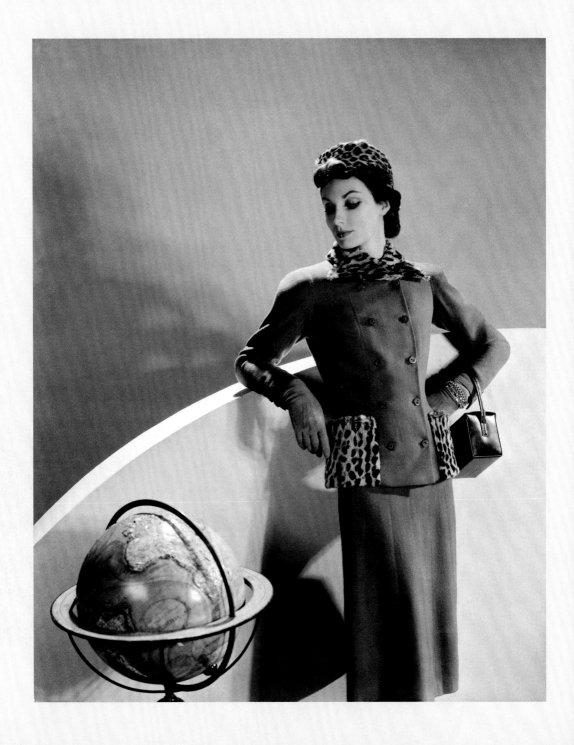

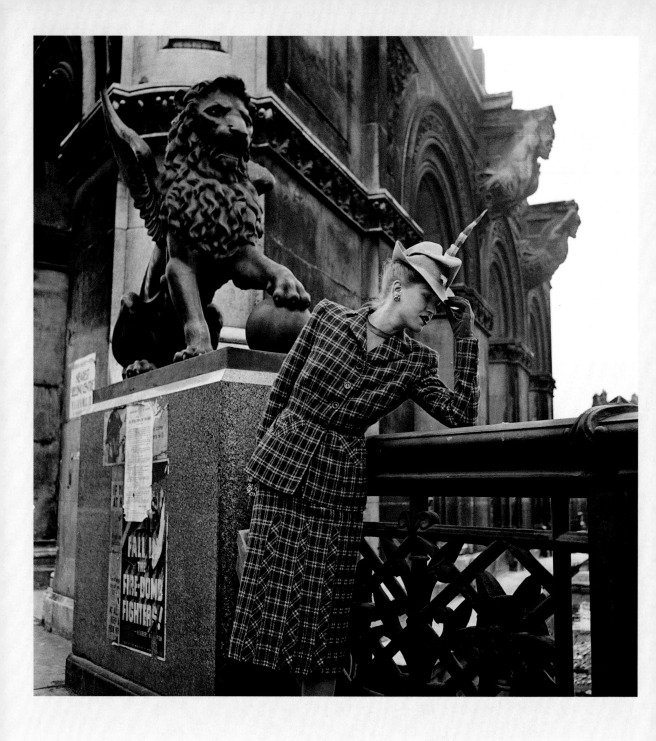

Above and opposite **"AMERICAN DRESS,"** BRITISH *VOGUE*

Photographs by Lee Miller, London, July 1942

Thanks to the feather on the model's hat, the pair comes to represent the lion and the unicorn—symbols of England and Scotland respectively—guarding the City of London from German bombs (opposite). Most Britons would have been familiar with the symbolism, having learned this popular nursery rhyme as schoolchildren:

> The lion and the unicorn
> Were fighting for the crown,
> The lion beat the unicorn
> All around the town.
> Some gave them white bread,
> And some gave them brown;
> Some gave them plum cake
> and drummed them out of town.[30]

For another photograph, Miller posed the model next to a sculpture representing the fine arts with a visibly bomb-damaged building in the background (below). Both

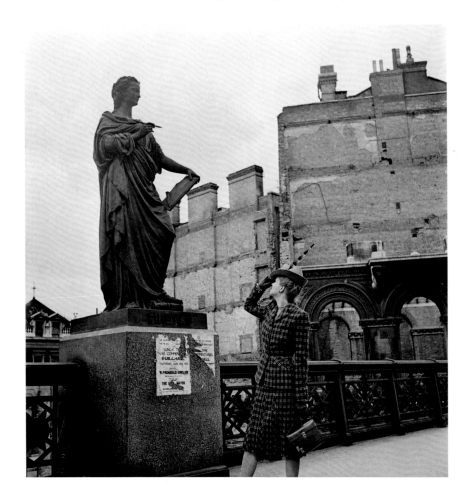

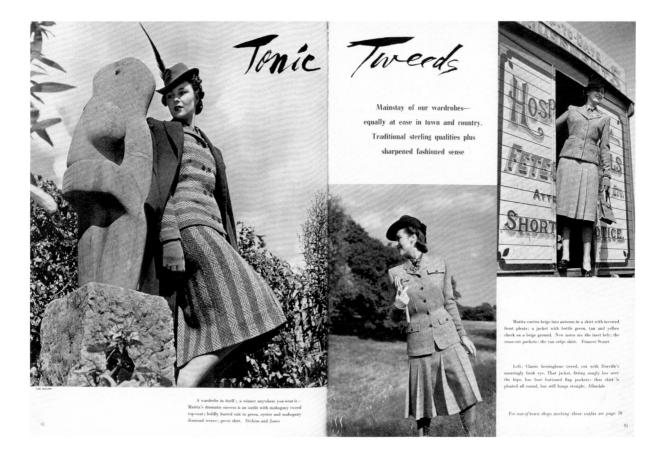

Tonic Tweeds

Mainstay of our wardrobes—
equally at ease in town and country.
Traditional sterling qualities plus
sharpened fashioned sense

A wardrobe in itself ; a winner anywhere you wear it—
Matita's dramatic success is an outfit with mahogany tweed
top-coat ; boldly barred suit in green, oyster and mahogany
diamond weave ; green shirt. Dickins and Jones

Matita carries beige into autumn in a skirt with inverted
front pleats ; a jacket with bottle green, tan and yellow
check on a beige ground. New notes are the inset belt ; the
cross-cut pockets ; the tan crêpe shirt. Frances Stuart

Left : Classic herringbone tweed, cut with Dorville's
unerringly fresh eye. That jacket, fitting snugly low over
the hips, has four buttoned flap pockets ; that skirt is
pleated all round, but still hangs straight. Allardale

For out-of-town shops stocking these outfits see page 70

images appeared as part of a feature entitled "American Dress," which appeared in the July 1942 issue of British *Vogue*.

Miller sometimes snuck into her photographs subtle references to her artistic interests and continuing involvement in modern art circles. In a September 1940 feature entitled "Tonic Tweeds," for instance, she enlivened what could have been a rather dull photograph by placing her model next to Henry Moore's 1937 sculpture *Mother and Child* (above).[31] Its inclusion was an inside joke that only Miller, her partner, and friends were likely to understand. Penrose had recently purchased this stone "bird-like statue" from Moore and placed it in "the small front garden" of their home in Hampstead.[32] In his memoir, *Scrapbook*, he recalls how "the tall monolith with its female rotundity … stood up admirable in front of the geometric flatness of the brick Georgian façade of my house, and was so great a pleasure to me that I could laugh at the shock it might cause to any of my neighbours." And shock it did. Newspaper

clippings from the time carry headlines such as "Grievance Over Modernist Statue in Front Garden," "This Annoys the Neighbours!," and "Nude, the Others Hissed." One news article quoted a neighbor as saying, "The L.C.C. [London County Council] wouldn't allow flats to be put up here, and now they've let this in."[33] In featuring this controversial statue in *Vogue*, Miller was thumbing her nose at these ignorant responses to works of modern art.

Miller was well known to her friends for taking pleasure in such practical jokes and for poking fun at people's prejudices, particularly toward modern art or her home country, America. On one memorable occasion, back in Cairo in 1937, Miller had thrown an elegant party soon after returning from the south of France where Picasso had painted her portrait. Word had spread among the "smart set" that a famous artist had recently painted her likeness. Aware of what many of her guests would say upon viewing Picasso's rendering of her, with its "two smiling eyes and a green mouth ... on the same side of the face," Miller hung the painting in her entrance hall, then strategically positioned her sister-in-law, Mafy, to eavesdrop. As she had anticipated, once the drinks were flowing, many guests began announcing that they could have done better than this artist with their eyes shut. "'OK!' she challenged, 'Let's see how you make out,'" and "flung open the doors to another room where paints, paper and brushes were all laid out. The party was a memorable success with all the guests ruining their evening clothes by daubing away with abandon."[34]

In the spring of 1942, modern art slipped into British *Vogue* again when Miller photographed her models inside the Redfern Gallery at 20 Cork Street, Mayfair (page 100). A five-minute walk from *Vogue*'s headquarters in Golden Square, Soho, Cork Street was the center of modern art in London, home to not only the Redfern Gallery but also the London Gallery (backed by Penrose), the Mayor Gallery, and the Guggenheim Jeune. (Within days of arriving in London in 1939, Penrose had taken Miller to the Mayor Gallery to see two of his paintings of her on display—*Bien Vise* and *Octavia*.[35]) In 1942 the latest works of the Surrealist Eileen Agar were being exhibited at the Redfern, along with those of Michael Rothenstein. Agar had joined the English Surrealist movement in 1933. Three years later Penrose and Herbert Read had selected three of her paintings and five of her objects for display in their International Surrealist Exhibition. The following year Agar had joined the rolling summer party that started in Cornwall, then moved on to Mougins in the south of France, and she

Opposite **"TONIC TWEEDS," BRITISH *VOGUE***

Photographs by Lee Miller, Hampstead, September 1940

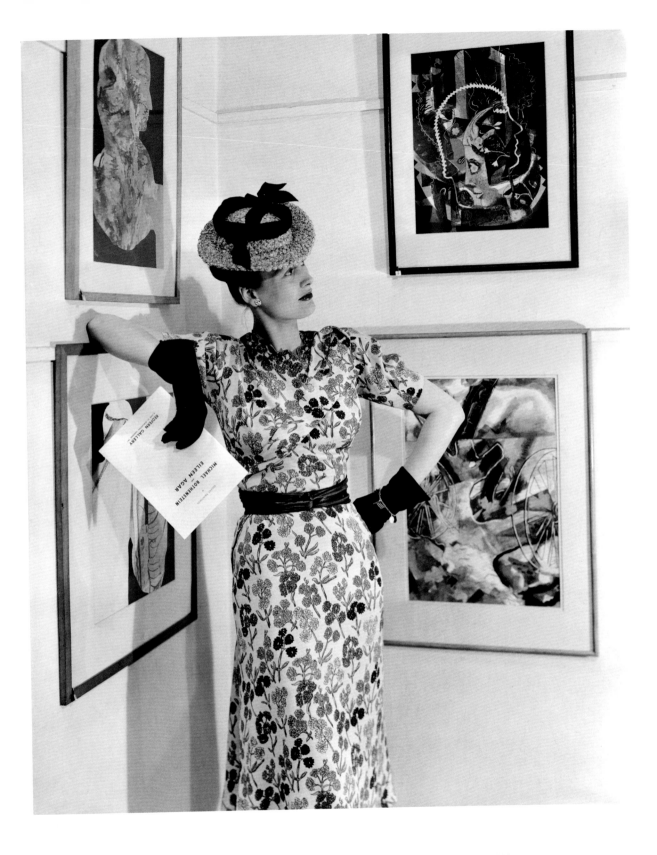

POSING AT THE REDFERN GALLERY Photograph by Lee Miller, London, May 1942

and Miller had become friends. Miller had photographed a stunning silhouette of Agar, "pregnant," as Picasso said, with her camera (page 211). Miller now promoted her friend by posing models throughout the Redfern Gallery with some of Agar's and Rothenstein's paintings in the background.

Life in 1940s Britain was entirely different from that idyllic, lazy, libertine summer. During World War II, the home front was involved as never before and the men who saw combat made up only a tiny minority of the population.[36] Tracing the war through Miller's photographs provides a fresh sense of the contortions and contrivances that everyday life could involve, from the most banal to the most extraordinary, when virtually every action could be interpreted as contributing to the war effort. Merely a fortnight after Britain declared war on Germany, British *Vogue* announced in its first wartime issue:

> In accordance with the Government wish that businesses would carry on
> so far as possible, *Vogue* will continue to be published during the war, but
> as a monthly [not bi-monthly] magazine. It will incorporate *Vogue Pattern*
> *Book*, *Vogue Beauty Book* and *Vogue House and Garden Book*.... *Vogue*
> promises you a practical and useful magazine. It will show you how to make
> shillings do the work of pounds in dress and personal grooming, household
> management, cooking and gardening. But *Vogue* in features and format will
> continue to be *Vogue*—charming and civilized, a tonic to the eye and to the
> spirit—more indispensable than ever.

The magazine then informed readers that "wartime conditions and transport problems make it impossible for magazines to be available ... for the casual reader to pick up wherever she pleases," so either a postal subscription or a standing order with a newsstand would be necessary. A few pages on, alongside a reproduction of the May 1918 cover of *Vogue*, which featured an illustration of a Red Cross nurse, an article proclaims:

> *Vogue*—VETERAN OF THE LAST WAR, COMBATANT IN THE
> PRESENT, PROPOSES NOW TO CARRY ON: Our policy is to maintain
> the standard of civilization. We believe that women's place is *Vogue*'s place.
> And women's first duty, as we understand it, is to preserve the arts of peace
> by practicing them, so that in happier times they will not have fallen out of
> disuse. Moreover, we believe that women have a special value in the public
> economy, for even in wartime they maintain their feminine interests and thus
> maintain, too, the business activity essential to the home front.[37]

This early injunction to British women to stay feminine and consume patriotically was furthered in another article from that issue, this one entitled "Here and now resolve to shop courageously to look your best." The piece instructs readers that as it is now the normal time of year to buy fall wardrobes they should "Shop for it now"— "Every time you hold back from buying, you throw the national economy a fraction off balance. Multiply that by millions, and it becomes a considerable punch on that very chin which the dress trade is trying to keep up." The article concludes: "It's our job to spend gallantly, to dress decoratively, to be groomed immaculately—in short, to be a sight for sore eyes."[38]

Vogue's instructions for British women continue a few pages on with a list of readers' other obligations during wartime. If a woman was not already "attached to the auxiliary reserves of the fighting forces," then she should "find something to do that will daily demand" her attention, "preferably some useful work outside your own interests and necessities." She should make use of all her "resources": planting vegetables where she had grown flowers, learning to sew, knit, or cook (now that middle-class women's cooks had gone off to do vital war work), organizing people to play bridge or darts, and learning, or re-learning, a musical instrument so as to be able to entertain and drown out the "noise of bombardment." Country-dwelling women should keep bees, rabbits, hens, or goats. On top of all this practical ingenuity, the British wartime woman should maintain her beauty exercises and keep her "hair and complexion in good trim" because "it would certainly be a calamity if war turned us into a nation of frights and slovens."[39]

A number of historians have written on the double-edged tenets of "beauty and duty" in wartime Britain.[40] Not only *Vogue* but also the more modest *Woman* and *Woman's Own* magazines made it clear that the British woman was expected to "make a vital contribution to the war effort while maintaining her femininity."[41] Women were to "keep up a front."[42] In the November 1939 issue of *Vogue*, readers were given the "thumbs up" for recognizing that "beauty should always have a place—that discreet maquillage can be the best war-paint, ... that the battle is to the fair." "Slackers in slacks" received the official "thumbs down" for padding around "in hairy sweaters and flannel bags, on duty and off, ... letting themselves go—and other people down."[43]

Makeup was promoted as a way to brighten a woman's look and even the government encouraged women to wear it as a morale-booster for soldiers home on leave. Official government surveys of the period discovered that two-thirds of all British women were using cosmetics, but this statistic broke down in interesting ways. Although ninety percent of women under thirty reported that they regularly applied

makeup, as did eighty-five percent of women who worked in offices, and seventy-five percent of those working in factories, only fifty-five percent of housewives, and retired and unoccupied women said that they did so.[44] Still, even in that group, over half were regularly using cosmetics.

Miller did a number of fashion shoots on makeup tips and trends. Her photographs accompany a February 1942 article entitled "Make the most of your face," which commences, "Since the cosmetic quota was cut to twenty-five percent, making the most of your face means making the most of your preparations. They have, in fact, to go three times as far." The article then lists many "everyday economy tips," including the unexpected—"brush moustache wax on your lashes, if you cannot get mascara"—and the more typical—"pat on foundation, rouge and powder so carefully that you never have to wipe off surplus." Other beauty remedies include "halibut liver oil capsules" for "the common complaint" of dry skin. A new hairstyle was also recommended to "alter your appearance," and suggestions on matching your hairstyle to the shape of your face follow.[45] Alongside such beauty banalities appear Miller's solarized photographs of actresses Deborah Kerr and Coral Browne, Elizabeth Cowell (the first female BBC television announcer), and *Vogue*'s features editor, Lesley Blanch.[46] The stylized portraits of the four women illustrate how shorter hair takes less time to style but is still attractive, making it the ideal look for the British woman active in war work.

A later article from February 1944 profiles Miss Lily Ehrenfeld, whose "brutal" twelve-hour shifts in a munitions factory are taking a real toll on her hands and complexion. "Miss Ehrenfeld's hands are coated day-long in grease and grime," at times even working "under running water." Miller's photographs reveal the treatments that are the solution, including painting the young woman's nails "with white iodine to harden them" and using "Cyclax Hand Bleach under an old pair of gloves in bed." A regime of facial cleansing and moisturizing is recommended too, as without "excellent care" her skin could become "disastrously dry" as a result of the "hot atmosphere of the factory,... charged with small bits of flying debris and dust."[47]

Such advice demanded more than double duty of women since many were also taking care of homes and children at the end of their workdays. However, as historian Pat Kirkham has argued, we "should not dismiss" these discussions of wartime hair and beauty regimes as they "formed an important part of women's everyday conversations and culture at the time."[48] In the feature "Make a Habit of Beauty," published in the summer of 1944, *Vogue* enjoins women to make their beauty care habitual—"a sort of smooth groove in your brain," rather than "an often-neglected chore"—and

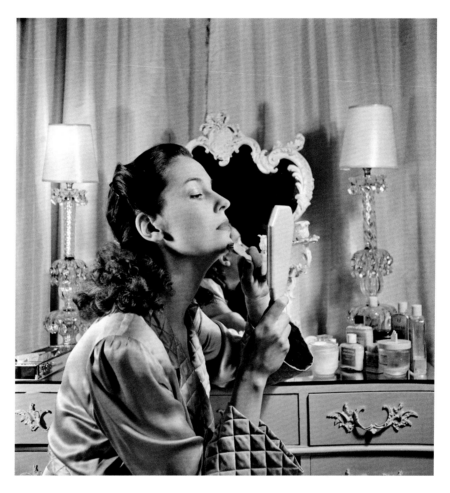

VALERIE HOBSON IN "MAKE A HABIT OF BEAUTY," BRITISH *VOGUE*
Photograph by Lee Miller, London, August 1944

shares the habits of four women in order to encourage an "automatic routine." Miller photographed Valerie Hobson, the celebrated actress, for the piece (above). Her flaw-less complexion is attributed to her at-home facial:

> Using a baby's soft toothbrush and a good soap, she scrubs her face thoroughly, especially round the nose and the chin. After rinsing, she works in a nourishing cream with the same brush. This treatment removes any lurking atoms of make-up, and is a wonderful circulation stimulant. But only once a week, please.[49]

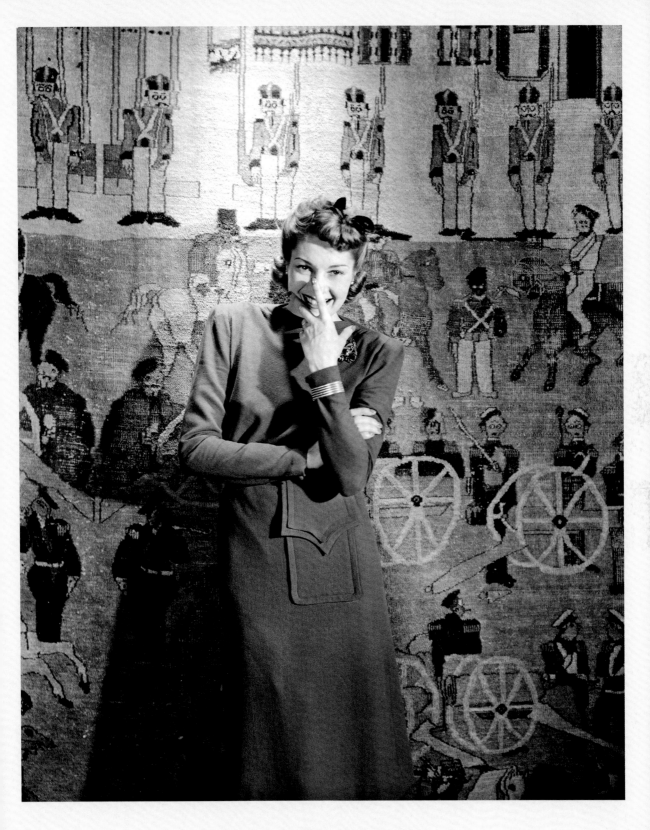

UNPUBLISHED PHOTOGRAPH FOR BRITISH *VOGUE*

Photograph by Lee Miller, London, October 1943

Vogue's "Smart Fashions for Limited Incomes" and "Bargain of the Month" features applied similar "beauty and duty" directives to fashion. In June 1941 the British government had announced clothes rationing in the form of the Utility clothes scheme. For many this "came as a complete shock and surprise," but the majority of people were "willing to put up with it as … an essential part of the war effort."[50] The soon-to-be-famous CC41 label, standing for Clothing Control 1941, was introduced as a way to guarantee that garments complied with new government regulations.[51] Utility cloth and clothing were strictly price controlled and all Utility goods, which over the course of the war came to include shoes, hosiery, knitwear, bedding, household linens, and pottery, were exempt from the thirty-three and a third percent purchase tax imposed on other goods.

Utility products were intended to be durable, long-lasting, and, made to a high standard, not necessarily inexpensive. As such, the Board of Trade enlisted the top London fashion designers to make the prototypes for Utility clothes.[52] A series of Making of Civilian Clothing restriction orders banned trimmings, even embroidery, from clothing and prohibited wasteful cloth cutting. Dressmakers and tailors were given strict instructions: dresses were to be restricted to a maximum of two pockets and five buttons; and the skirt of a woolen dress could have no more than six seams and only two inverted or box pleats, or four knife pleats.[53]

The "Smart Fashions for Limited Incomes" feature of March 1942 (pages 108–109) posed the question, "How is chic to be maintained on an income much reduced?" Its answer: "Utility Clothes. They are pretty, very reasonably priced, but, of necessity, shorn of those tricks of finish and fashion still to be found in more expensive things like *Vogue*'s Bargain of the Month—a wise long-term investment if you have a little extra money to spend."[54] In April 1943 Miller's photographs accompanied a *Vogue* article that advised, "Today's Standard" is "fewer, simpler, better clothes" (page 115):

> You'll have fewer clothes because you have not the time, money or coupons
> to clutter up your life with non-essentials…. You'll have simpler clothes
> because in these days anything elaborate looks silly…. You'll have better
> clothes because anything you buy will be chosen, after long thought,
> to last for the duration—and beyond…[55]

Opposite **UNPUBLISHED PHOTOGRAPH FOR BRITISH *VOGUE***
Photograph by Lee Miller, Oxford, May 1942

Following pages **"SMART FASHIONS FOR LIMITED INCOMES," BRITISH *VOGUE***
Photographs by Lee Miller, London, March 1942

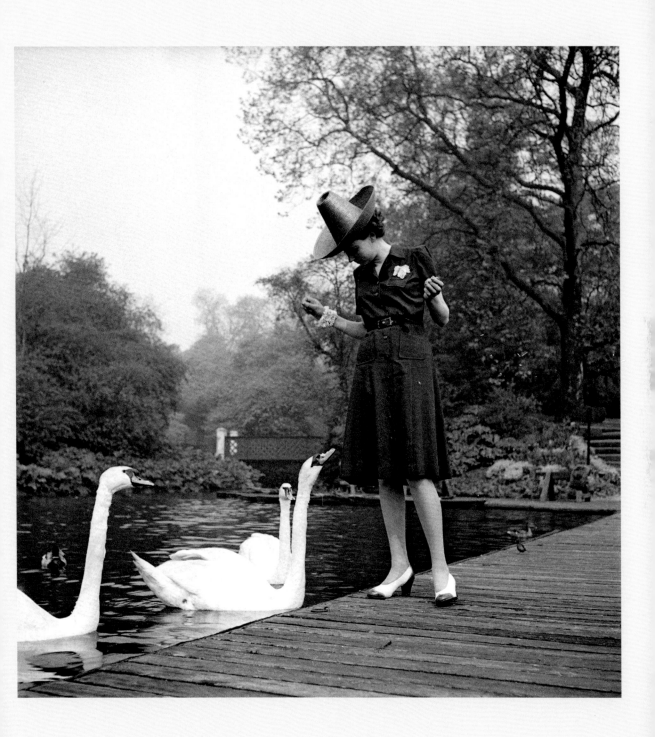

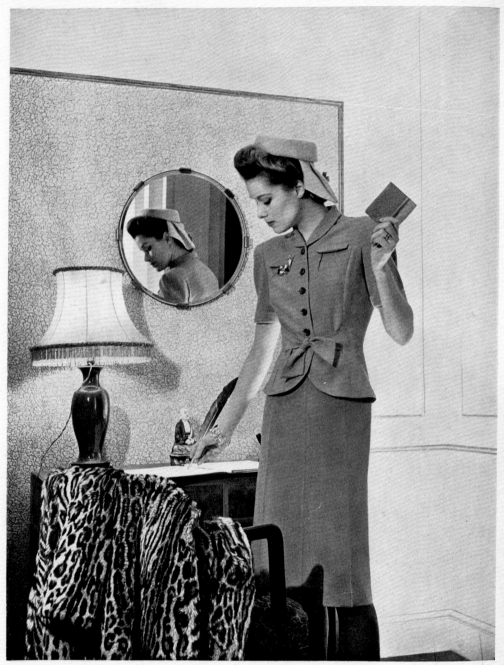

PHOTOGRAPH TAKEN AT SANDERSON'S, BERNERS STREET.

BARGAIN
OF THE MONTH

An all-in-one jumper suit of pure, soft wool, in a choice of three colours—grey, green or beige—all good mixers. As skirt and top are attached, it has the advantage of the lower coupon value of a dress, while giving the appearance of a street suit. The jumper fastens with wooden buttons, is half-belted behind. 6 guineas, 11 coupons, from Harrods

58

SMART FASHIONS FOR LIMITED INCOMES

'How is chic to be maintained on an income much reduced?' The answer to this *cri de cœur* is: Utility Clothes. They are pretty, very reasonably priced, but, of necessity, shorn of those tricks of finish and fashion still to be found in more expensive things like Vogue's Bargain of the Month—a wise long-term investment if you have a little extra money to spend

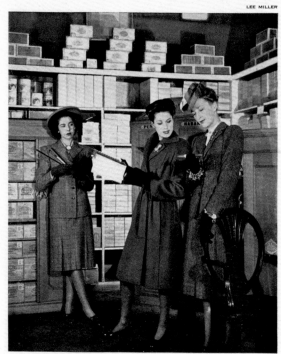

Left. Marlbeck suit cut on classic lines in a smooth Glen check, brown, beige, green. The skirt has inverted pleats. 68s. 2d., 18 coupons at D. H. Evans, London; Webber, Oxford

Centre. Dereta coat, half lined, cosy in green wool. It has padded shoulders, tie-belt. 83s. 11d., 15 coupons. At Fenwick, London; Bon Marché, Liverpool; McDonalds, Glasgow

Right. Harella suit in flecked tweed, 95s. 11d. 18 coupons at John Lewis, London. Photographed among cigar-boxes and humidors at Savory's cigarette shop in New Bond Street

Left. Sumrie suit in wine and blue checked tweed. 97s. 5d., 18 coupons. At Peter Robinson. Photographed in Coty's New Bond Street Salon, now opening shorter hours

Centre. Rembrandt wool all-day dress in several good colours, with contrasting belt and buttons. 62s. 10d., 11 coupons. At John Lewis, John Barnes and Peter Jones, London

Right. Selincourt plaid tweed coat half lined, in heathery red, green and mauve. 95s. 2d., 15 coupons. At John Lewis, Peter Jones and John Barnes, London; Caleys, Windsor

59

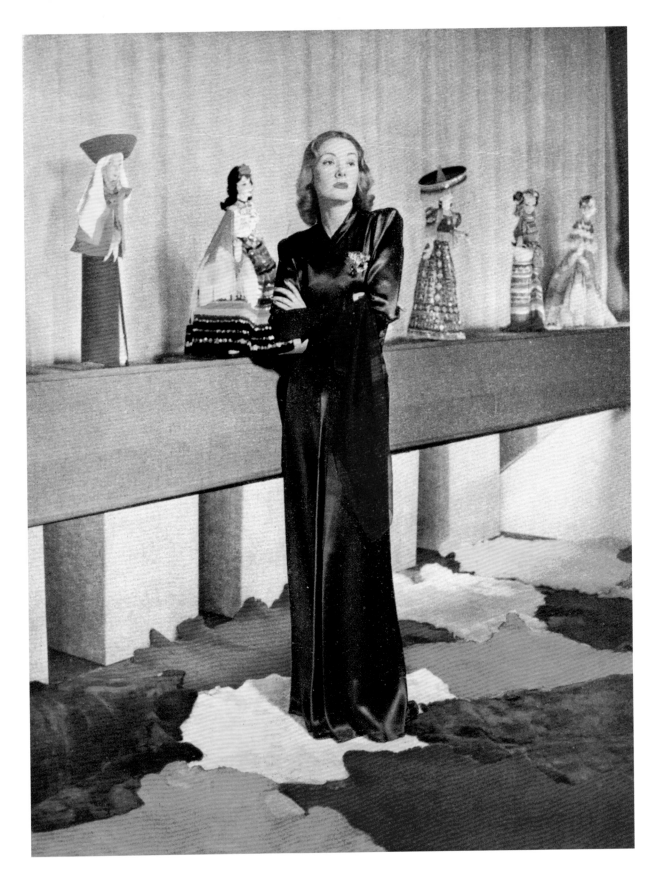

In October 1940 the *Picture Post* ran an article on Lee Miller and the preparations for a fashion shoot for *Vogue*. Its author, Anne Scott-James, had been hired as the publication's women's editor with the explicit remit of forwarding the government's "beauty and duty" message.[56] In her article Scott-James wonders, "Why all this fuss about a photograph when the country is fighting for its life?" But the explanation, she finds, is simple; upholding the status of British fashion "maintains Britain's position as the world's greatest exporter of fabrics" and "fashion pays for planes and supplies."[57]

The following spring British *Vogue* featured a "London fashion collection specially designed" for "the women of South America," which was part of a government-sponsored venture aimed at raising this desperately-needed export revenue.[58] So successful was the collection that its mastermind, the Royal dressmaker and couturier Norman Hartnell, went on to found the Incorporated Society of London Fashion Designers in 1942. IncSoc, as it was known, worked with the government to promote British fashion and textile sales abroad and created thirty-four designs under the Utility scheme bearing the CC41 label. Unlike his rival couturier Hardy Amies, another IncSoc member, Hartnell was too old for military service when war broke out and so had joined the Home Guard while continuing to design clothes. Throughout the war he actively promoted British fashion exports in North and South America, as well as selling his designs to foreign diplomats living in London.

In 1943 his South American contacts persuaded him to organize an exhibition of small dolls wearing miniature versions of authentic costumes from twenty Latin American countries. The dolls were made of sacking and stuffed with sawdust but dressed in Norman Hartnell designs of beaded silk, recycled from pre-war remnants and patterns found in his workrooms. Helen Lee Barclay sculpted the dolls' clay heads. Hartnell painted and wigged them himself.[59] The Anglo-Latin-American Costume Exhibition, as it was named, toured Great Britain and beyond, raising funds for the Soldiers, Sailors, and Airmen's Family Association.[60] For the first issue of 1944, Miller photographed five of these small dolls standing on a shelf behind a well-coiffed model sporting a satin Norman Hartnell dinner dress (opposite)—"grey as the elephant … but sleek and soft as a cat," according to the caption.[61]

After the glamour of the 1930s, the square silhouette foisted on British women as a result of clothing restrictions and uniforms meant that many were more than happy to follow *Vogue*'s advice and offset their severe looks with generous makeup,

Opposite **"ELEPHANT GREY," BRITISH *VOGUE***
Photograph by Lee Miller, London, January 1944

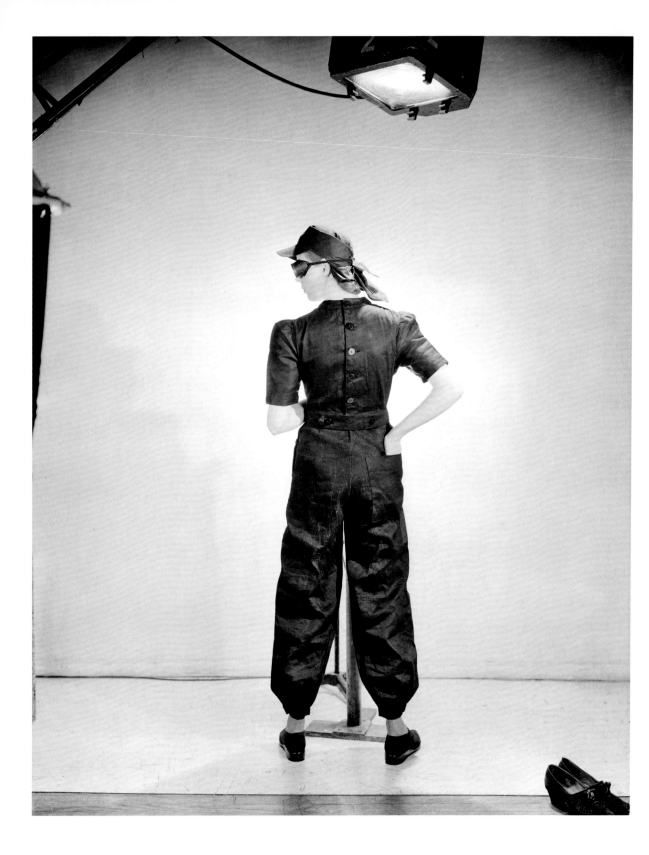

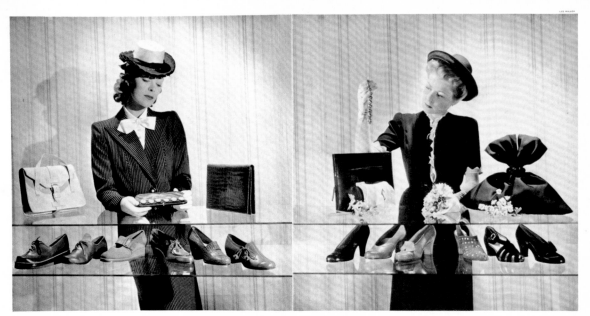

FOR MORNING. A navy and white coat and skirt, strictly tailored in man's suiting, worn with a dazzling white piqué waistcoat, a pot-crowned white straw hat with a waffley brim of navy felt. All of these come from Bradley. *Handbags.* On the left, a satchel-shaped, handstitched natural calf Taxi bag at Harrods. On the right, a golden crocodile pochette, from Delman. *In her hands.* A set of flower-sprigged china buttons from the Golden Past. *Shoes, left to right.* She has a fine choice: a crêpe-soled platform shoe, tan calf piped with hazel; Lilley & Skinner. A green and red calf shoe with moulded arch: Brevitt 'Bonneer' (on sale soon) Harrods and Russell and Bromley. Suede pigskin shoe with calf wedge; Joyce 'Buckler', at Harvey Nichols. A tie-shoe, tan and nigger calf, or in suède; Pinet. A crocodile shoe, to match bag above; Delman. 'Baby last' side-tie shoe (on sale soon) Lotus.

ACCESSORY FACTORS
Prolong your single suit into infinity

FOR AFTERNOON. Black satin-backed crêpe dress, cuffs and bosom edged with white broderie. It looks like a coat and dress. Debenham & Freebody. *On counter, left to right.* Zipped grain calf bag; Tallula. Handmade celandine posy; Fortnum & Mason. Frilly Victorian 'tuzzy-muzzy'; Ships. Spray of apple-blossom, in leather; Jacqmar. Black grosgrain handbag; Galeries Lafayette. *In her hand.* Blue and gold glass necklace; Duvelleroy. *Shoes, left to right.* A high-heeled pump in lizard, now coming into its own; Rayne. A high-vamped calf pump, navy or tan; Brevitt at Marshall and Snelgrove's country shops. A nut-brown calf pump with punched toe trimming; Delman. A strap sandal in punched suede and several colours; Lilley and Skinner. A streamlined black suède sandal; Russell & Bromley. And a neat pump in calf and suède—wine, navy, brown or black, Fortnum & Mason

50 51

Above **"ACCESSORY FACTORS,"** BRITISH *VOGUE*
Photographs by Lee Miller, London, May 1942

Opposite **"FASHIONS FOR FACTORIES,"** BRITISH *VOGUE*
Photograph by Lee Miller, London, June 1941

stylish hairstyles, and inventive accessories.[62] At the outbreak of war, long, curled hairstyles copied from Hollywood actresses had been particularly popular. But such styles proved dangerous for women working in factories and the Ministry of Labour called for a ban on long hair. In response, editor Audrey Withers instructed her staff to write features on turbans, draped cloche hats, and sleek hairdos, and to announce them as the latest "looks from Paris."[63] Miller photographed these styles for a number of features, including "Fashions for Factories," which appeared in the June 1941 issue (opposite). Harry Yoxall, then British *Vogue*'s managing director, proudly noted in his memoir that thanks to these features "within a few months ... accidents had disappeared from our workshops."[64]

British *Vogue* also promoted accessories as the perfect means to "prolong your single suit into infinity" (above).[65] Hats were exempt from rationing and, for those who

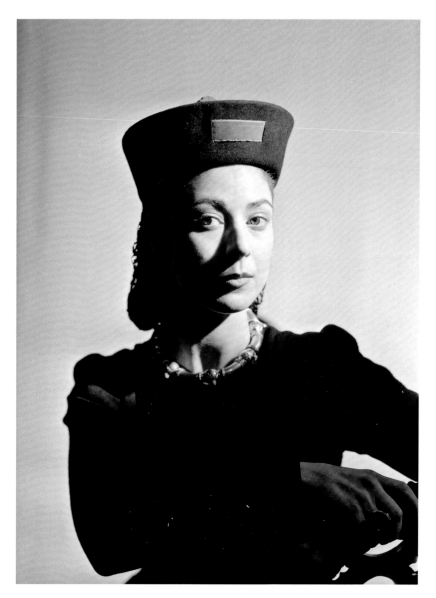

UNPUBLISHED PHOTOGRAPH OF MARGOT FONTEYN, BRITISH *VOGUE*

Photograph by Lee Miller, London, January 1944

could afford them, were an easy way to smarten up a drab, much-worn ensemble.[66] Several photographs from the Lee Miller Archives reveal shoots especially devoted to hats, including one featuring the ballerina Margot Fonteyn (above). For "Hats Follow Suit" in the September 1942 issue, Miller borrowed a trick from Man Ray to liven up the spread. Seven years earlier, in 1935, Man Ray had devised a Surrealist deck of playing cards that included Nusch Éluard—wife of the artist Paul Éluard—as the queen of clubs and Jacqueline Lamba as the jack of hearts. He had positioned their

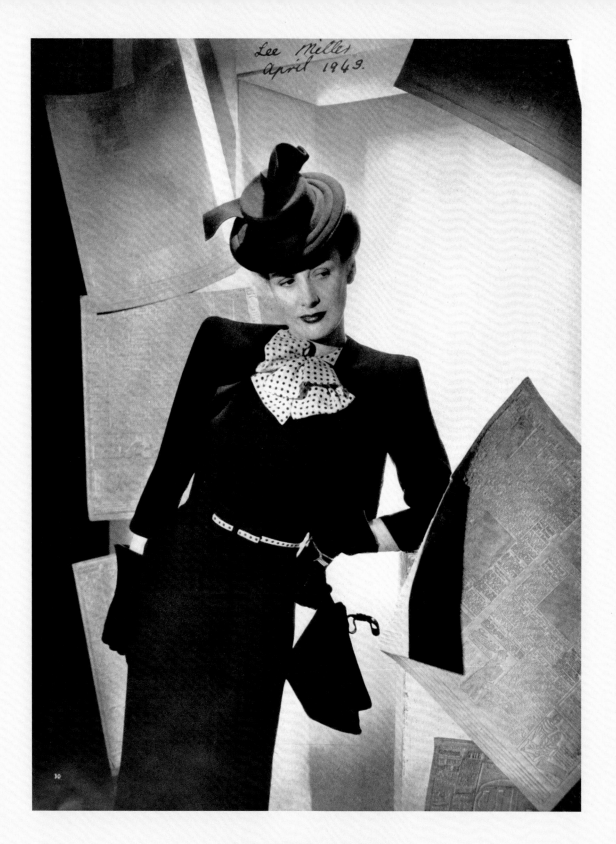

"TODAY'S STANDARD," BRITISH *VOGUE*

Photograph by Lee Miller, London, April 1943

Hats follow suit

Your autumn suit will be devoid of trimming, tailored on austerity lines. Your hat will follow suit, relying on line rather than trimming for its effect.

This does not mean severity or monotony, as the hats on these pages prove. Rolled brims, dipping brims, berets, back-of-the-head hats . . . one will surely suit you and your suit. And remember, when you're hat hunting, that felts are becoming scarcer, so a good felt is more than ever a good investment. We tell you how to nurse such an investment on page 93. These hats are on sale all over the country; for a list of out-of-town shops stocking them, turn to page 84.

1. Broad-brimmed brown felt, bound and banded with grosgrain, that you clap on the back of your head and wear with a town suit or country tweeds. Face-framing, flattering. Cross Keys hat: Selfridge

2. Velveteen, smooth across the front and swathed across the back, gives a soft look to this tailored brown felt beret; to complement a classic profile, a sleek town tailleur. Reslaw hat: Dickins & Jones

3. Pheasant feathers swathe the turned-up brim and round crown of this simple brown felt sailor, which you wear dead straight, and well forward. A Berkeley model, from out-of-town shops on page 84

1

2

3

"HATS FOLLOW SUIT," BRITISH *VOGUE*

Photographs by Lee Miller, London, September 1942

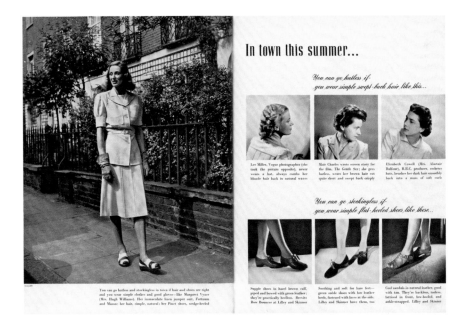

"IN TOWN THIS SUMMER...," BRITISH *VOGUE*

Photographs by Lee Miller, London, July 1943

photographs on these cards in much the same way that Miller did her photographs for this hats spread (opposite).[67] For those who found hats stuffy, Miller among them, *Vogue* deemed it acceptable by the summer of 1943 to go "hatless … in town," so long as readers sport "simple swept back hair." Reprising her role as model and photographer in one of the article's three photographs, "Lee Miller, *Vogue* photographer," models her blond hair styled "back in natural waves" since she "never wears a hat." The caption notes that Miller took "the picture opposite" as well (above).[68]

During World War II, fur was not rationed but prices were fixed to keep furriers from charging exorbitant prices and siphoning off everyone's surplus purchasing power. The glamorous fox and mink coats sported by Hollywood film stars throughout the 1930s had caused the fur trade in London to boom between the wars. In 1914 only about two thousand silver fox pelts went to auction in London; by 1934 that number had risen to three hundred and fifty thousand.[69] Miller photographed fur coats many times for wartime *Vogue*, sometimes bringing her sense of humor into play with interesting studio props. This was particularly true in the November 1941 feature "Fur Bearers," for which she posed her models with lifelike stuffed bears and giraffes (pages 118 and 119).

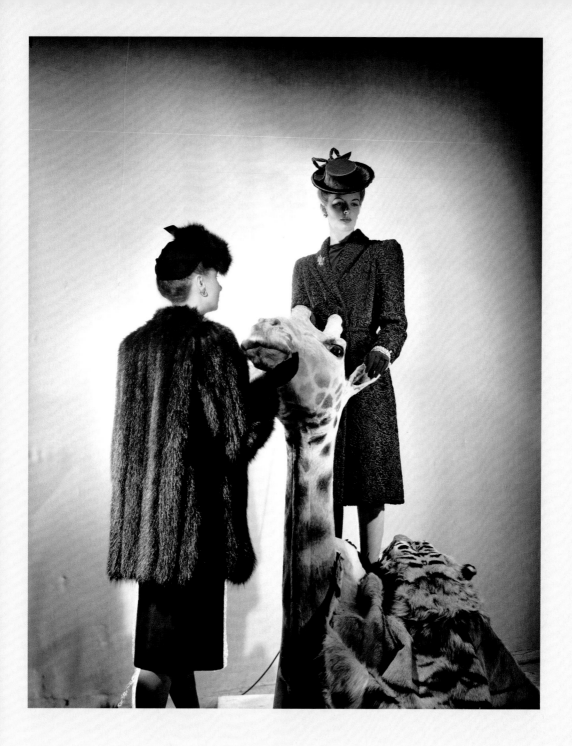

Above and opposite **"FUR BEARERS,"** BRITISH *VOGUE*

Photographs by Lee Miller, London, November 1941

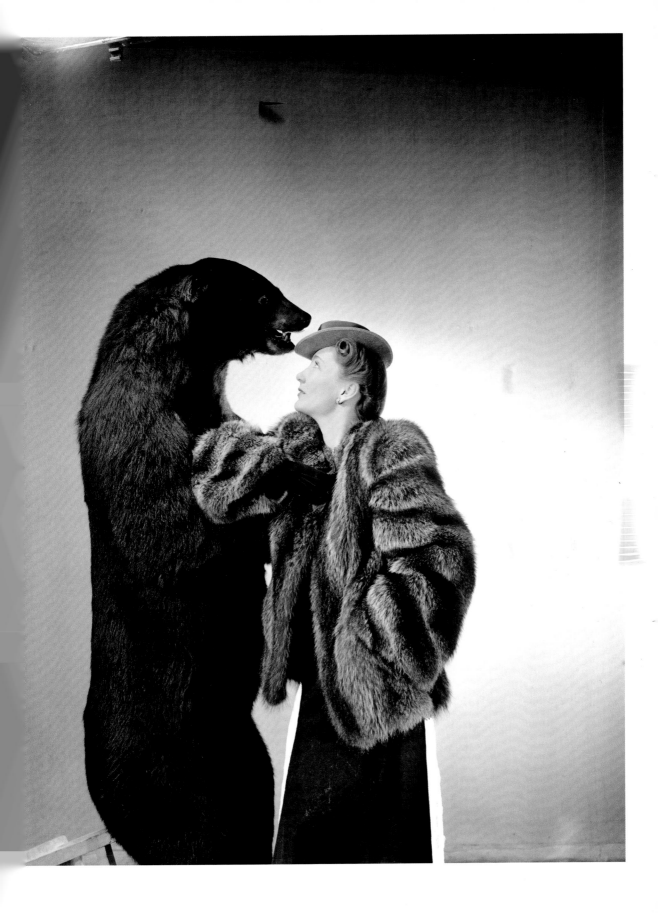

In addition to her work for British *Vogue*, Miller contributed photographs to two book projects, *Grim Glory: Pictures of Britain Under Fire* and *Wrens in Camera*. *Grim Glory* illustrates the resolve of Londoners in the face of German attacks and was published simultaneously in Britain and America in 1941. The American broadcaster Edward R. Murrow contributed the preface and it was hoped that the book would encourage American support for the British war effort.[70] Nor was this merely a question of morale. More than anything, Britain needed hard currency.

Taking the photographs for these publications gave Miller an outlet to contribute to the war effort beyond the pages of *Vogue*. Penrose, though a Quaker and a conscientious objector, was also contributing—he volunteered as an air-raid warden and applied his artistic skills to work on camouflage. He and another Surrealist painter, Julian Trevelyan, had decided on the ship back to England in 1939 that they could best assist the war effort by developing new camouflage techniques and so had founded the Industrial Camouflage Research Unit at 7 Bedford Square in Bloomsbury, central London. Their company was short-lived, however, closing in June 1940 when the government forbade such commercial efforts and absorbed the artists into official military camouflage research. At the end of August 1940, the Royal Engineers' Camouflage Development and Training Centre opened at Farnham Castle in Surrey. Its team included Penrose and Trevelyan, along with the magician Jasper Maskelyne and the zoologist Hugh B. Cott. At Farnham, Trevelyan later recalled, they "learnt the camouflage techniques of the 1914 war, where plaster trees were erected in the night to hide snipers, and where dummy plaster heads were popped up above the trenches to draw enemy fire and to pin-point the enemy snipers' nests."[71]

In 1941, the same year *Grim Glory* appeared in print, Penrose published *The Home Guard Manual of Camouflage*. Befitting a painter, nature lover, and Surrealist, he dotted his practical text with illustrations relating to examples of camouflage in nature, such as how a zebra's stripes help it to disappear into the scenery.[72] Penrose was subsequently recruited to the army as a camouflage instructor with the rank of Captain and put in charge of the Eastern Command School of Camouflage in Norwich, England. His lectures on the latest techniques were spiced up with a surprise "startle slide" that showed Miller nude but "camouflaged" in green Elizabeth Arden makeup and netting (opposite). The slide caught the attention of even the dopiest audience members.[73] Penrose went on to explain to his now attentive listeners that if he could hide Miller's seductive charms, he could hide anything.[74]

The photograph of Miller had been taken by the latest addition to the Miller–Penrose household, David E. Scherman, a twenty-five-year-old New Yorker and

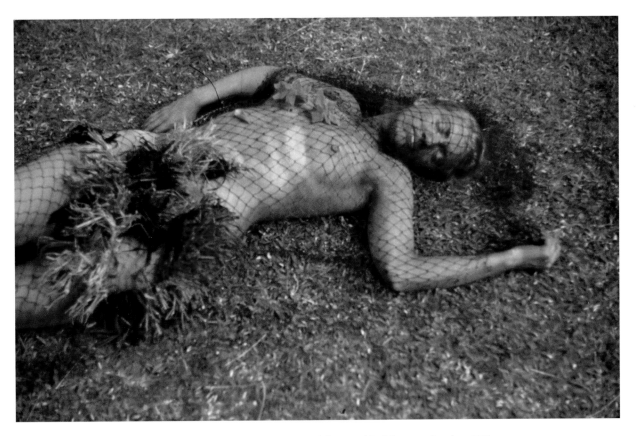

LEE MILLER IN CAMOUFLAGE Photograph by David E. Scherman, London, 1942

Time–Life journalist working out of Dean Street in Soho. His sense of humor was as sharp as Miller's and they had hit it off at a dinner party in December 1941 and soon become lovers. By February 1942 Miller was considering sharing a flat with Scherman and two other "*Time–Lifers*" since Penrose was so often away lecturing on camouflage. When the couple discussed it, however, Penrose insisted that Scherman should instead move into the house on Downshire Hill. Scherman later told an interviewer, "It was a ménage à trois, but Roland was in the army so it soon became a ménage à deux."[75] Miller and Scherman often collaborated on his photographs for *Life* magazine. He taught her his photojournalist approach to photography, which he had learned from Margaret Bourke-White and Alfred Eisenstaedt. He labeled it "pictorialism with a meaning" and believed that "'You invent a good picture' … often some time after the fact."[76]

For a woman who had been photographed nude by her father for most of her life, whose navel had been pronounced the most beautiful in all of Paris, and whose breast had been the model for a champagne glass, perhaps it seemed unexceptional

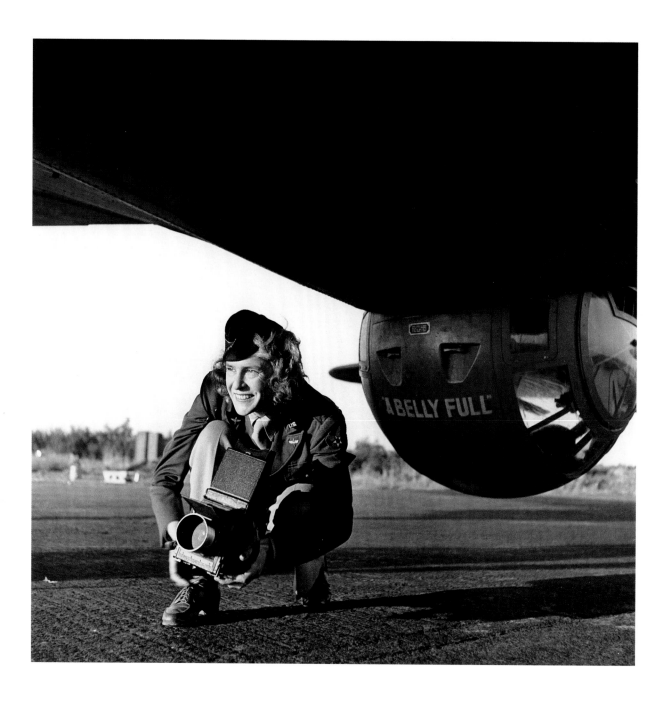

MARGARET BOURKE-WHITE IN "AT THE OTHER END OF THE LENS," BRITISH *VOGUE*

Photograph by Lee Miller, London, January 1943

to Miller to be photographed nude by one lover in order to be used as a "startle slide" by another.[77] At the age of thirty-five, however, she was only very occasionally modeling; to be asked to pose nude by Penrose must have been flattering. And the fact that Surrealism was considered a key aspect of camouflage research during World War II meant that she could also consider herself, once again, an active participant in artistic work, now in service to the war. Max Dupain, a member of the Sydney Camouflage Group formed in 1939, commented on this connection between Surrealism and camouflage:

> Surrealism … was closest to a camouflage way of thinking. Surrealist
> techniques such as simulation to mimic reality, dissimulation to
> decompose reality and metamorphosis to transform reality were all
> designed to put the viewer's certainty of sight and powers of reasoning
> into question. They are also basic techniques of military camouflage
> where the objective is to use visual surprise and disorientation for military
> gain. Like Surrealist art, camouflage is designed to unsettle the senses and
> subvert the hegemony of vision.[78]

Decades later, Penrose wrote in his biography of Picasso, illustrated with photographs by Miller, that "Harlequin, Cubism and military camouflage had joined hands. The point they had in common was the disruption of their exterior form in a desire to change their too easily recognized identity."[79]

Back at *Vogue*, Miller photographed the innovative use of embroidery for camouflage in late 1942. For the feature "Evolution in Embroidery," she shot embroidered tapestries made by WVS needlewomen. As Penrose's guide explains, it is more important to match the texture of the landscape than its color. A coat of paint alone does not do the job because aerial photography eliminates color from its observations and accentuates differences in tone.[80] The WVS's embroidered landscapes had been found to work better than photographs because the needlework could reproduce "both the colour and texture of the country under survey."[81] Miller's photographs appear in the January 1943 issue. In the same issue, for a feature entitled "At the Other End of the Lens," she turned her camera on another female photographer, Scherman's mentor Margaret Bourke-White (opposite).[82]

Almost none of Miller's fashion photography from the 1940s has been republished since it first appeared in British *Vogue*. And, as is so often the case with fashion photography, the unseen contact sheets and negatives are the most revealing.[83] Even in the staged studio shots it is her wonderful sense of humor that shines through most in

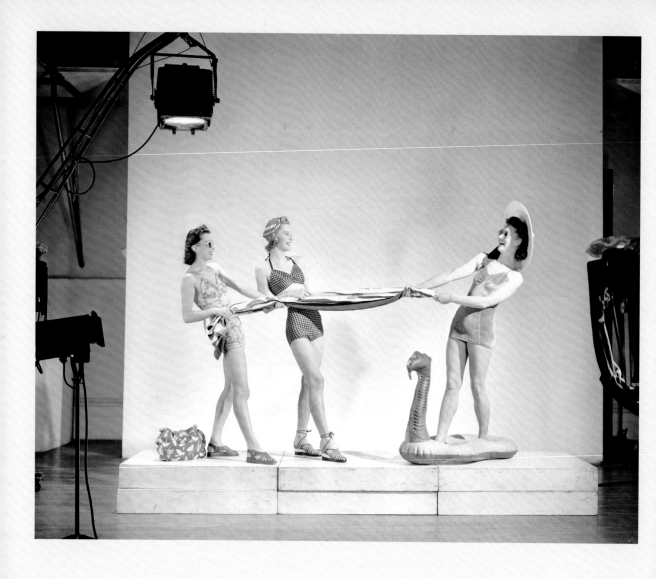

Above **"SMART FASHIONS FOR LIMITED INCOMES," BRITISH** *VOGUE*

Photograph by Lee Miller, London, 1940

Opposite **UNPUBLISHED PHOTOGRAPH FOR BRITISH** *VOGUE*

Photograph by Lee Miller, London, February 1941

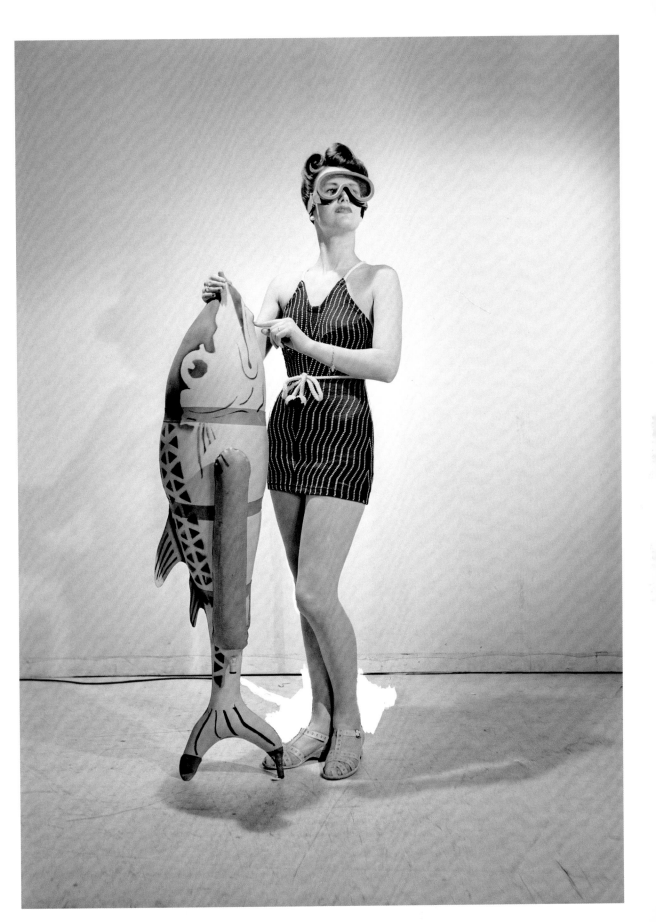

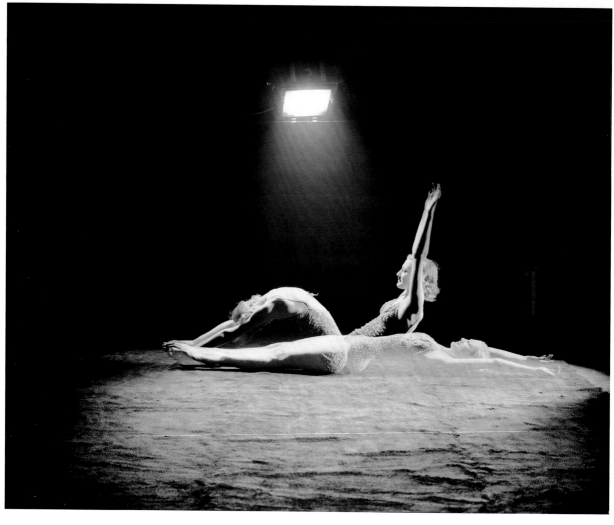

"LIMBERING UP FOR THE BIG PUSH," BRITISH *VOGUE*

Photograph by Lee Miller, London, August 1942

these unpublished works. As we have seen, Miller was a prankster who liked to have a good laugh. Silly stage props dug up in the basement of *Vogue* Studios, or perhaps purchased from the inexpensive Woolworths store on her way into work, clearly amused her and evoked playful days of seaside fun rather than the gloom of bombed London (pages 124 and 125). Other unpublished works in the archive exemplify the various techniques that she had learned from Man Ray and Hoyningen-Huene during her Paris years. Her mastery of cropping and retouching is apparent in several marked-up archival photographs (opposite), while for an assignment on women's exercise regimes she made multiple exposures in order to demonstrate movement and add interest (above). She also revisited her and Man Ray's solarization technique

Below **PHOTOGRAPHIC PROOFS WITH CROP MARKS**

Photographs by Lee Miller, London, December 1939

Following pages **UNPUBLISHED PHOTOGRAPHS FOR BRITISH *VOGUE***

Solarized photographs by Lee Miller, London, May 1942

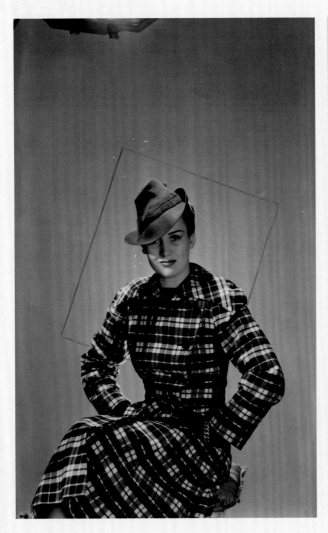

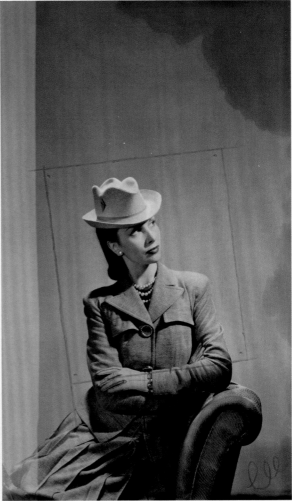

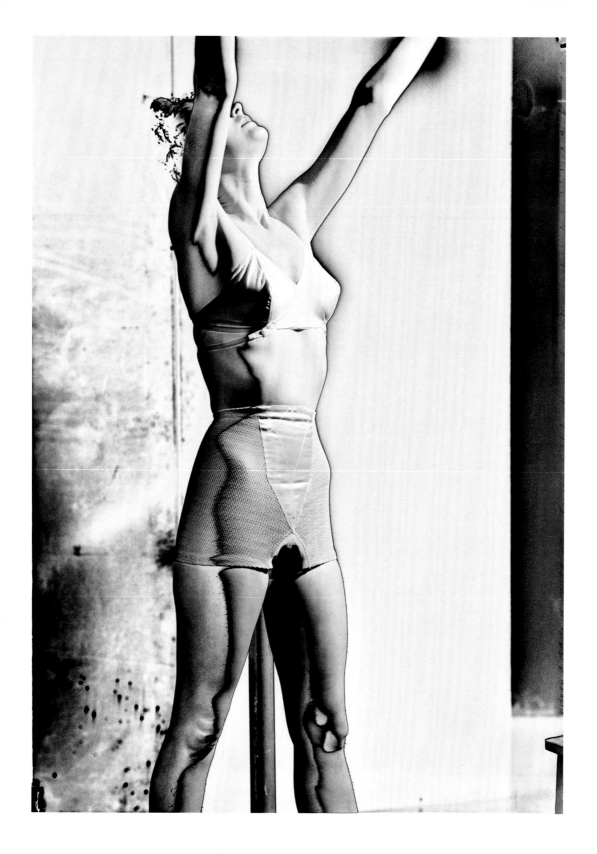

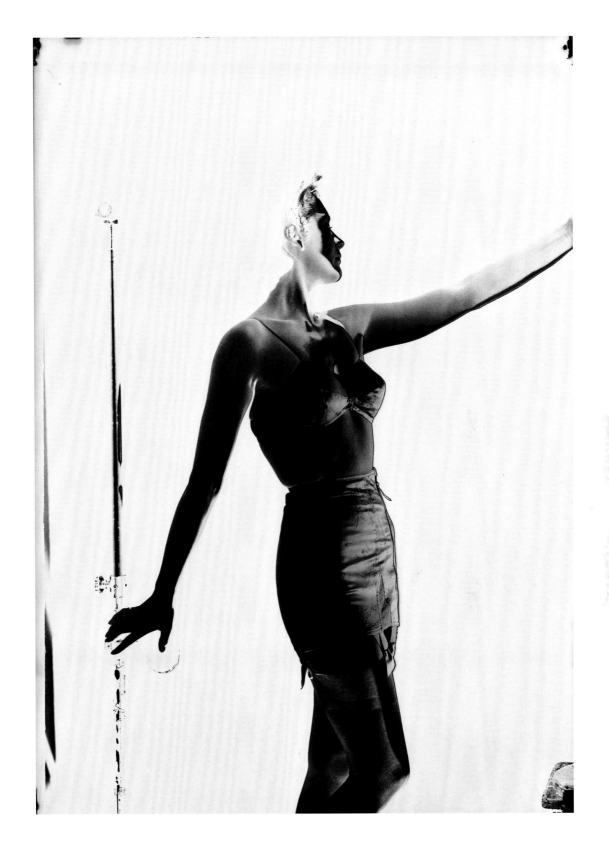

when developing the film for a feature on corsetry in May 1942 (pages 128 and 129). Earlier that year, she used a montage technique that she seems to have learned from Hoyningen-Huene. For a feature called "Make the Most of Your Figure," she positioned her model's face looming large above her hands, which rest lightly on two transparent "bubbles," each containing the same miniature model but in different poses in order to emphasize "the shocking effect on clothes and figure" of good and bad posture (opposite).[84]

As Mark Haworth-Booth has discovered, George Hoyningen-Huene produced a similar montage for the August 1932 issue of French *Vogue*, though in his version a woman's face does not hover over "the encapsulated models."[85] Yet, in another montage by Hoyningen-Huene from the same period (previously misattributed), we do find Miller's face looming over the model Agneta Fischer, who poses inside a similar bubble (page 36). Both montages possess the same Surreal, dreamlike qualities, although in Hoyningen-Huene's version it seems the bubble is not a bubble at all, but a crystal ball, which Miller consults as she peers down at the encapsulated and miniature Agneta.

With all these techniques to hand, by spring 1944 Miller was clearly the leading photographer contributing to British *Vogue*. For the April issue, she shot the color cover (page 132) and the inside color feature, "Contrast in Checks," for which she posed a model in front of an abstract painting by Henry Moore.[86] Miller also shot the photographs for "Cover Coats" that month, five photographs for "Rayon—the Stuff of Summer," two photographs for "New Clothes for Old," five photographs for a feature entitled "Private Practice," and two portraits.[87] The May issue included eight color and fourteen black-and-white photographs taken by Miller, and only five by Cecil Beaton and three by Norman Parkinson. For the June issue, she once again shot the cover, as well as twenty-one photographs for the contents within.

Then, in August 1944, Miller made her first appearance as a writer for British *Vogue*.[88] Fed up with the vapid texts that frequently accompanied her photographs, Miller had "badgered" editor Audrey Withers into allowing her to write articles as well.[89] "Citizens of the World: Ed Murrow—Photograph and text by Lee Miller" was her debut in this new role. Edward R. Murrow was an American broadcast journalist based in London, whose broadcasts about the war played to millions throughout the United States. (It was Murrow who contributed the preface to *Grim Glory*.) Although

Opposite **"MAKE THE MOST OF YOUR FIGURE," BRITISH *VOGUE***
Montage created from photographs by Lee Miller, London, February 1942

VOGUE

INCLUDING VOGUE PATTERN BOOK

few in England had the opportunity to listen to his American broadcasts, he was well known in England and Miller began her article:

> Very few people in England have heard Ed Murrow: but we know him, like him, and respect him. He is a star in our journalistic constellation. He is constantly quoted and referred to by people who know people who have short-wave sets, and he is cable-quoted back from New York to the Press here as an authority. A radio prophet is a man without a face in his own country. Here he is without voice like the Mermaid in Hans Christian Andersen's fairy tale.[90]

Miller submitted the article to Withers along with a letter filled with self-doubt, in which she writes that agreeing to write the article had been "a big mistake," that after spending "fifteen or so years … learning how to take a picture—you know that thing that is worth ten thousand words," she was now "cutting" her own throat, "imitating these people, writers, who I've been pretending are démode."[91] But Miller's own assessment of her writing is clearly incorrect. Her text anticipates her readership well and its fairy-tale allusions would become characteristic of her unique voice as she moved into the next stage of her career.

Opposite **COVER OF BRITISH** *VOGUE*
Photograph by Lee Miller, London, April 1944

CHAPTER 5

"Who else can swing from the Siegfried Line to the new hipline?"

WAR AND FASHION REPORTAGE, 1944-46

The war on the home front was long and trying. After the bombs stopped falling daily in May 1941, it demanded patience above all else. Miller wrote to her parents at the end of that year: "It seems pretty silly to go on working on a frivolous paper like *Vogue*, tho it may be good for the country's morale it's hell on mine."[2] Yet Miller and London continued about their daily business, until, in the spring of 1942, a touch of excitement was added when American servicemen began to arrive in droves, following the attack on Pearl Harbor. Although thrilling for some, Miller found her compatriots in their tailored Savile Row uniforms, rich with cigarettes, canned goods, Scotch, and Kleenex, "insufferable," according to David E. Scherman.[3] "They were also preparing, not so secretly, for what was obviously to be a re-invasion of the European mainland. The two phenomena, no-Kleenex-in-the-midst-of-plenty and the threat of being left out of the biggest story of the decade, almost drove poor Lee Miller mad." Scherman had the solution. He suggested that she too, "a perfectly bona fide Yank from Poughkeepsie, apply for accreditation to the US forces as a war correspondent."[4] On December 30, 1942, Miller was issued her US War Department identity card (page 138).

The wait for D–Day was agonizingly protracted. Miller wrote to her parents in May 1943: "Now I wear a suit on account of what (sic) I'm war correspondent for the Condé Nast press.... You ought to see me all done up and very serious like in olive drab and flat heeled shoes."[5] And it was true. Audrey Withers, with the support of Condé Nast, had agreed that Miller could act as *Vogue*'s war correspondent in Europe.[6] But it would be eighteen long months before the liberation of France began.

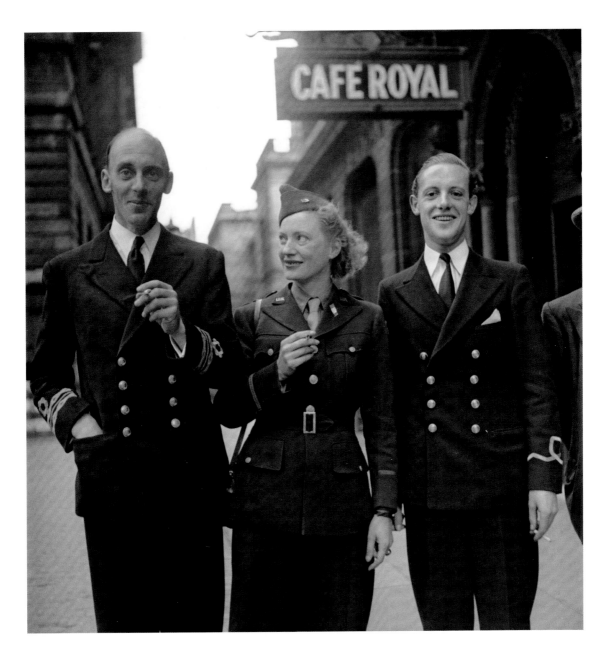

Above **LEE MILLER AND ROYAL NAVY RESERVE OFFICERS**

Photograph by David E. Scherman, Edinburgh, August 1943

Page 134 **UNPUBLISHED PHOTOGRAPH FOR BRITISH *VOGUE***

Photograph by Lee Miller, Paris, October 1944

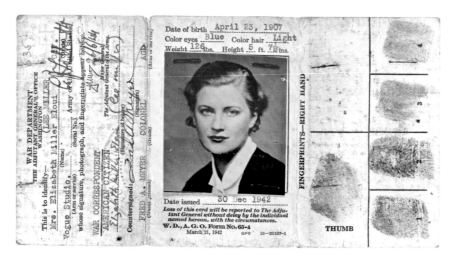

LEE MILLER'S US WAR CORRESPONDENT IDENTITY CARD Issued December 30, 1942

The Allies invaded Normandy on June 6, 1944. Miller did not intend to miss this. She got in line for several rounds of vaccinations and learned to cope with the new nerve-wracking German bombs raining down on London. These V1s, commonly called "doodlebugs," were accompanied by the warning sirens' near-constant wailing. Miller headed to France and as close to the front as she could in late July. Penrose had already left England for Italy to work on camouflage for the troops there. Years later, Withers explained her decision to use Miller as *Vogue's* war correspondent: "It was all very well encouraging ourselves with conventional patter about keeping up morale, but magazines—unlike books—are essentially about the here and now. And this was wartime."[7] Receiving Miller's first submission as war correspondent was "the most exciting journalistic experience of my war," Withers added. "We were the last people one could conceive having this type of article, it seemed so incongruous in our pages of glossy fashion."[8]

Withers had asked Miller to write a quiet image-led story on US Army nurses working in the field hospitals of Normandy. What she received from her wayward correspondent was something altogether different: a hard-hitting article entitled "Unarmed Warriors," along with fourteen photographs of two tent hospitals and a front-line casualty clearing station. It was published in both the American and British issues of September 1944 and "established [Miller's] domination of the major features of *Vogue* for the next year and a half."[9] Second Lieutenant Herbert "Bud" Myers recounted to me his memories of Miller and her visit to that casualty clearing station. Myers was the medical liaison staffer for the regimental commander and had been

assigned to show Miller around and keep her "out of mortar fire," which was "the biggest danger to medical facilities."[10] She had arrived at the station—well "within earshot" of the Battle of the Falaise Gap—in a jeep with a one-star general. Many journalists and photographers came through the regiment's stations but, as Myers recalled, they were all male and "showed very little interest in our end of it, most of them." In contrast Miller had a "high level of interest and a high level of understanding" of the operation. Whereas most of the male correspondents just "wanted to be a part and be able to explain what it was like to be a GI Joe under fire, in a firefight," Miller was "unusual" and conducted herself with "real class" as she moved respectfully and sensitively among the wounded men.[11]

Miller's wartime articles are some of the most arresting ever to have appeared in *Vogue*. Just as earlier in her career she had ignored the presumed boundaries between artist and model, fine art and commercial fashion photography, she now broke down barriers between fashion and war reportage.[12] Her wartime pieces overflow with rich descriptions of her sensual impressions of the scenes of war around her—sounds, smells, and especially sights. Those scenes, as well as the details of clothing, bodies, and hair, were frequently described in terms of high art. Of one patient whose leg was being bandaged in the surgical tent at the "Evac.," she wrote, "in the chiaroscuro of khaki and white I was reminded of Hieronymus Bosch's painting, 'The Carrying of the Cross.'"[13] Her references and descriptive style speak to her extraordinary eye, honed by her experiences in art and couture over the previous two decades.

Eileen M. Sullivan has argued that there was no room for "individual opinions or personalities" in World War II culture, "no freedom of dissent or approval; the culture was homogenous, shallow and boring."[14] Yet Miller's wartime articles for *Vogue* contradict such generalizations. Her pieces are direct, sometimes shocking, and often witty. Audrey Withers reflected: "When you think that every situation she covered was completely outside her previous experience, it makes the sheer professionalism of her text even more remarkable."[15]

The headline for her next article, published in the October 1944 issue of British *Vogue*, read "St. Malo ... the siege and the assault ... covered by Lee Miller ... only photographer and reporter there, under fire, throughout."[16] Written over three days of non-stop typing, it ran to some eight pages in print and was accompanied by thirteen of her photographs, two of them reproduced as half-pages. Miller writes that she "had thought that watching a battle from a hillside had gone out with the glamorous paintings of Napoleon," but, when she arrived at the town of Saint-Malo in northern France, that was exactly the experience awaiting her. She had "believed the

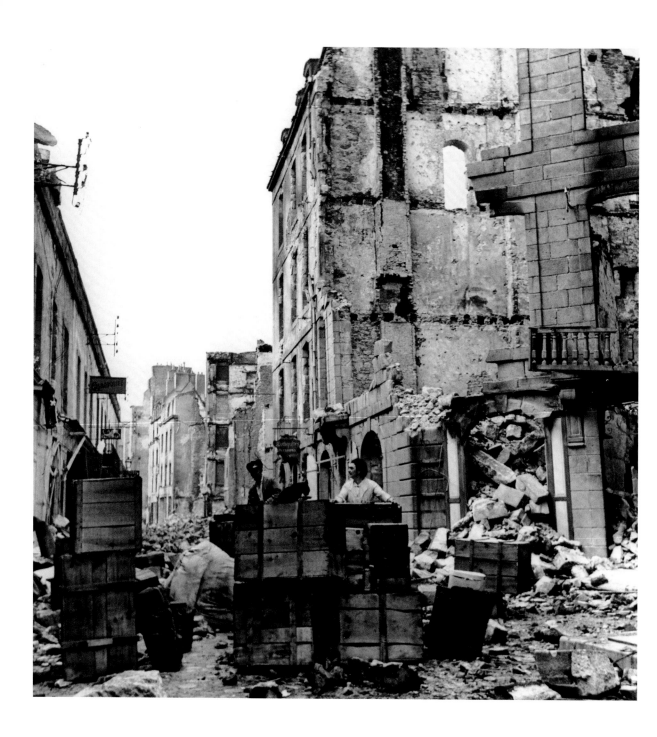

DEVASTATION IN SAINT-MALO

Photograph by Lee Miller, France, August 1944

newspapers when they said that St. Malo had fallen." But in reality the "Germans had merely been isolated from the main land," and the encircling American forces were fighting "bloody, heroic, tricky battles" to subdue them.

Miller was "the only photographer for miles around" and realized that she "now owned a private war." She stayed on in Saint-Malo with only the clothes she was "standing in, a couple of dozen films, and an eiderdown blanket roll." Among vivid descriptions of the bombing and the arrests of female collaborators come these signature Miller lines: "A company was filing out of St. Malo, ready to go into action, grenades hanging on their lapels like Cartier clips, menacing bunches of death."[17] Later in the article she writes of gunfire bringing "more stones down in the street" and how she "sheltered in a kraut dugout, squatting under the ramparts." There she entered a macabre scene that could have featured in one of Luis Buñuel's Surrealist films:

> My heel ground into a dead, detached hand and I cursed the Germans for
> the sordid, ugly destruction they had conjured on this once beautiful town.
> I wondered where my friends that I had known here before the war were;
> how many had been forced into disloyalty and degradation—how many
> had been shot, starved or what. I picked up the hand and hurled it across
> the street, and ran back the way I'd come bruising my feet and crashing
> in the unsteady piles of stone and slipping in blood. Christ it was awful![18]

In juxtaposing the flinging of a disembodied hand across the street with her pre-war friendships Miller's unique voice comes to the fore. Here, she sounds disgusted, tough, yet vulnerable.

It was now late August 1944 and Miller heard a rumor that Paris was on the verge of liberation. Her beloved city had fallen to the Germans four years earlier on June 14, 1940, and an armistice, signed between France and Germany eight days later, had established northern France as German-occupied territory. Hitler had instructed his commanders that Paris must be defended under any circumstances, that it must not fall into the enemy's hands except as "a field of ruins." The City of Light's seventy-odd bridges were to be demolished if necessary. Just before midnight on August 24, 1944, however, a small French force, led by Captain Raymond Dronne, rolled along side roads and back streets, crossed the Seine by the Pont d'Austerlitz, drove along the quays of the Right Bank, and reached the Hôtel de Ville. The bells of nearby Notre Dame Cathedral began to ring triumphantly and then one church after another sounded its refrain. Soon all of Paris's churches were ringing their bells in celebration.

Not many Parisians could sleep that night, but few wanted to. The Germans were withdrawing and, thanks to a fortuitously operating telephone system, everyone was aware that Allied soldiers were in the suburbs. The liberation of Paris from the Nazis was clearly underway. On August 25, 1944, an enormous crowd of jubilant Parisians welcomed the Second French Armored Division, which swept into the western half of Paris, past the Arc de Triomphe and the Champs Elysées, while American forces secured the eastern half. The Germans had mostly fled during the night. Only two thousand remained in the Bois de Boulogne, with seven hundred more in the Jardin du Luxembourg. A few fought and died, taking brave French men and women with them. Most surrendered.[19]

Miller headed to Paris knowing that she might not be the "first woman journalist on the scene" but she would be "the first dame photographer … unless someone parachutes in," as she wrote to Withers.[20] She cabled both the London and New York offices of *Vogue* her impressions of the liberation celebrations:

```
AFTER TREMENDOUS THREE DAY WELCOME AND HAND WAVING,
EVERY ONE EXHAUSTED. PARIS HAD A TERRIBLE HANGOVER.
TOWN LOOKED LIKE A BALLROOM MORNING AFTER. FOUNTAIN
BASINS STREWN WITH CIGARETTE BUTTS, BUT NONETHELESS
BEAUTIFUL TO ME.

TANKS AND BURNED CARS DID NOT LOOK SINISTER ANY MORE
WITH CHILDREN AND PRETTY GIRLS CLIMBING IN AND OUT.
EVERY GUN, TANK, JEEP HAS A BEVY OF GIRLS. YANKS WITH
DICTIONARIES SAT IN TURRETS ALTERNATING THEIR STRUGGLE
TO MAKE DATES WITH DUCKING BEHIND TREADS AND RETURNING
SNIPERS' SHOTS. COMBINATION OF LEVITY AND BLOODSHED.
IN ONE STREET, FLAG WAVING AND KISSING; NEXT STREET,
DUEL SNIPER VERSUS PARTISAN.

PARIS PHONES FUNCTIONED THROUGHOUT, SAME PHONES
AMERICAN ARMY INSTALLED DURING THE LAST WAR. MANY
STORIES PEOPLE RINGING ONE ANOTHER UP SAYING "THERE'S
A GUY HANGING OUT OF OPPOSITE WINDOW WITH HAND
GRENADE, IF YOU ATTRACT HIS ATTENTION I WILL DEAL
WITH HIM FROM BACK."
```

LIBERATION CELEBRATIONS AT THE HOUSE OF PAQUIN

Photograph by Lee Miller, Paris, August 1944

CIVILIANS TOOK WHOLE TIME AS A TERRIFIC PARTY WITH
LIFE OR DEATH STAKES LIKE A BACCARET GAME. POPULATION,
ALREADY EXHAUSTED MALNUTRITION, SHOWED TRUE FRENCH
HOSPITALITY BY SPENDING LAST CALORY TO CELEBRATE.
LATER DISAPPEARED TO LISTEN TO RADIO OPENLY IN MAIN
HALL OF HOUSE.[21]

When Miller arrived in the midst of these celebrations, it was not just freedom that smelled sweet in Paris. She was struck by the surprisingly ubiquitous smell of perfume in the air of the newly liberated city.[22] As she wrote in an article for *Vogue*, "all the soldiers noticed the scent and [when] asked what they thought of Paris, became starry-eyed. They would say: 'It's the most beautiful place in the world and the people smell so wonderful.'"[23] Miller explained to her readers that this was a truly curious change. In the past Paris had smelled of a "combination of patchouli, urinals and burnt castor oil which wreathed the passing motorcycles."[24]

This was but one of many surprises in store for Miller and the American GIs. French women had not been pampered during the occupation. They had learned to carry their own packages, cycle everywhere "rain or shine, skirts billowing against the wind," and "do their own scrounging" for whatever necessities of daily life they could find. Yet still the young women were truly "dazzling" in their "full floating skirts" with "tiny waist-lines" and flowing hair.[25] (Although it is forever associated with the *après guerre*, Christian Dior's "New Look" of 1947 had its roots in this Parisian mode of sartorial resistance.[26]) The GIs "gasped en masse" at the dress of the *Parisienne*, but it took them only a little while to realize that these changes were not because "tales of wild women in Paris had come true." Rather, "good women and bad—the fast and the loose and the prudes—the innocent and the wicked, they all had deliberately organized this style of dressing and living as a taunt to the Huns—whose women were clumsy and serious—dressed in gray uniforms (the German army women were known as the *Souris Gris*)."[27]

American and British women had been told throughout the war that it was their duty to continue their beauty regimes, no matter how demanding their work. As we have learned, this "beauty as duty" rhetoric extolled women to look feminine and well groomed in order to keep up morale. In occupied Paris similar injunctions went even further. The columnist Lucien François, editor of the monthly magazine *Votre Beauté*, proclaimed unabashedly to the women of Paris: "The day when you cease to be coquettes [and like pretty clothes], half Paris will be unemployed,

because foreigners will no longer want what has not been created to answer the needs of the women of our country.... The universal function of the Parisian woman is to remain a coquette."[28]

Miller was impressed by the "youthfulness of all of the women because most make-up could not be found for love or money and there had been continual rumours that the Huns were going to forbid all make-up, even if a French woman could lay her hands on the stuff.... Gone is sophisticated maquillage: rimmel and foundation creams are non-existent; nail varnish is such bad quality as to be scorned, though for victory days it appeared."[29] Adding to their informal, youthful look, "Parisians wear their beautiful lingerie blouses, rinsed and unironed, with style."[30] Miller admitted that the lovely women's "silhouette was very queer and fascinating" to her "after utility and austerity England," and she recognized that the contrary logic of occupied France needed to be explained to English readers, who had lived with strict rationing for many years. She noted that for French women, "saving material and labour meant help to the Germans" and so it was "their duty to waste instead of save.... If three yards of material were specified for a dress—they found fifteen for a skirt alone."[31] Miller further elaborated in a letter to Withers, noting that in Britain "one hoped that a percentage of what one saved would reach the war," but in France, "whatever they saved, it wouldn't help their own people."[32]

The German occupation had ushered in an era of organized scarcity in which wool clothes, leather bags, and shoes had all but disappeared. In a nation defeated and occupied, the French had to adapt and create fashions under vastly changed circumstances. French women continued their love affair with fashion in new ways. Many discovered untapped talents and used unrationed materials such as felt, straw, and ribbon to decorate old garments and shoes. Others devised hats made from blotting paper or even used newspaper.

Carmel Benito movingly told the story of the amazing hats of occupied Paris in an article published in both the British and American editions of *Vogue*, in October and November respectively. The nineteen-year-old daughter of "Edouard Benito, well-known fashion artist," Benito had been an apprentice "chez Reboux" during the war and was "now working with the Paris editor of *Vogue*."[33] Her article was illustrated with Miller's photographs of "Milliners at Work making first hats since Liberation Day," and it began with a question that its author must have been asked over and over again: "What has life in Paris been like during the last four years?" Her answer might seem surprising today if one fails to recognize that Reboux, her employer, was a famous Paris milliner. Benito writes: "Those famous hats tell the story as well as

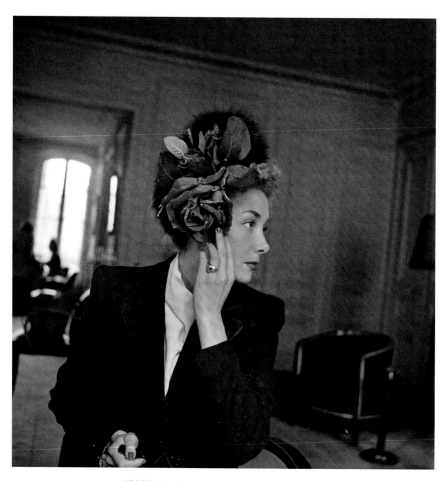

"PARIS MILLINERS AT WORK," BRITISH *VOGUE*

Photograph by Lee Miller, Paris, October 1944

anything. They show how we had to make do, tell how we sharpened our wits. Felt gave out, so we made hats of chiffon. No more chiffon—all right, take straw. No more straw—very well, braided paper." She explains that only one yard of fabric was allocated for a beret, turban, or sailor hat. The French solution? "We mixed beret, turban, and sailor together and used three yards for one hat.... Hats rose to bewildering heights. When hungry, we made pastry-coloured hats covered with birds, fruits, berries. You see, hats have been a sort of contest between French imagination and German regulation."[34]

Just as we begin to giggle at the idea of these huge hats, evoking as they do the extravagance of Marie Antoinette's preposterous poufs, Benito returns to the realities of occupied Paris.[35] These overly elaborate hats "offset figures that were getting thinner, thinner at the same time that spirits were falling lower." But French women were determined to "show the Germans that spirits wouldn't fall, no matter what

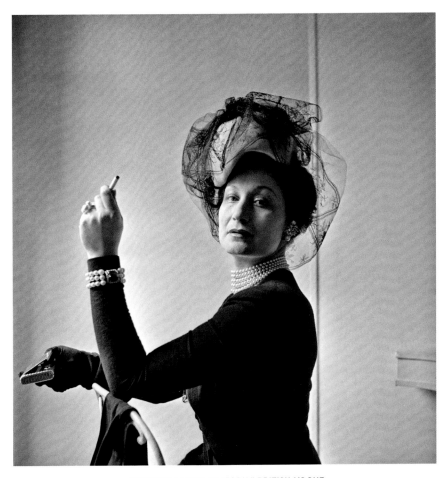

"PARIS MILLINERS AT WORK," BRITISH *VOGUE*

Photograph by Lee Miller, Paris, October 1944

they devised to make life more trying." They were "prepared to do without food, fuel, light, soap, servants." But they were not prepared "to look shabby, outworn."

> After all, we were *Parisiennes* of Paris.... As we hadn't the slightest idea
> how long the trouble would last, we couldn't just leave the capital, give up
> the intellectual, artistic life, and live more or less pleasantly in the country.
> We didn't want to abandon Paris. We wanted to make it ready for the days
> that we knew would return."[36]

Benito goes on to describe many of the same things that Miller would report on in other issues of *Vogue*—the lack of electricity at the hairdressers, the stifling, overcrowded Metro, queuing overnight to buy a pound of onions, the horrible wooden-soled shoes, the girls in dirndl dresses fashioned from curtains, astride bicycles (page 134). Benito writes of her own attempts to cook on the balcony of her apartment with a ghastly,

POWERING HAIRDRYERS AT SALON GERVAIS

Photograph by Lee Miller, Paris, October 1944

smoking, "plate-sized" charcoal stove—and then the overwhelming joys of the arrival of the French and American soldiers.[37] She concludes her piece: "To sum up, women have shown they didn't need a gun to fight. They stood up for four years against the trials of war and won. Perhaps because they kept smiling and wore those hats."[38]

Miller also covered the conditions faced by Parisian women, writing "everyone has neuralgia from going about with wet hair, because there is no means of drying it."[39] For "La Ville Lumière is no more ... not because it is black-out but because there is literally no light: there has not been enough coal to make electricity for weeks." During the occupation the metro had closed down stop by stop, then the buses had stopped running. "Current is supplied for twenty minutes in twenty-four

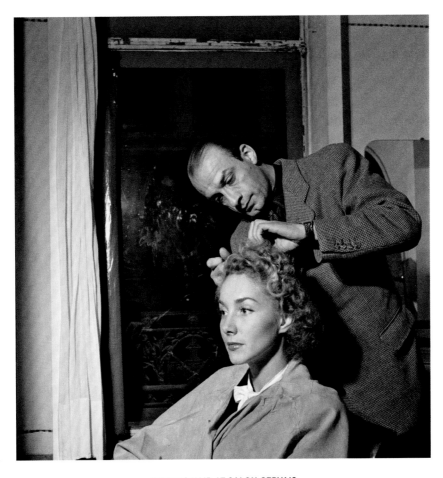

STYLING HAIR AT SALON GERVAIS
Photograph by Lee Miller, Paris, October 1944

hours. Candles are a fabulous treasure."[40] With this state of affairs, "high turbans are a warm cover for wet heads, straight from the coiffeur who has no dryer." She continued:

> There is one hairdresser in all Paris who can dry hair: 'Gervais,' and
> he was already the star turn of coiffeur designing since the war [above].
> He has rigged his dryers to stove pipes which pass through a furnace
> heated by rubble [opposite]. The air is sent by fans turned by relay teams
> of boys riding a stationary tandem bicycle in the basement. They cover
> 320 kilometres a day and dry half as many heads…[41]

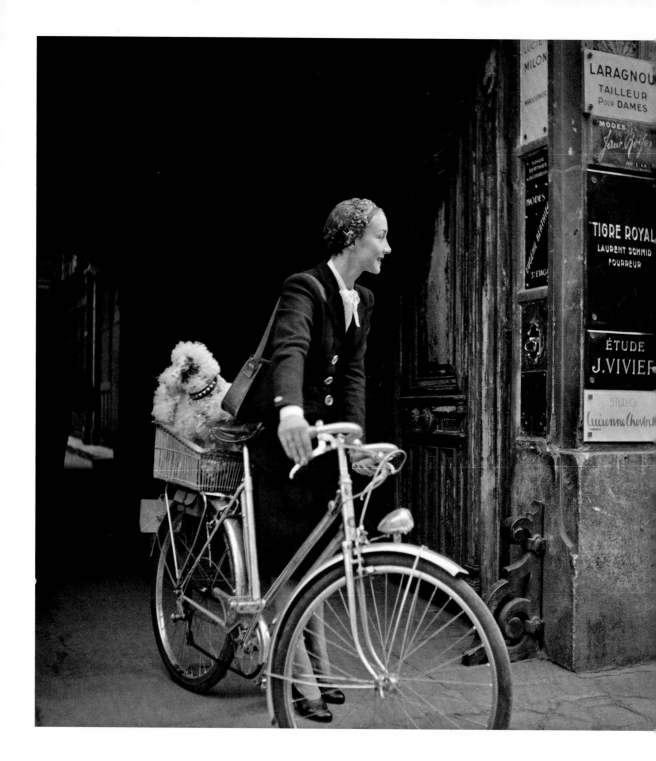

Opposite and below **"THE WAY THINGS ARE IN PARIS,"** BRITISH *VOGUE*

Photographs by Lee Miller, Paris, November 1944

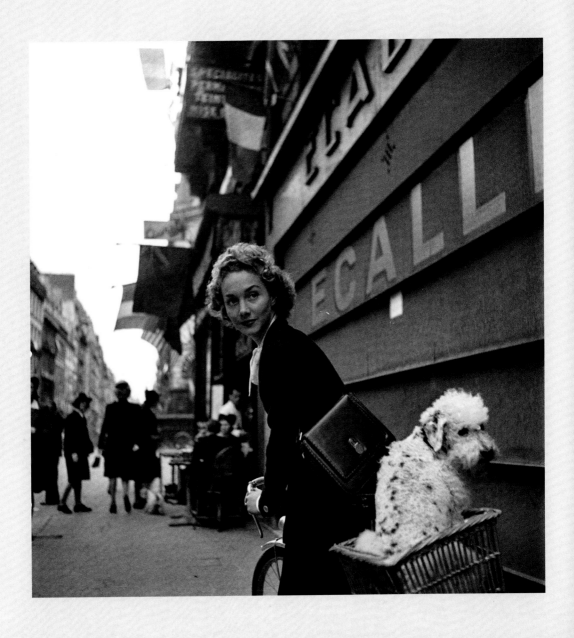

UNPUBLISHED PHOTOGRAPH FOR "PARIS SCRAPBOOK," AMERICAN *VOGUE*

Photograph by Lee Miller, Paris, November 15, 1944

Not only had the smell and look of Paris changed but so too had the sound of Paris, as Diana Vreeland noticed when she visited shortly after the war:

> Everyone was in wooden shoes. *Clack clack clack*. You could tell the time
> of day from your hotel room by the sound of wooden soles on the pavement.
> If there was a great storm of them, it meant that it was lunch hour and
> people were leaving their offices for the restaurants. Then there'd be another
> great clatter when they returned to the office.[42]

Miller described these awkward shoes in her liberation coverage for *Vogue*. The Parisians were "weighted to the ground with clumsy, fancy, thick-soled wedge shoes," she wrote. The result was that "the entire gait of the French woman has changed with her footwear. Instead of the bouncing buttocks and mincing steps of 'Prewar' there is a hot-foot long stride, picking up the whole foot at once." Although Miller made it sound appealing for the pages of *Vogue*, in a service letter to her editor she pointed out that "everyone's feet hurt due to the ill fittingness of the sabots," the only shoes available after the disappearance of shoe leather.[43]

Other less amusing reminders of the realities of the Nazi occupation come from notes that Miller appended to the pictures and captions sent to Withers with her written coverage. These include all sorts of tidbits on the young women featured in her photographs. For example, she wrote to Withers in her characteristically quirky spelling and punctuation:

> Lilian Benoist d'azy, the pretty seventeen year old in the same set of pix is
> a red cross first aid worker ... Countess Franqueville's cousin is the former
> prisoner of war ... semi-greek ... her father was a port engineering designer
> ... made Brazzaville and was kicked out firmly by the germans ... Mme
> Tabourdeau, (the lady on the balcony) [opposite] is a bride ... and spent
> the war learning book binding ... seriously.[44]

In the midst of these descriptions, Miller instructs her editor:

> Please pay especial attention!... don't use the picture of the blonde girl in
> front of Metro station with soldiers and also appears in background of pony
> and cart as it appears she behaved abominably during the occupation.... too
> bad because she was smart and pretty.[45]

That "picture of the blonde girl," the alleged collaborator, appears in these pages for the first time (page 154).[46]

UNPUBLISHED PHOTOGRAPH OF AN ALLEGED COLLABORATOR WITH AN AMERICAN GI

Photograph by Lee Miller, Paris, September 1944

Miller also wrote to Withers of her meeting with Lucien Lelong and how he had welcomed her "with charm and enthusiasm" to his office and his atelier, "where he fiddles with material and ideas."[47] She was very impressed by Lelong. At the time of the German invasion, he had been a couturier at the height of his career and President of the Chambre Syndicale de la Haute Couture, a role he took very seriously. With the outbreak of war, the Parisian couture industry had immediately transformed when the houses of Chanel and Vionnet preemptively closed, and the couturiers Mainbocher and Edward Molyneux returned to America and England respectively. Lelong resisted such defeatism. He told an interviewer for *Votre Beauté* that haute couture had a job to perform in the face of war. "Our role," he said, "is to give France an appearance of serenity: the problems must not hamper the creators. It is their duty to hold aloof from them. The more elegant French women appear, the more our country will show that it is not afraid to face the future."[48]

Less than a year later, it fell to Lelong to negotiate directly with the occupying German regime, which wanted to transfer all aspects of the French fashion industry to Berlin or Vienna. Five Nazi officers arrived at the Chambre Syndicale's headquarters on July 20, 1940 and demanded to inspect the premises. Five days later they broke into the building and left with its entire archive. The Nazi plan was to transfer the staff of all the Parisian ateliers and couture houses to Germany or Austria, where they would train up a new generation of German dressmakers and establish the new home of haute couture. Lelong responded that this plan was impossible. French couture, he explained, was the result of decades of educated craftsmanship. Tiny ateliers in France employed thousands of skilled artisans, each one specializing in one small aspect essential to haute couture, such as embroidery or silk flowers. Lelong convinced the German regime that French fashion was dependent on its home environment.[49] The Nazis returned the Chambre Syndicale's archive and agreed to allocate a ration of fabric to couture in order to maintain production and to only draft five percent of its workforce.[50]

Miller told *Vogue* readers how Lelong had "managed, with Gallic subtlety, to tight-rope over the heads of the Germans for four years."[51] She wrote to Withers that her favorite story was of Lelong organizing a 1942 trip for the entire Paris Opera to Lyons in the Vichy Zone for what he described in advance as a "charity show." In actual fact, he had procured the *laissez-passers*—official visas enabling transit between the occupied north and unoccupied south—for the mannequins (models) and relevant staff of fourteen couture houses to show their collections to over five hundred buyers from neutral countries. Miller said he wanted to "test the validity of the French claims

to designing fame."[52] Despite Lelong's efforts, in due course the Germans instituted strict rationing. In January 1944 they shut down the couture houses of Madame Grès and Balenciaga for exceeding their fabric quotas. Merely a month before the liberation, the Germans were once again threatening to end haute couture in Paris.[53]

Lelong had the great pleasure of seeing his efforts to preserve the French fashion industry bear fruit. On October 1, 1944, the couture houses officially reopened. Miller was there to provide coverage for all three editions of *Vogue*. In the November issue of British *Vogue*, she emphasized the importance to the French people of the first postwar couture collections:

> They regard it in the nature of an art exhibition ... by loving hands and
> grateful hearts. The whole thing has been done in good faith, trustingly—
> just as they gave the last resources of their larders to the liberators. Each
> dressmaker wanted to express some sort of *joie*. They know there is no
> question of "buyers" from abroad (it is no longer patriotic to flaunt new
> clothes, as [it was] in the face of the Germans). But the workroom people
> need work and wages; and it wouldn't make sense now, to change over
> production of factories and labour to war produce. The only thing France
> will have will be the *main d'oeuvre* jobs and the exportation of her taste...[54]

She wrote privately to Withers that although "seductive clothing has little to do with the starving bodies behind the scenes" it had "a lot to do with the starving souls."[55]

Unlike the everyday wartime styles of the Parisians, the severe rationing now in place meant that the first couture collections of liberated Paris were dominated by the "simpler lines we predicted," in *Vogue*'s words. The November 1944 issue of British *Vogue* carried a piece by Miller simply entitled "Paris Fashions," which was accompanied by nine of her fashion photographs, some staged meaningfully in front of the Ministry of Justice and the Place de la Concorde (page 168). With her intimate knowledge of fashion from her modeling days, Miller described these "simpler" clothes as "plainer and more practical, but rich in ideas." Bosoms and hips were emphasized in most designs. "Windbreaker jackets, good for cycling, persist, often fur-lined." Fur was popular, while "silk and rayon are rare fabrics." "Looking ahead to a bitter winter, most designers use ersatz angora for their dressier dresses," adding sequins, velvet, or gold and silver embroidery to jazz them up. "As always," there was "much black," along with red, chocolate—"tantalizing choice of a sweet-starved people"—tan, and beige.[56]

Cristóbal Balenciaga had returned to Paris from his native Spain, Miller wrote, and, with "one look at what his partner had been doing, screamed the place down

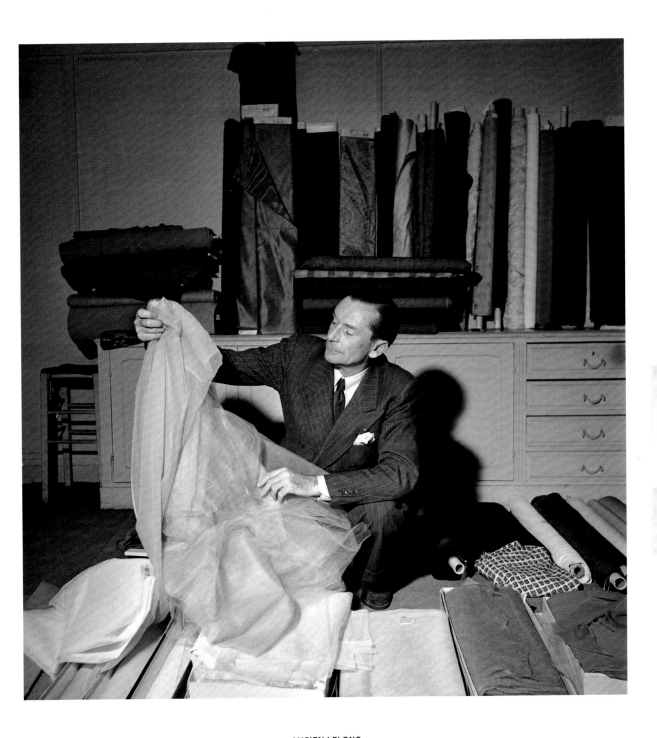

LUCIEN LELONG

Photograph by Lee Miller, Paris, October 1944

and tore out all the basting threads and is busy doing it over again, hence his opening was delayed."[57] Other Paris couturiers generously shared their fabric quota with him, making it possible for him to recreate his collection from scratch.[58] His October show was met with both "hurrahs and boos, but was entertaining and although Doctor Jekyll and Hyde-ish" Miller thought it "very good." "He is plugging the Renaissance female figure with slightly pregnant tummy, rounded hips and curved but not bulgey behind," she reported to Withers.[59]

In her photographs of the collections Miller aimed to capture not only their historic importance but also the very difficult daily conditions of life in newly liberated Paris. She photographed models at the House of Paquin lying on the floor wrapped in muslin, probably to keep their clothes clean, but also to keep warm (above). Two of them read, one of them naps, as they wait to show the latest designs. The shot reminded Miller "of the between party scene in Gone with the Wind," though the legs of the upturned chairs on which the models rest their heads bear a menacing resemblance to shotguns.[60] In another photograph Miller caught on camera uniformed US

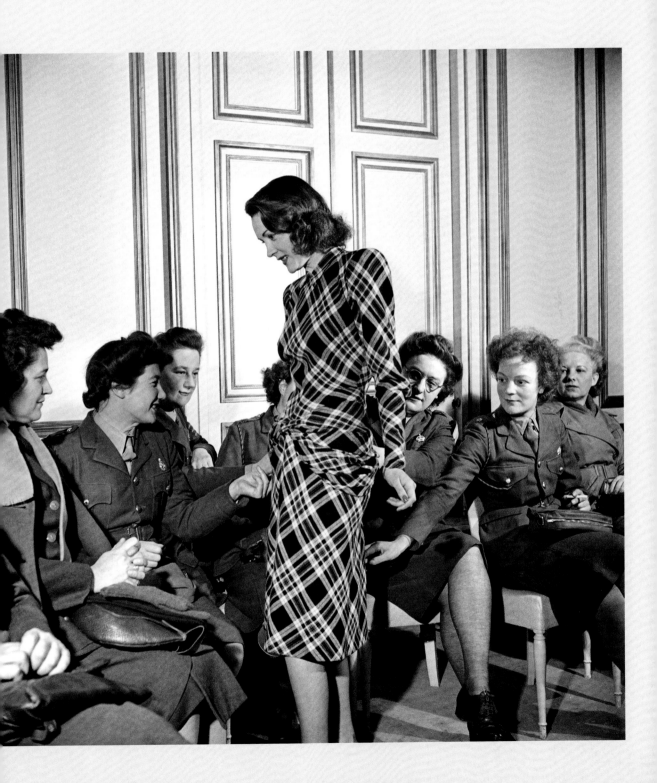

servicewomen touching the fabric of a dress modeled in a couture salon (page 159). In response to these and other photographs, on the final day of the shows Miller received a telegram from Withers, relaying on Edna Woolman Chase's galling reaction to those received so far in New York:

EDNA CRITICAL SNAPSHOT FASHION REPORTAGE AND
ESPECIALLY CHEAP MANNEQUINS URGES MORE ELEGANCE BY
STUDIO PHOTOGRAPHS + WELLBRED WOMEN.... EDNA SAYS
QUOTE CANT BELIEVE PICTURES TYPICAL OF HIGHCLASS
FRENCH FASHION ... CAN'T SOLANGE GET LADIES TO POSE
UNQUOTE. CABLE SOME STATEMENT FOR US TO CABLE HER
STOP[61]

Once again Woolman Chase and American *Vogue* were woefully out of touch with European realities. Miller wrote back to Withers:

I find Edna very unfair—these snapshots have been taken under the most difficult and depressing conditions—in the twenty minutes a model was willing to give of her lunch hour—most of which was being taken up with further fittings for unfinished dresses—or after five o'clock in rooms with no electricity—using only the seeping daylight from the courtyard with the howling mob around.... Edna should be told that maybe there is a war on— that maybe Solange hasn't the heart to concentrate with the knowledge of the horrors her husband and family are going through in the German prison camps.[62]

Miller was less preoccupied with pleasing New York than with helping Michel de Brunhoff, the editor of French *Vogue*, re-launch the magazine, which had been suspended during the occupation. With incredible courage and ingenuity, de Brunhoff had instead published four fashion albums—"collecting the material in Paris, making blocks in the suburbs"—that were then printed and sold in Monte Carlo for international distribution. Outwitting and enraging the Germans, these albums soon made their way back into Paris where they bolstered spirits.[63] (De Brunhoff admirably also put his office to use as a mail-drop for the Resistance.[64])

Along with fashion photography, Miller provided the three editions of *Vogue* with standard fare on the celebrities in Paris, including Fred Astaire, Marlene Dietrich, Maurice Chevalier, and the celebrated author Colette.[65] And she visited with old friends Dora Maar, Jean Cocteau, and Picasso, who, when he met her, hugged her

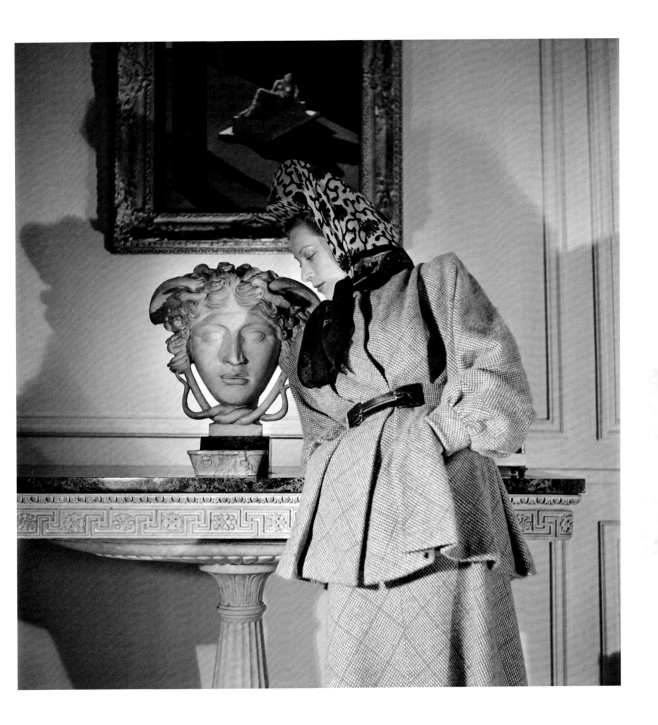

THE LATEST PARIS FASHIONS

Photograph by Lee Miller, Paris, October 1944

and proclaimed, "This is the first allied soldier I have seen, and it's you!"[66] He was less thrilled to discover that while he was out of the room, she had eaten the tomatoes off the small plant he had cultivated throughout the occupation, and which had been the inspiration for a dozen paintings.[67] Although her impulsive act made him go red in the face, he quickly forgave his old friend. Miller also found and photographed Paul and Nusch Éluard, who had fared less well and were painfully thin. Her photographs of these reunions appeared in the October 1944 issue of British *Vogue* with the title, "Within: The Cultural Life of Paris Flourishes Bravely." It included the shots of Picasso and her—and the infamous tomato plant—the Éluards, de Brunhoff with former *Vogue* artist Jean Pages, and Boris Kochno and Christian "Bébé" Bérard on their shared studio's balcony (on which they had "loaded rifles" for six Free French soldiers who had used the balcony as a fire base).

In late 1944 Miller finally filed an article from France that Withers had been asking her to write for months. It was entitled "Pattern of Liberation" and far from what her editor had imagined. Instead of a piece on the fashion mood of liberated Paris, Miller wrote a dreamlike, intimate report on the lives of people returning to their homes for the first time in years:

> The pattern of liberation is not decorative. There are the gay squiggles of
> wine and song. There is the beautiful overall colour of freedom, but there is
> ruin and destruction. There are problems and mistakes, disappointed hopes
> and broken promises. There is wishful thinking and inefficiency. There is
> grogginess as after a siesta, a "sleeping beauty" lethargy. The prince had
> broken into the cobwebbed castle and planted his awakening kiss. Everyone
> gets up, dances a minute, and lives happily ever after.

In the sort of surprise turn that became a trademark of her wartime writing for *Vogue*, Miller continued:

> The story does, but shouldn't end there. Who polished the verdigrised
> saucepans? Who replaced the rusted well chain? Were the shelves dusted?
> The cupboards clean? Who swept up the "petits moutons" which must have
> gathered under the bed? There must have been a hell of a mess. Did they
> start their quarrels where they left off? Did they ask what the neighbours had
> been saying about them all this time? Had the milkman left rows of bottles
> on the windowsill? Were there fresh lettuce and eggs in the larder? Maybe
> the prince solved these problems and brought all these things, too, or was
> liberation enough?[68]

The fairytale allusions and the hallucinatory quality of this piece are striking, as are Miller's accompanying photographs of refugees. In October Withers had given Miller the chance to do what she wanted "more than anything … to follow the war to the finish."[69] She sent her to Luxembourg. Miller, who knew little about the place, soon discovered the horrors of the Nazi occupation in that country, so small it had no army, where intellectuals, teachers, and lawyers were shot as traitors and all of the Jews disappeared overnight.[70] In September the Allies, hoping to bring the war to an end, had attempted to cross the Rhine in an assault on the Siegfried Line. Their first attempt had failed, and for a month there had been fighting in the Vosges Mountains and in the forests south of Aachen in Alsace-Lorraine.

When Miller arrived in the Duchy of Luxembourg, she was quickly reunited with officers from the 29th and 83rd divisions, the units that she had accompanied into Saint-Malo. Upon seeing her, one sergeant said, "Lady, every time you turn up something's bound to happen."[71] The general asked her where she had been and what she had been doing since they last saw her. "I told him about the Paris collections—the mad-house of openings—the gorgeousness of the ersatz clothes. He looked me up and down, muddy boots, soaked hooded cloak, and said, 'It may or may not be "better," but it certainly is different. You'd best stay around with us.'"[72] Miller told her *Vogue* readers:

> The Siegfried Line was just landscape to the unaided eye. Through the
> glasses I could see luscious flat lawns like putting greens. They were the fire
> areas between the black mushrooms which were gun emplacements—a tank
> trap accompanied by a gun was at a crossroads and on the horizon was a
> village which they said was housing two divisions of retreated Huns.[73]

Miller went on to cover the Alsace Campaign, the liberation of Brussels, and the "last leap" across the Rhine, which took the Allies into Germany. She found covering the war in Europe exhausting but invigorating. An article for the April 1945 issue of American *Vogue* reflects her camaraderie with the American soldiers she was following and the sense of humor they shared. In "G.I. Lingo," she wrote, "we 'liberate' a bottle of brandy when we beat down a mercenary publican, we 'liberate' a girl when we detach her from her chaperone."[74]

On May 8, 1945, Nazi Germany surrendered. The war in Europe was over, and Miller returned to Paris and further fashion assignments. She photographed the preparations for the Schiaparelli show, including the bicycle garage and the delivery of all the little gold chairs for the audience (pages 164 and 165). Miller had met Elsa

Schiaparelli during the early 1930s, when she first photographed the designer's chic, outrageous creations.[75] "Schiap," as she was called, was the couturier most involved with the Surrealists and had commissioned Cocteau, Bérard, and Dalí to design fabric and embroideries for her garments. Schiaparelli considered dress design an art. In 1936 she had created a suit based on two of Dalí's drawings, *City of Drawers* and *Venus de Milo with Drawers*. The result was her "Desk Suit," featuring vertical true and false pockets embroidered to resemble desk drawers with buttons for knobs.[76] When the Nazis invaded Paris, Schiaparelli had left behind her still-operating couture house for America, where her daughter had been born and now lived. In July 1945 she returned to Paris and had a similar response to Balenciaga when confronted with the fashions created by staff in her absence:

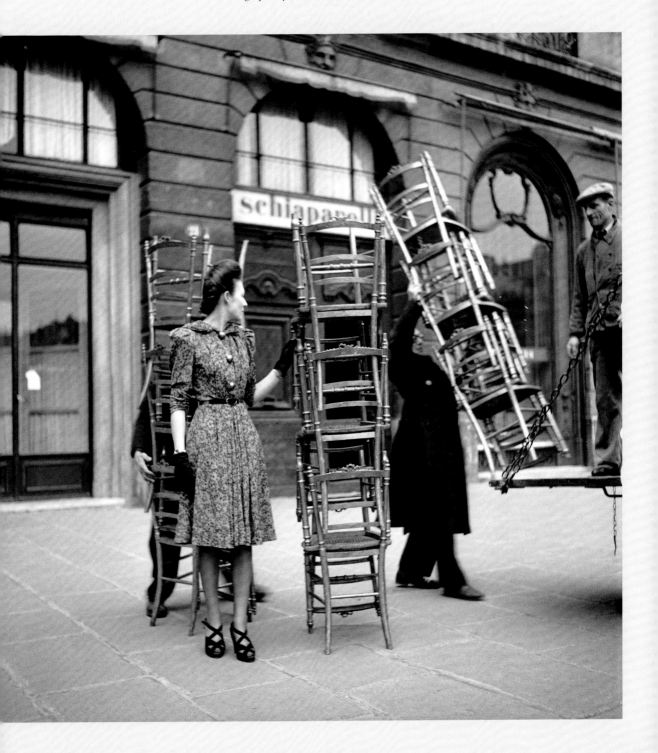

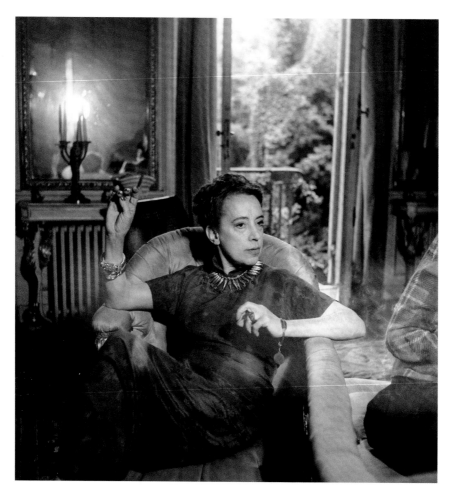

ELSA SCHIAPARELLI

Photograph by Lee Miller, Paris, 1945

I urgently wanted to sweep away the ugliness of the clothes and the incredible
horror of the hats.... The hats may possibly have evolved from the turbans
I so often wore, but they had developed into monstrous cobras that might
have coiled up to sleep after a dreamy enormous meal. They bulged in
huge waves, leaving the face of the unhappy woman underneath looking
like an afterthought.[77]

Schiaparelli felt daunted by the task of starting again but was reassured when the final
newspapers of 1944 concluded the year with her triumphant return to Paris, alongside

the invasion of Germany, labor unrest in Detroit, and the news that Frank Sinatra would be kept to 4–F Draft.

The most interesting wartime issue of British *Vogue* is the "Victory number" of June 1945. Perusing it today is a slightly surreal experience, for want of a better word. Sandwiched between articles with titles such as "Colour in our Lives"—a piece on artists' views "on the no doubt pressing question of colour in the home"—we find Miller's article, "Germany—The War that is Won." Dotted around the final pages of this piece are advertisements for the "fine cosmetics" of Roger & Gallet and for JB and Gothic "foundation garments," as well as two full-page, color-photograph

MODELING SCHIAPARELLI OUTSIDE THE BOUTIQUE

Photograph by Lee Miller, Paris, October 1944

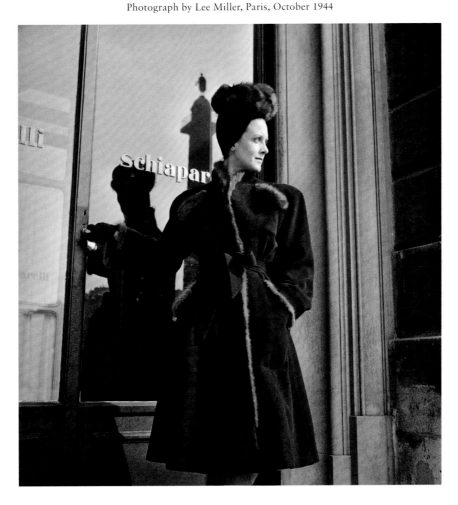

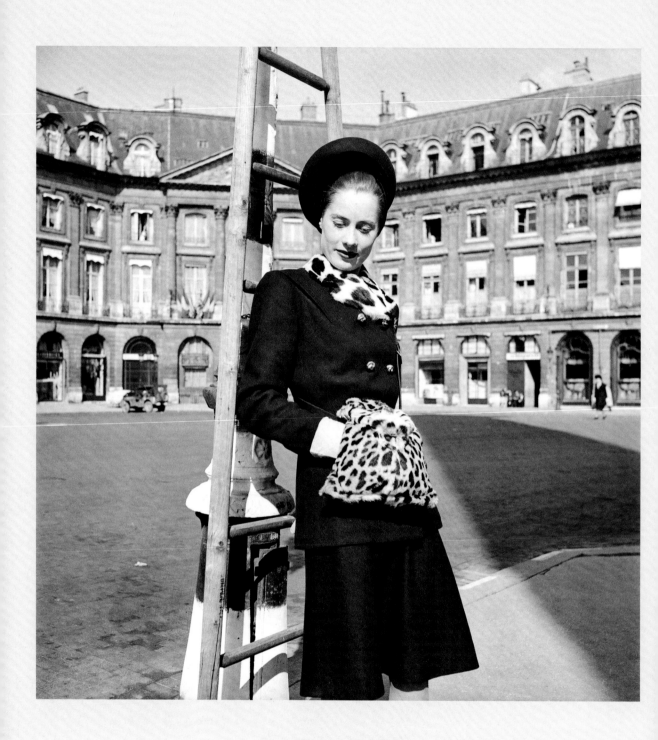

"PARIS FASHIONS," BRITISH *VOGUE*

Photograph by Lee Miller, Paris, November 1944

advertisements: one for "a utility suit by Harella" and another for a slip made of "Celanese."[78] Out of the midst of this typical fashion magazine fare, Lee Miller's article explodes:

> Germany is a beautiful landscape dotted with jewel-like villages, blotched
> with ruined cities, and inhabited by schizophrenics. There are blossoms
> and vistas; every hill is crowned with a castle. The vineyards of the Moselle
> and the newly ploughed plains are fertile. Immaculate birches and tender
> willows flank the streams and the tiny towns are pastel plaster like a modern
> watercolour of a medieval memory. Little girls in white dresses and garlands
> promenade after their first communion. The children have stilts and marbles
> and tops and hoops, and they play with dolls. Mothers sew and sweep and
> bake, and farmers plough and harrow; all just like real people. But they
> aren't; they are the enemy. This is Germany and it is spring.[79]

Within a paragraph she has transported her readers to the horrors of Buchenwald and its concentration camps, which are absent from the "Baedecker tour of Germany," she notes in dark understatement, "because no one in Germany ever heard of a concentration camp, and I guess they didn't want any tourist business either.... Visitors took one-way tickets only, in any case, and if they lived long enough they had plenty of time to learn the places of interest ... by personal and practical experimentation."[80] She recounts the horrors of slave labor in these camps and her incredulity at the "slimy invitations to dine in German underground homes":

> How dare they? Who do they think we'd been braving flesh and eyesight
> against, all these years in England? Who did they think were my friends
> and compatriots but the blitzed citizens of London and the ill-treated
> French prisoners of war? Who did they think were my flesh and blood
> but the American pilots and infantrymen? What kind of idiocy and
> stupidity blinds them to my feelings? What kind of detachment are they
> able to find, from what kind of escape zones in the unventilated alleys of
> their brains are they able to conjure up the idea that they are liberated
> instead of conquered people?[81]

Miller's disdain for repression and her emphasis on the visual—or "eyesight"—both point to important themes in Surrealism. And, indeed, the art director of American *Vogue* at the time, Alexander Liberman, a Russian émigré who was very impressed by Miller, later declared her an "adventurer and a Surrealist—going to the front was a Surrealist gesture."[82]

British *Vogue* included only one of Miller's photographs of the "horrors of a concentration camp, unforgettable, unforgiveable," as the caption read.[83] It was published at a tiny one-sixteenth of a page. The same month's issue of American *Vogue* reproduced a quarter-page photograph of the "burned bones of starved prisoners" with camp victims wearing the now familiar striped trousers in the background, a quarter-page photograph of the "orderly furnaces to burn bodies," and a full-page photograph of "a pile of starved bodies" at Buchenwald. On the page facing this last photograph, Liberman reprinted words from Miller's cable for the title: "Believe it."[84] The different layouts of these photographs, captions, and headlines come down to editorial decisions. In London Withers believed that "the mood" was for "jubilation" and thus "it seemed unsuitable to focus on horrors."[85] In New York, Liberman insisted that Miller's coverage of the concentration camps must appear in American *Vogue*. He even managed to convince Edna Woolman Chase, who gave him full control of the images, design, layout, and headline.

The following month Miller's quirkily titled "Hitleriana" appeared in British *Vogue*.[86] It begins with a vivid account of Hitler's mountain retreat at Berchtesgaden going up in smoke and ends with a detailed description of the Munich apartment of Eva Braun, Hitler's mistress. This is the article that includes the now famous photograph taken by David E. Scherman of Miller in Hitler's bathtub, a classical sculpture perched to her left, a photograph of the Führer to her right. Her filthy combat boots sit on the tiled floor, having rudely tramped dirt all over the once white bath mat. Other photographs depict the "hausmeister" of Sternecker Hofbrau Haus in Munich, where Hitler held regular Nazi meetings in a private drinking room, and an American serviceman using the "Hotline" in Hitler's apartment while reading *Mein Kampf*. Annalisa Zox-Weaver has argued that Miller's articles and photographs for *Vogue* complicate "the protocol of wartime documentation by challenging the boundaries between candid reportage and aesthetic practice."[87] She writes that Scherman's photograph in particular "banalizes Hitler" to some degree.[88] Certainly the layout of the article in British *Vogue* did so. Scherman's incredible photograph was given only a tiny one-twenty-fourth of the page and the article occupies only half of the page; on the remaining half, an announcement from the UK Ministry of Food explains how to bottle summer fruit.

In her text Miller tells how in Braun's apartment the portraits that "Hitler tenderly autographed to Eva and her sister, Gretl, who lived with her, were in plain view." She catalogs the "furniture and decorations," which "were strictly department store like everything in the Nazi regime: impersonal and in good, average, slightly artistic

taste." She describes what remained of Braun's "envied wardrobe and equipment" and the "odds and ends" scattered on her dressing table—"tweezers, Elizabeth Arden lipstick refills … a half bottle of Arden skin tonic, little funnels and spatulas for transferring beauty products"—telling readers, "nothing was grimy, everything looked new." Braun's bathroom was also "supernormal" except for two "crammed" medicine chests, full of enough "drugs and patent preparations … for a ward of hypochondriacs."[89] Miller's descriptions render Nazi taste ordinary, even as they poke fun at Hitler and Braun's personal inadequacies. Touching what Hitler had touched, with the news of his suicide coming over the radio that night, Miller wrote to Withers that "the machine-monster," as she called him, was now more real and "therefore more terrible."[90]

When Miller reported to *Vogue* readers that she "took a nap on [Braun's] bed and tried the telephones," she destabilized preconceptions and brought out the disturbing ordinariness of the domestic habits of a tyrant.[91] She wrote to Withers: "It was comfortable but … macabre, to doze on the pillow of a girl and a man who were now dead, and to be glad they were dead."[92] The idea of sleeping in Braun's bed, where she and Hitler slept and made love, is truly chilling. As when she used his bath, with this action Miller mocked and emasculated the now dead and powerless Hitler through her "brazen engagement with and transgression of his own intimate spaces."[93]

The article ends with a description of "the large brass globe of the world" on "Eva's living room table," designed to hold "glasses and bottles for toasting." Miller imagines Hitler and Braun toasting each other, "Morgen Die Ganze Welt … Tomorrow, the Whole World."[94] This strange intermingling of detailed descriptive writing, of the sort that you would expect to find in a domestic interiors article, with the staggering reminder of Hitler's plan for world domination exemplifies Miller's frequent use of juxtaposition. The effect gestures toward the glaring discrepancy between fashion and decoration features and the realities of Auschwitz, Buchenwald, and Dachau. How could one ever enjoy a toast with friends after imagining Hitler's own toasts? How could life ever return to normal after the Nazi atrocities? How could fashion ever regain relevance after the horrors of war?

From Germany Miller traveled to Denmark after being commissioned by American *Vogue* to report on the end of five years of German occupation. The Danish had impressed the world with their acts of resistance and their commitment to smuggling Jewish friends and neighbors to safety in Sweden. King Chrisian X had even informed the Nazis that if Danish Jews were to wear yellow stars, then he and all the royal family would do the same. Miller photographed the crown princess and her daughters, the

MODELING CARLI GRY OVERALLS IN DENMARK

Photograph by Lee Miller, Copenhagen, spring 1945

liberation celebrations in Tivoli Gardens, and a charming young woman in overalls made by designer Carli Gry from a steamer rug (opposite). She described further how the women of Denmark had banded together in mutual support:

> The National Women's Council and the National Householding
> Organization doubled their energies in binding the women of the country
> together by extending their teaching facilities and establishing preserving,
> mending, and cooking classes. This not only encouraged food and clothes
> economy but legally broke the law forbidding crowds.[95]

By 1946 editorial policy at British *Vogue* was beginning to return to normal, or at least as much as postwar conditions would allow. Of course, all through the war, issues had included regular features on "dresses worth a straw" or how to achieve the "complete elimination of fuzz" from legs.[96] Today the contrast between fashion and beauty coverage and Miller's wartime reportage can come across as schizophrenic. But Miller's journalism often managed to bridge these two spheres. The unique devices that pepper her articles frequently evoke the senses, high culture, and the familiar terrain of upmarket women's magazines—travel writing, interior decoration, and cosmetic advice.

In July 1945, as her article on Hitler began to hit newsstands, British *Vogue* threw a gala luncheon in London in Miller's honor. In a speech Harry Yoxall praised Miller for her ability to cover any manner of material. "Who else can swing from the Siegfried line to the new hipline?," he asked:

> Lee's work ... embodies the quintessence of what we have been trying to
> make of *Vogue* during the last five years: a picture of the world at war, an
> encouragement to our readers to play their part, with no flinching from
> death and destruction: but with a realization that these are not all, that taste
> and beauty represent permanent values.[97]

Years later Audrey Withers likewise shared her admiration for Miller and her wartime work: "I felt that Lee's features gave *Vogue* a validity in wartime it would not otherwise have had ... [her] photographs and reports taking the magazine right into the heart of the conflict."[98]

"But in peace time *Vogue* was primarily a fashion magazine"

DISENCHANTMENT AND DEPARTURE FROM FASHION, 1946–77

orld War II was a source of both shock and strength for Miller. She experienced many of the horrors of the war and came into her own as a war photographer and correspondent, forging a deeply personal vision. Peace brought with it a different kind of shock and depression. The war over, she was expected to return to London and to fashion photography. Looking back, Audrey Withers felt her friend was "reluctant to abandon the adventurous life in which she had found her true vocation and she sensed, rightly, that she would never again have the opportunities it had given her."[2] They discussed the possibility of Miller moving to New York to do the "same kind of thing" for American *Vogue* as she did for British *Vogue*.[3] Withers broached the idea with Edna Woolman Chase, who responded that she would be delighted to pay Miller's expenses for her to "come home" and "make us a visit."[4]

Miller was restless. As she told David E. Scherman, she had "damned itchy feet."[5] But rather than heading to Manhattan, Miller left London to spend the rest of 1945 and early 1946 primarily in Eastern Europe photographing the destruction of war and writing what articles she could for British *Vogue*. She wrote to Roland at the end of September: "This trip is working very slowly. I'm not at all sure it's successful.... I seem to have lost my grip or enthusiasm or something with the end of the war. There no longer seems to be any urgency."[6] And yet her "itchy feet" kept her moving on to "destinations as inhospitable as possible."[7] Salzburg and Vienna depressed her deeply; Austrian support for Hitler had left the country "conquered and starving" and lacking medical supplies.[8] In October she moved on to Budapest, where about fifty miles outside the city she discovered what seemed "a living folklore museum"

Above DELLA OAKE IN "FASHION FOR TRAVEL," *GLAMOUR*

Photograph by Lee Miller, Hampstead, February 1949

Page 174 "IN SICILY," BRITISH *VOGUE*

Photograph by Lee Miller, Sicily, May 1949

of peasant women in beautifully embroidered dresses. They lived "primitively in crowded houses with permanently closed windows, stinking outhouses."[9] Back in the capital in early January, Miller photographed the execution of László Bárdossy, Prime Minister for a period during the German occupation; he had been found guilty of war crimes.[10]

On January 7, 1946, Harry Yoxall cabled Miller to say that he and Woolman Chase were agreed that they could no longer fund her travels, concluding: "RETURN LONDON SOONEST POSSIBLE VIEW PROCEEDING NEW YORK."[11] Withers sent a similar cable two weeks later. After arguments, followed by months of silence from Miller, Penrose was drifting toward a permanent relationship with another woman. Aware of this development, Scherman added his voice to the mix and cabled two words: "GO HOME."[12] Miller would return to London and to Penrose, but first she traveled to Romania to photograph and write a piece that would be published some months later in both the American and British editions of *Vogue*. Dutifully, she reported on the "personalities" of Romanian society, anticipating that would be what Withers thought important. In truth she was far more interested in "authentic" peasant culture, and what she really wanted was a bear massage, something she had heard about for years. Via her contacts she learned of such a talented bear about an hour from Bucharest and found an "ancient taxi" to take her there. "The bear knew her business," she wrote for her article, "she walked up and down my back on all fours as gently as if on eggs." The result was that Miller felt "marvelous ... flexible and energetic. I discovered I could move my neck and shoulders in patterns I'd forgotten." The bear's owner reluctantly took "the equivalent of a dollar and a half" as payment, "all we had left with us at the end of a couple of months peregrinations."[13]

When she finally returned to London in late February 1946, Miller found her homecoming deemed worthy of a short newsreel produced by Pathé News for the cinema. In "Candid Camera with Lee Miller," she arrives in uniform at 21 Downshire Hill, Hampstead, passing what the announcer of the film calls a "strange-looking carving by the modern sculptor Henry Moore" in the front yard.[14] Penrose, also in uniform, welcomes Miller and presents her with a kitten born in her absence. She settles on the sofa under one of their modern paintings and leafs through a copy of the only recently published *Wrens in Camera*. Pages from *Vogue* featuring her war coverage are shown on screen next, and the narrator tells the audience how she reported on the "German horror camps and other dramatic war stories." Miller returns on screen now wearing a patterned dress and high heels, something "gayer" than the uniform

"VOGUE'S ROUNDABOUT" FEATURING LEE MILLER, BRITISH *VOGUE*

Drawing by Vic Volk, August 1946

Vogue televises a basic wardrobe
(continued)

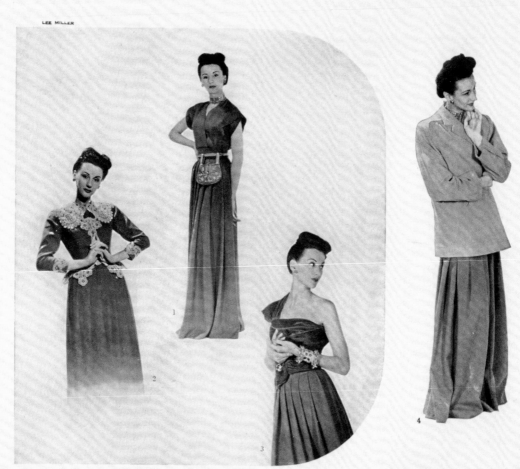

LEE MILLER

–for evening

The theme is still that of basic skirt and changeable top. **1.** The skirt is in fine dark red wool with graceful unpressed pleats. The matching top has cap sleeves and deep stitched shoulder tucks. (Embroidered pocket-bag, Fortnum and Mason). **2.** An alternative matching top in another mood: a romantic fitted jacket with coarse cream-coloured lace encrusted on yoke, on boned basque and edging the three-quarter sleeves. **3.** Full décolleté top for formal evenings: in velvet, cut with the favourite single bared shoulder. **4.** The same versatile yellow, kidskin-lined jacket you saw on the previous pages (Molho). Cameo Corner jewellery. Evening skirt and alternative tops designed by Matilda Etches

WONDERFUL FOR FIRESIDE EVENINGS: PLAID SOFT TWEED SKIRT WITH SIDE-RAISED HEMLINE; BLACK DOLMAN-SLEEVED JERSEY: JAEGER

⟶

COFFIN

of a war correspondent. According to the announcer, "this dress was presented to her by the Danish underground fighters who made it from material intended for the lining of German uniforms."[15] The short film ends with Miller typing captions and cleaning her camera in preparation for the next assignment. British *Vogue* also celebrated Miller's return. In an August 1946 drawing by Vic Volk entitled "Vogue's Roundabout," she appears, the only woman, riding on a carousel of contributors, alongside the likes of illustrator Eric and photographers Cecil Beaton, Clifford Coffin, and Horst P. Horst (page 179).[16]

Miller and Penrose spent the summer of 1946 traveling in the United States, first visiting her parents in Poughkeepsie, then old friends in New York, including Peggy Guggenheim and Alexander Liberman, followed by Max Ernst and Dorothea Tanning, now living in Oak Creek Canyon, an artistic community in Arizona, and finally Miller's brother and sister-in-law, Erik and Mafy Miller, who had been residing in Los Angeles since 1941.[17] By mid-September, Miller knew that after all her years abroad she had become too European to remain permanently in the United States.[18] Less than two weeks later, she and Penrose were back in London, where she quickly resumed her photographic work for British *Vogue*. She spent three weeks in Dublin photographing a piece about James Joyce, then in November shot "a basic simple wardrobe"—"a challenge in these rationed days"—for a new television series entitled "Editor's Choice."[19] Rationing had continued and in some cases increased as Great Britain descended into a postwar currency crisis.[20] Withers had been chosen as the program's first contributor, and British *Vogue* covered the event in a three-page article in its January 1947 issue (opposite). Miller's nine photos illustrated how to combine a basic skirt with a variety of tops in order to create different looks for "country, town, evening."[21]

That same January, on assignment in St Moritz with Peggy Riley (now better known as Rosamond Bernier, the "world's most glamorous lecturer on art and high culture"), Miller discovered that she was pregnant with Penrose's child.[22] She wrote to him with the news:

> Darling, This is a hell of a romantic way to tell you that I'll shortly be
> knitting little clothes for a little man…. I'm very pleased…. There is only
> one thing—MY WORK ROOM IS NOT GOING TO BE A NURSERY.
> How about your studio? Ha Ha.[23]

Opposite **"VOGUE TELEVISES A BASIC WARDROBE," BRITISH *VOGUE***
Photographs by Lee Miller, London, January 1947

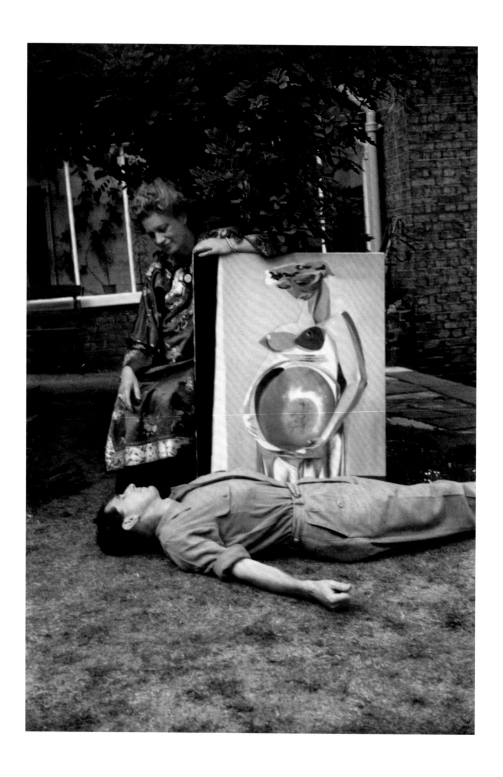

A PREGNANT LEE MILLER WITH ROLAND PENROSE AND HIS PAINTING *FIRST VIEW*

Photographer unknown, Hampstead, summer 1947

Unfortunately Miller had a difficult pregnancy, often necessitating bed rest. She and Penrose complicated matters further by deciding to move across the street to the larger 36 Downshire Hill, and, to top things off, it was the famous winter of 1947, one of the coldest ever on record in London. Aziz Eloui Bey kindly came to London to grant Miller a divorce under Muslim law, pronouncing from the foot of her bed, "I divorce thee, I divorce thee, I divorce thee."[24] Penrose and Miller were married on May 3, 1947, in a civil ceremony at the Hampstead Registry Office, with Sylvia Redding, the *Vogue* studio head, and the painter John Lake as their witnesses. Their only child, Antony Penrose, was born the following September.

A special photographic feature in the Christmas edition of British *Vogue* inadvertently reveals Miller's state of mind in late 1947. For "*Vogue* photographers interpret Christmas," as the title read,

> *Vogue* invented a game—you try it, too. Close your eyes, and think of
> Christmas, conjure up its essence and make a mental picture. We played it
> on our photographers, who went one stage further; they took the pictures,
> wrote the words, borrowed priceless props from famous houses—and asked
> several well-known people to join in the fun. Turn over and see the results for
> yourselves...[25]

In striking contrast to her rival Cecil Beaton, who photographed Nellie Wallace as a "traditional pantomime dame," and John Deakin, who proclaimed a "diamond-encrusted Mae West ... the epitome of the Christmas theatre spirit," Miller photographed her six-week-old son (page 184). Her subject, however, was not the most remarkable aspect of her contribution. Norman Parkinson's photograph also featured a child; a skeptical, perhaps unhappy, little girl of about seven wearing a party dress and carrying a present down some stairs, while watched over by a uniformed nanny. His photograph was entitled "Better a Picnic in July," and the accompanying text discusses the overexcitement and ambivalence that Christmas inspires in many children. What is most illuminating and distinctive about Miller's answer to *Vogue*'s Christmas game is her text. She titled her photograph, "First Baby, First Christmas," and captioned it: "Gay tinsel and a brand new baby is my formula for a Merry Christmas this year. Maybe by the time he finds there isn't a Santa Claus this not so shiny world won't need one as badly as it does now."

If we were to omit Miller's contribution from this feature, we might be forgiven today for forgetting how recently World War II had ended and how very difficult the postwar recovery was in Britain. These facts did not elude Miller, who, her now adult

THE PHOTOGRAPHER
Lee Miller
Her hobby, cooking strange dishes;
her love, her six-weeks-old son;
her pictures express her humanity

THE PICTURE'S TITLE
"First Baby, First Christmas"
Six-weeks-old Anthony Penrose poses for
his mother in full Christmas regalia—new shawl,
paper cap; his first public appearance

"Gay tinsel and a brand new baby is my formula for a Merry Christmas this year. Maybe by the time
he finds there isn't any Santa Claus this not so shiny world won't need one as badly as it does now"

LEE MILLER

59

"VOGUE PHOTOGRAPHERS INTERPRET CHRISTMAS," BRITISH VOGUE

Photograph and text by Lee Miller, London, December 1947

son believes, was struggling with post-traumatic stress disorder. Her postwar physician, Dr. Carl H. Goldman, diagnosed Miller as having "neuroses brought on partly by the war."[26] But when she confided, "I get so depressed," his response, typical for the time, lacked any insight into the complexities of her condition: "There is nothing wrong with you, and we cannot keep the world permanently at war just to provide you with excitement."[27]

Miller carried on with her assignments for *Vogue* as they provided an outlet, however limited, for her creativity. In one article that she wrote her old wit shines through as she offers "tips, as wise as gay, on what to take with you for comfort, amusement and good looks," when checking in at the maternity hospital. The feature was published in the April 1948 issue of British *Vogue* as "The High Bed." She told readers that she had advised a friend to "discard all shyness and dive into this list":

> Tomato Catsup, Worcester-type Sauce, Horseradish Sauce, and real
> Mayonnaise (they'll do wonders to a hospital menu). Smoked trout, pâté de
> foie gras, red or black caviar, a tin of Nescafé, evaporated milk, tins and tins of
> grapefruit juice or tomato juice, lump sugar, lemons, a pepper mill, homemade
> biscuits, a freshly washed green salad matched with a bottle of French
> dressing, a standing order of ice-cream from Selfridges with a jar of chocolate
> sauce, a constant supply of ice-cubes in a large-jawed thermos jug, a girl from
> Elizabeth Arden's to do your face.... And now is your big chance! Say boldly
> to the owner, "How about lending me your Picasso or Sutherland to put on the
> wall for a fortnight?"... your room will become a palace and the nurses will
> treat you with great attention as a patient liable to become violently demented
> if not handled with caution. Finally, unless you want all your visitors to tear
> off to the nearest pub at opening hours, don't forget the bottle of gin.[28]

In November 1948 Miller returned to fashion photography in earnest, photographing Barbara Goalen, then London's top model, in pearls for *Vogue* (page 186). One of only three British models to work internationally during the 1940s and 1950s, and one of the first to be invited to show the Paris collections, Goalen had the haughty, elegant look that suited the couture of the time. Dubbed "La Goalen" by the press, she was practically a household name in Britain during the 1950s.[29]

In the winter of 1949 Penrose decided to fulfill his lifelong dream of becoming a gentleman farmer and bought Farley Farm in Muddles Green, Chiddingly, East Sussex. With its 120 acres and relative ease of transport to London by train and to Europe by cross-Channel ferry, it seemed to Roland the perfect spot.[30] Selling the

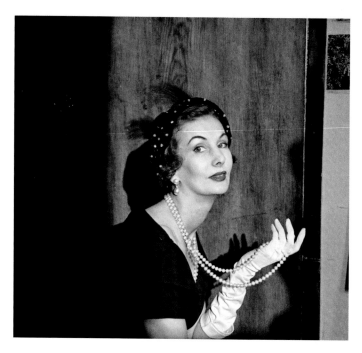

BARBARA GOALEN MODELING THE LATEST HAT STYLE, BRITISH *VOGUE*

Photograph by Lee Miller, London, November 1948

Downshire Hill property but keeping a small rented apartment in London's fashionable South Kensington, the Penrose–Miller family moved to the countryside, with mixed results. Although Miller enjoyed gardening and commenced a "self sufficiency jag" of making butter and slaughtering her own pigs, she discovered that life in the English provinces was culturally and socially closer to that in Poughkeepsie than interwar Paris.[31]

Fashion photography now offered Miller the chance to return to London for work. That winter in a rare commission for *Glamour* magazine, she posed the model Della Oake in a series of photographs for a "Fashion for Travel" article. The photographs were shot in and around Miller's old neighborhood of Hampstead and made use of some of her well-practised techniques, such as shooting through windows, outdoors, and with models in action (page 10 and 177). For one photograph she posed her model elegantly in front of a Rolls-Royce (page 188). For another she captured Oake wearing a gorgeous Hardy Amies suit in the back of a black taxicab, her skirt beautifully fanning out across the seat (page 189). Miller also photographed Oake in London's Waterloo railway station, the steam of a train adding to the atmospheric setting and, surely for many, evoking the romance of David Lean's film *Brief Encounter* (page 11).[32]

As did some of the other great photographers of her time, especially Norman Parkinson, her senior at British *Vogue*, Miller preferred to work on location, or at

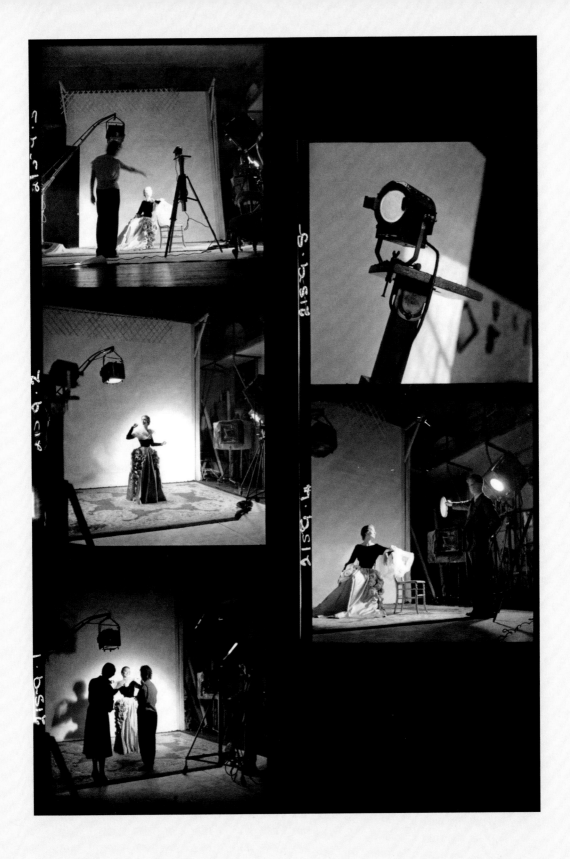

LEE MILLER DIRECTING A SHOOT AT *VOGUE* STUDIOS Photographs by Patrick Matthews, September 1949

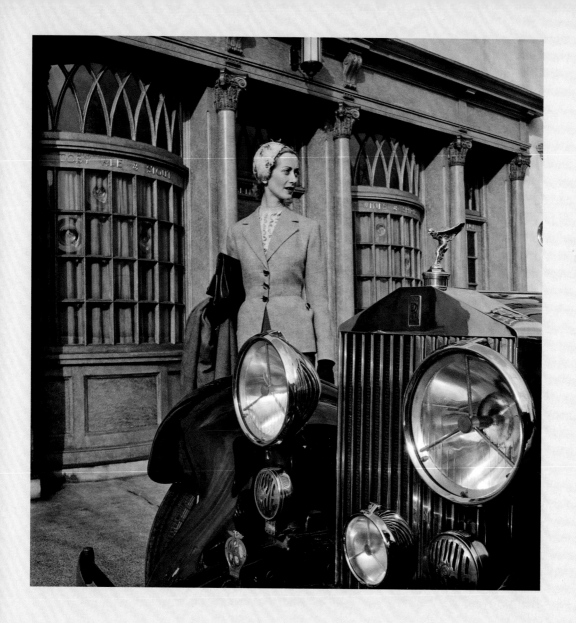

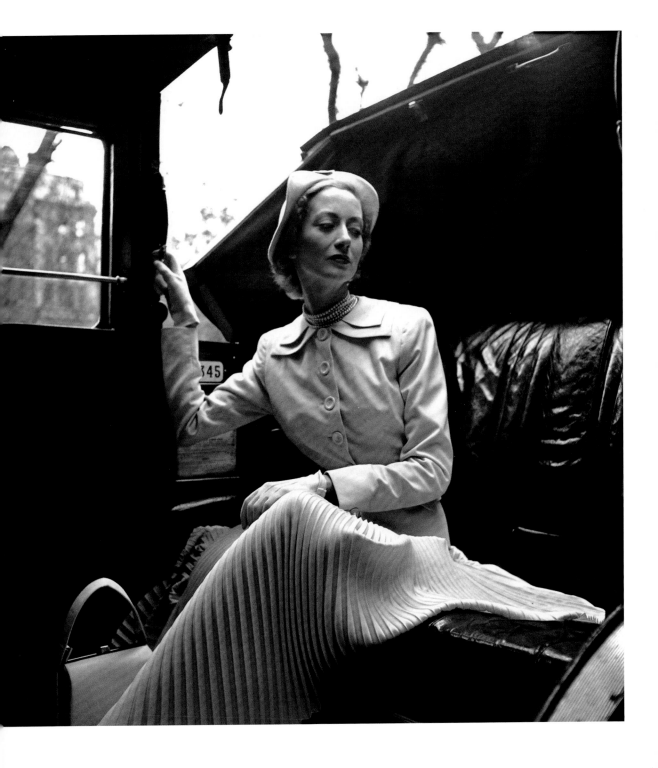

Opposite and below **DELLA OAKE IN "FASHION FOR TRAVEL,"** *GLAMOUR*
Photographs by Lee Miller, Hampstead, February 1949

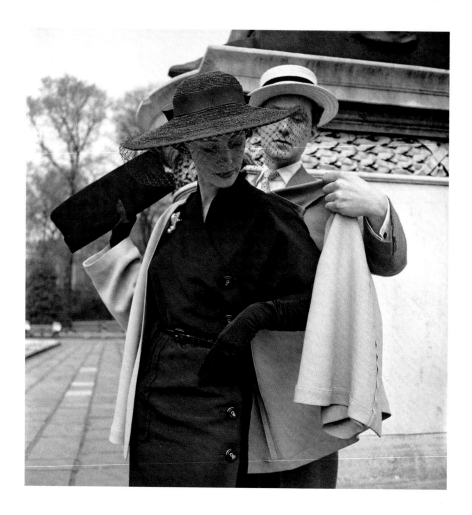

least outdoors, whenever possible, rather than in the studio. She photographed "Shantung Summer" in a London park, capturing a suited gentleman in a boater hat helping an equally elegantly attired woman put on her coat (above). Miller also shot more than one swimsuit feature at a swimming pool (pages 12 and 13), and a rare postwar photograph shows her and an assistant checking the lighting on location for a related sportswear assignment (opposite). Like Parkinson, Miller also took many of her fashion photographs around her home, whether in London or East Sussex.[33] Two previously unpublished fashion photographs from 1950 were shot in Chiddingly. One features a model wearing a hooded wool coat, suited to "country living," in the graveyard of a local church (page 192). For the other Miller shot a model in trousers pushing a wheelbarrow, a lovely hazel hurdle fence behind her (page 193).

Most writers on Lee Miller have subscribed to the dominant narrative that the postwar period was an "anti-climax." Priscilla Morgan, a fellow Poughkeepsian who

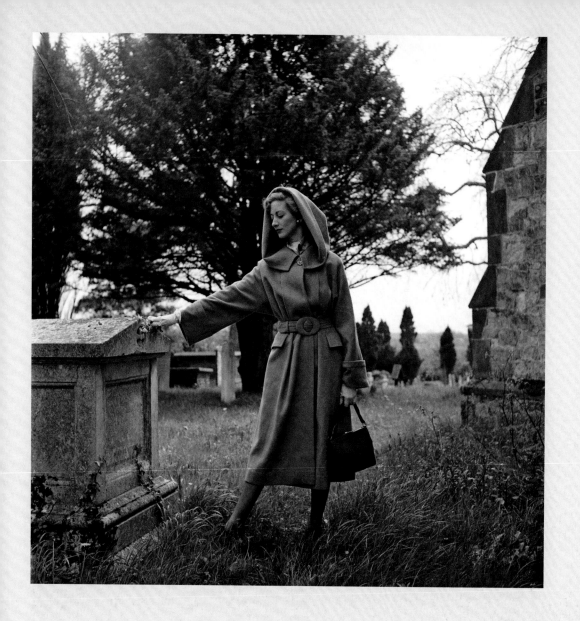

Opposite and below **UNPUBLISHED PHOTOGRAPHS FOR BRITISH *VOGUE***

Photographs by Lee Miller, Chiddingly, East Sussex, May 1950

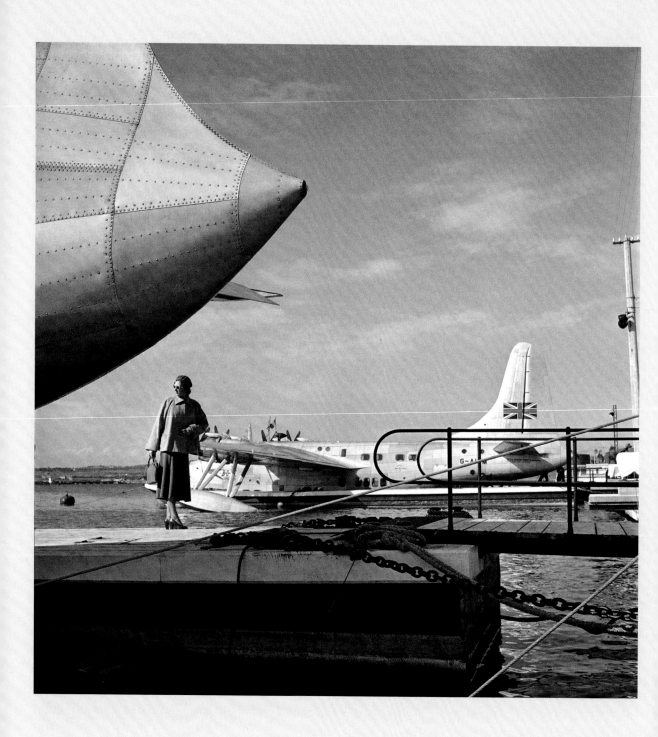

knew Miller after the war, described her as "a hugely creative person who wasn't fulfilling her potential."[34] Yet if we let the treasures of the Lee Miller Archives guide us—"looking when possible through her eyes"—there are surprises.[35] We find remarkable fashion photography taken for British *Vogue* that reflects Miller's eye for the incongruous, the somewhat disturbing, or the humorous, much of it so jarring that it was not chosen for publication. We also find unpublished photographs that serve as important reminders of the devastation of the recent war and Miller's negotiation of this newly challenging terrain.

Photographs for "In Sicily"—simultaneously a fashion and travel feature—provide particularly strong examples of the lingering artistic influence of Surrealism on Miller. The published article ran to ten pages in the May 1949 issue of British *Vogue* and featured a flight from England to Sicily aboard the British Overseas Airways Corporation's double-decker flying boat, as well as photographs of frocks and swimwear set in picturesque Sicilian locales. Miller used some of her favorite fashion photography tropes and shot her models beside sculptures or with columns as backdrops (page 174). She played up the touristy, foreign vacation angle in the photographs and posed her model holding tight to a donkey, in a fruit and vegetable market, and alongside a local basket weaver (page 196).

But as we leaf through the contact sheets from this trip, we find an altogether more ominous tone in the unpublished photographs, many of which evoke a sense of dread. A Sicilian yucca plant looks poised to prick the pale, delicate skin of a swimsuit-clad model applying sunscreen (page 197); the huge flying boat's nipple of a nose threatens to topple onto the model standing beneath it (opposite). Correspondence reveals that Miller boarded the plane afraid that her newfound happiness as wife and mother might be met with tragedy. She wrote to her husband how she felt "all sorts of panic about leaving" him and their infant son behind, and wanted Roland to understand that, although she had not told him, he must know "how much I love you & how terribly happy I've been this last year, so much that I'm scared that it'll have a horrible pay off."[36]

Opposite **UNPUBLISHED PHOTOGRAPH FOR "IN SICILY," BRITISH *VOGUE***
Photograph by Lee Miller, Sicily, April 1949

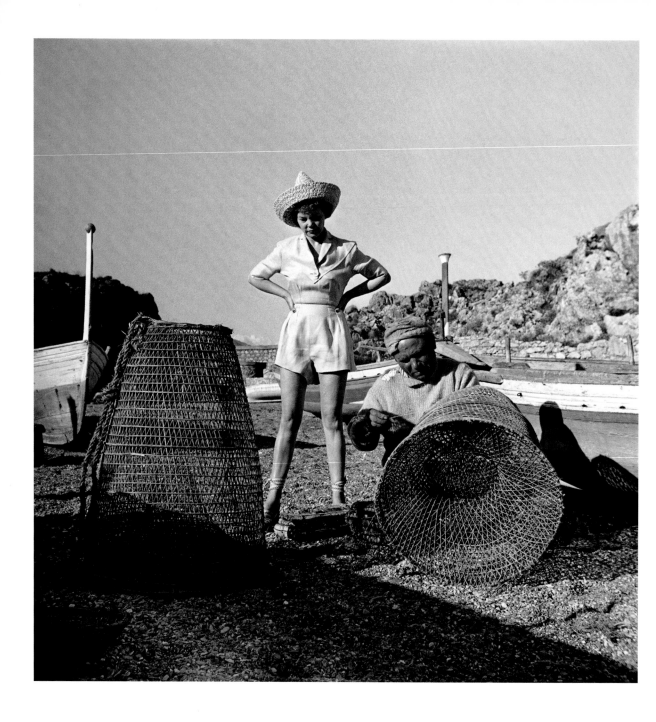

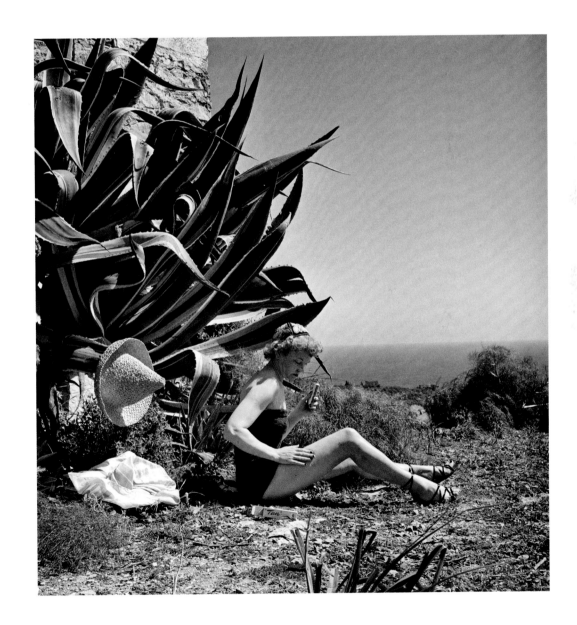

BOUTIQUES — IN LONDON

There's a breath of Paris in the very word "boutique"—but London has translated it into something expressive of the personality and enterprise of her own Couture houses, several of whom have now opened these entrancing little shops in their salons. With them, shopping gains a new excitement and a long-felt need is met, for here are well-designed sweaters, blouses, skirts, odd jackets and an exhilarating selection of what the French call *petits superflus*—interpreted here as scarves, gloves, handbags, costume jewellery ... Some of the boutiques offer another service—a small Collection of simple clothes made-to-measure with one fitting—couture clothes at boutique prices. These two pages show three typical boutiques

Joy Ricardo

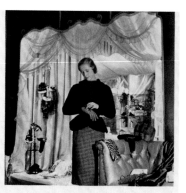

In this softly draped coral pink and beige "boutique corner" are to be found such specialities as velvet or fur muffs, little hostess aprons, evening corsets in gay colours—and gloves, head-dresses, trinkets ... see the gilt filigree bib below, little evening gloves, black mantilla, huge red velvet rose ...' Here, too, is a "Little Salon" one-fitting Collection—from it, the casual suit, right, with navy corduroy belted jacket, pink and navy checked skirt

Molyneux

Cool grey walls, crisp cut chandeliers, an air of quiet restraint: until the contents of a long grey drawer spill colour everywhere—with gloves of every imaginable length, blouses, sweaters like the cashmere one shown above, scarves—see the picture on the right, *boutonnières*, long umbrellas in gay cases, handbags, amusing belts ... And a "one-fitting" Collection of day, cocktail, evening clothes —this day-length evening dress of heavy turquoise satin, full skirted, with swathed, strapless top, is an example

Wallace

Here is a genius for exciting presentation— the quilted peach-bloom hat poised above draped silken scarves (left)—in the foreground of the picture, a tiny jet-studded cocktail "beanie" worn with topaz-coloured necklace and earrings—or the little spread hands (right) festooned with strings of beads; the square of spotted taffeta, the flung violets ... a treasure-house of unusual accessories. And, while there is no boutique system of fittings for dresses, you can walk in and, from a limited number, choose one there and then ...

"BOUTIQUES IN LONDON," BRITISH *VOGUE*

Photographs by Lee Miller, London, January 1950

A different threat lurks in a shoot undertaken some months later for the first issue of 1950.[37] The published piece, "Boutiques in London," includes a quirky photograph featuring a model perhaps talking to a sculpture (above). But there is also a stranger unpublished photograph that suggests an altogether more disturbing incongruity; the drawers of a dresser overflow with gloves and other accessories in sinister disarray, possibly gesturing toward either an out-of-control consumer, a perverted intruder, or the scenes of chaos Miller would have seen all over Europe in 1945 (opposite). Whether the disorder depicted in this photograph was created *by* an imaginary female shopper, who has frequented one too many London boutiques, or inflicted *on* that same woman by a stranger who has mishandled her private store of accessories, British *Vogue* did not find the image suitable for publication.

Above **CONTACT SHEET FOR "LOOKING TO 1951," BRITISH *VOGUE***

Opposite **"LOOKING TO 1951," BRITISH *VOGUE***

Photographs by Lee Miller, South Bank, London, October 1950

For the October 1950 feature "Looking to 1951," Miller photographed new "slim suits" and raincoats on London's South Bank, then under construction as the site of the 1951 Festival of Britain (above).[38] One of the two published photographs from this assignment seems to have been selected for its relatively tidy depiction of London in the background.[39] Yet most of Miller's photographs for this spread were actually staged so as to highlight the controversial rebuilding of the South Bank site (opposite). This bombed and derelict embankment recalls wartime scenes of destruction as much as postwar construction.

Miller ceased writing and photographing for *Vogue* in the early 1950s. Roland Penrose secretly wrote to Audrey Withers, "I implore you, please do not ask Lee to write again. The suffering it causes her and those around her is unbearable."[40] According to her son:

> The act of writing never came easily. It took a monumental effort before she could concentrate on her thoughts and focus her attention on the task. This took hours of what she termed "boondoggling," when she would find any number of things except the matter in hand to occupy herself. As the dead-line approached, the many alternatives to work seemed increasingly urgent. She would make love, hang around the bar, get drunk, argue, sleep, curse and rail, cry, in fact do anything rather than make a start on the article.[41]

30th June 1949.

Mrs. Penrose,
36 Downshire Hill,
Hampstead N.W.

Dear Lee,

I am very sorry to realise that you are
feeling tired and rushed, and that the idea of
doing an article for us seems out of the question
at present. Please do not worry about this.
I know very well that you find writing a strain,
and that you need to be feeling fresh and rested
to do it. Take it easy and enjoy your holiday,
and when you come back let's have a talk and see
whether it would be best to make some modifications
in your contract. I believe you know that I
admire your writing very much indeed, and have
always been proud to have published it in Vogue.
I still hope that there will be some more for us
to publish, but it is no good forcing it if it
means upsetting yourself.

The August "Choice" is a honey, with de
Valera (or her offspring?) stealing the picture
as usual.

Yours with love,

Withers herself was well aware of Miller's inability to meet deadlines. As early as spring 1949 she had exchanged interoffice memos with colleagues at *Vogue* about Miller not delivering the eight illustrated features they had been expecting.[42] In June 1949 Withers wrote to Miller reassuring her that if she was feeling too "tired and rushed" to write an article for *Vogue* they could discuss it later when she returned "fresh and rested" from her summer vacation (opposite). She later encouraged Miller to write on anything of interest to her, including her new love—cooking.

Miller found cooking fun, creative, and even a bit sexy. Katharine Reid, a much younger friend whose father was director of the Tate Gallery, remembered laughing a lot when Miller taught her to cook and how "driven" she was: "She did the cooking with the same spirit as the photography."[43] Miller's article "Bachelor Entertaining" appeared in the March 1949 issue, accompanied by her photographs. It shared various single male friends' secrets for hosting successful dinner parties, complete with recipes and cocktail advice.[44] By winter 1952 Withers was publishing Miller's original recipes and plan for a "thirteen-meal-long" Christmas.

The last full feature that Miller completed for *Vogue* appeared in July 1953. It was a quirky piece entitled "Working Guests" and Miller had been writing it for some time. She explained that she had "devoted four years of research and practice to getting all my friends to do all the work" when they came for weekends at Farley Farm. The witty article is dotted with many photographs of famous artists, curators, and editors who are, indeed, in the process of performing small jobs around the house and farm, from fashion editor Ernestine Carter injecting chairs against wormwood, to Henry Moore adjusting the position of his sculpture, and artist Richard Hamilton mending curtains with a needle and thread. Miller explains to her readers that "since most visitors sleep all morning, and I'm siesta-minded after lunch, it takes dove-tailed planning to keep industry on its feet."[45] Fittingly, the final picture in the article features Miller asleep on the sofa at Farley Farm (page 205).

By the time Antony Penrose was old enough to remember, his mother's renunciation of her photographic career was complete. "All requests for access" to her photographs were "politely and firmly deflected."[46] According to Penrose, she would say things like, "'Oh, I did take a few pictures—but that was a long time ago.'"[47] A friend of hers told me decades later that Miller had decided there was room for only one career in their household and, from the early 1950s on, it was to be her husband's, not hers.[48] We can never know for sure whether it was Miller's postwar domestic life or her wartime experiences—or a combination of both—that made her turn her back on photography and her always fraught writing career. Withers felt that

"fashion photography never really captured her interest, because fashion itself didn't. No reason why it should; but in peace time *Vogue* was primarily a fashion magazine."[49] David E. Scherman said in a 1995 interview that the war had rescued Miller from the "boredom of being a fashion photographer for *Vogue*, which she secretly hated like poison."[50] A return to fashion photography could only dissatisfy Miller after the war reportage she had undertaken during World War II.

Further insight comes from Miller herself. On returning to England from a trip to Paris in the summer of 1951, she wrote to Alison Settle, British *Vogue*'s fashion editor, of her dismay at the callous attitudes she encountered:

> The French aren't anywhere near as sensitive to the horrors as you think the English might be … gloomed by atom designs in textiles [then on display at the Festival of Britain].

> The famous skimpy bathing costume was named "Bikini" before the ashes had settled and last week, in Paris, a friend was wearing a new Dior hat … a snow-white panama with a naval anchor called "Narvik."[51] I'm told Cecil Beaton, somewhere in print, described an elegant and attenuated creature as a "Belsen Beauty" while there were still bodies on the ground in other unliberated camps…. The ladies are tough, I think, and would trim themselves with mice or spiders to be fashionable or remarkable.[52]

Miller was clearly still haunted by the war and what she had witnessed, as were so many other combat journalists and photographers. Returning to civilian life as a fashion photographer, even for a former model, was a dramatically dissonant experience. And, indeed, her letter to Settle reveals how distasteful she found fashion's wordplay with the names of naval battles and concentration camps. Concentration-camp chic did not amuse her. She had realized her creativity before the war by transforming herself from an object of the lens to a photographer in her own right. But what personal, assertive statement could she possibly make in *Vogue*'s pages after detailing the horrors of Dachau and Buchenwald a few years earlier? Audrey Withers described these war dispatches as "exciting" but "incongruous in our pages of glossy fashion."[53] Incongruity was not what *Vogue* sought from Lee Miller in postwar Britain.[54]

Most of the 1950s were tough for Miller. Penrose was writing a book on her friend Picasso and had accepted a post with the British Council in Paris. He had also taken

LEE MILLER IN "WORKING GUESTS," BRITISH *VOGUE*

Farley Farm, East Sussex, July 1953

up with Diane Deriaz, a trapeze artist and ex-lover of Paul Éluard, and Ninette Lyon, a painter, writer, gourmet, and, worse, mutual friend, who was married to another friend, Peter Lyon. Miller turned a blind eye to the latter liaison.[55] When Lyon asked her what the letters "NA" meant, scrawled as they were across her dressing table's mirror, she said they stood for "Never Answer—and it is to remind me that I am expected to carry on without protest."[56] At some point during these years Miller had a painful facelift at the hands of the well-known London surgeon Lady Claydon. Miller's friend Roz Jacobs remembers it as a success, removing the bags under Miller's eyes and giving her face greater tautness overall. "Look at my chin!" she happily proclaimed when Jacobs visited her in the hospital.[57]

But "it was food that saved her life," according to Antony Penrose.[58] For her fiftieth birthday, in spring 1957, Roland gave her a six-week Cordon Bleu course in Paris, which she passed with flying colors. Four years later she met her future best friend, Bettina McNulty, at a private lunch party at Madame Prunier's London restaurant. Boston-born McNulty had worked in fashion in Paris during the 1950s and was a contributing editor to the American edition of *House and Garden*. Her husband, Henry McNulty, represented the French Champagne and Cognac Federation in the UK and wrote small, elegant cocktail books for British *Vogue*. From that first meeting, McNulty and Miller were fast friends, fellow cooks, and co-conspirators in menu planning, reading, dinner parties, travel, and, sometimes, practical jokes. McNulty recalled, "We had more fun than our guests did. Most hosts don't have fun; they do it, but they don't have fun!"[59] The McNultys introduced Miller to their friend James Beard, the pioneer of American gastronomy. The next fifteen years were filled with McNulty and Miller's travels and the exotic gourmet dinner parties they threw upon returning to England.

Only occasionally did Miller's past in fashion and photography intersect with her *gourmand* present. In December 1974 she and Penrose flew to New York for a Man Ray retrospective at the New York Cultural Center. One of the ancillary events was a re-creation of Count and Countess Pecci-Blunt's famous Bal Blanc of 1930, that ball where Man Ray's infatuation with Miller had been at its height. John Loring, assistant to curator Mario Amaya, asked Miller to help him prepare a dinner of all white dishes for one hundred special guests. They cooked all afternoon, fueled by multiple martinis. Loring remembers Miller that day as "ebullient," with "the presence of a woman who has always known she was beautiful." With the first course, *brandade de morue*, they were "up to their ears in cream, olive oil and cod fish." Miller shouted, "More garlic! More olive oil! More martinis!" Other dishes on the menu included

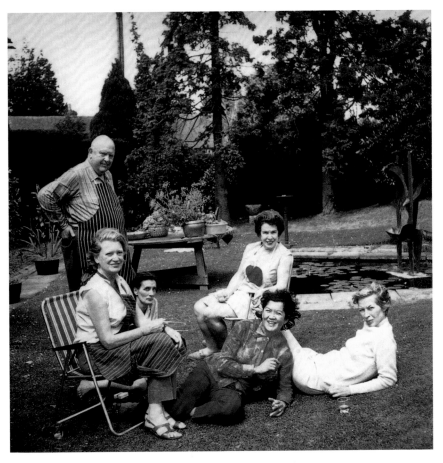

LEE MILLER (LEFT) AND BETTINA MCNULTY (RIGHT) WITH FRIENDS, INCLUDING JAMES BEARD

Photograph by Henry McNulty, Farley Farm, summer 1966

veal with cauliflower, rice, and endives, and vanilla ice cream with lychees. The actress Lillian Gish claimed it was "the first acceptable meal" she had eaten, but the cooks concluded that "food of one color made them uneasy."[60] In any case, this dinner was Miller's swan song. By the mid-1970s, she was no longer cooking or entertaining the way she had a decade earlier. So many of her dear old friends had died, including Picasso, Max Ernst, and Man Ray. On July 21, 1977, Lee Miller died of cancer.

LEE MILLER'S EYE DECORATES AN ANN DEMEULEMEESTER NECKLACE

Paris, spring 2008

AFTERWORD

Despite her best efforts to consign her career to the dark, Lee Miller and her work in fashion, on both sides of the camera, continue to intrigue and inspire. In the world of fashion, she remains an at times unacknowledged, though frequently recurring, figure, right down to the present. Fashionistas know, for instance, that Gucci's creative director, Frida Giannini, took Miller as her muse for her fall/winter 2007–8 collection, calling her "a pioneer—talented, passionate and fashionable, just like strong women of today."[1] The same year, the Belgian fashion designer Ann Demeulemeester had her models walk the Paris catwalk sporting monocle-like necklaces, each featuring a photograph of Miller's eye. Thirty years earlier, former British fashion editor Brigid Keenan wrote *The Women We Wanted to Look Like*. There, alongside the likes of Hedy Lamarr, Audrey Hepburn, Jean Shrimpton, Jacqueline Kennedy, Gloria Guinness, Lady Diana Cooper and Lauren Hutton, Lee Miller commanded more pages than most. Keenan wrote that "there were stars among the models as early as in the late twenties. Lee Miller was one of the first and the loveliest of faces to acquire a name."[2]

Above **THE LATEST HAT** Photograph by Lee Miller, *Vogue* Studios, London, April 1942

Opposite **EILEEN AGAR** Photograph by Lee Miller, Brighton, England, 1937

But, as we all now know, Miller was not merely a beauty and fashion icon; she was also an incredibly talented photographer. Francine Prose notes in her best-selling book *The Lives of the Muses* that "unlike the majority of muses' life stories, hers is not primarily a duet for muse and artist but rather a solo performance with remarkable variations as she became one of the few muses—that is, former muses—to produce a body of first-rate work."[3] Of Miller's unique photographic contribution to *Vogue*, and particularly her Surrealist inclinations, the acclaimed playwright David Hare has argued:

> Today, when the mark of a successful iconographer is to offer craven
> worship of wealth, or a yet more craven worship of power and celebrity, it is
> impossible to imagine an artist of Lee's subtlety and humanity commanding
> the resources of a mass-market magazine. Photography is now used by
> editors to seal off the rich and famous, to deny us access, not to grant it.

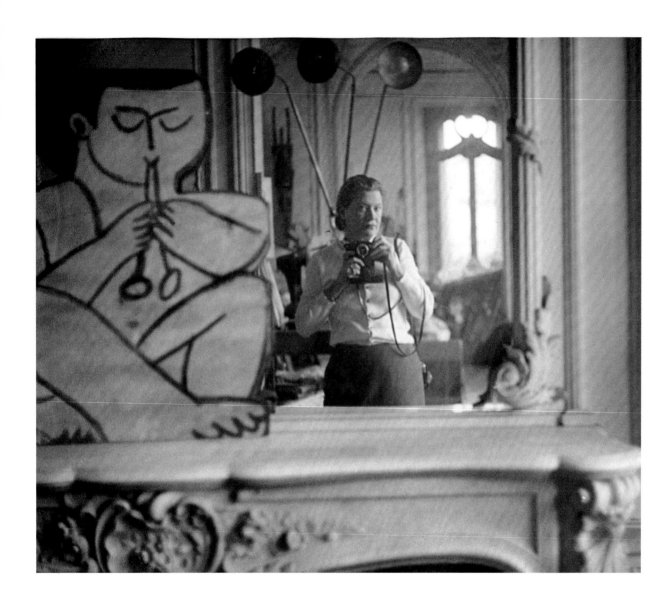

SELF-PORTRAIT IN PICASSO'S STUDIO

Photograph by Lee Miller, Cannes, 1956

But this young art form was, for a period in the middle of the last century, the means by which the world looked new and strange. The men in the surrealist movement talked their philosophy, but a woman lived it.[4]

For their subversive Surrealism, ironic juxtapositions, and humbling humanity, the fashion photographs of Lee Miller deserve better recognition in the history of developments and trends in fashion photography. Such a history would include not only the better known work of her compatriot Toni Frissell but also other mostly forgotten postwar fashion photographers at British *Vogue*, including Eugene Vernier, Clifford Coffin, and Ronald Traeger, as well as those who came after.[5] Another indicator of the historic importance of Miller's fashion photography is how it anticipated British photographic trends of the 1960s. The photojournalistic approach that Miller perfected during World War II would reemerge in the work of the next-generation "Young Meteors"—Antony Armstrong-Jones (later Lord Snowdon), Terence Donovan, Brian Duffy, and David Bailey, among others—so dubbed by photography scholar Martin Harrison. These young men and their agenda of photographic "integrity" dominated the British scene throughout the "Swinging Sixties."

Lee Miller the war photographer and artist has achieved more recognition than Lee Miller the fashion photographer, particularly since the turn of the new century, thanks to a series of important exhibitions, including *The Surrealist and the Photographer: Roland Penrose and Lee Miller* at Edinburgh's Scottish National Gallery of Modern Art in 2001, *Surrealist Muse* at Los Angeles's Getty Museum in 2003, *Lee Miller: Portraits* at the National Portrait Gallery, London, in 2005, and *Lee Miller: Picasso in Private* at the Picasso Museum, Barcelona, in 2007. That same year, Mark Haworth-Booth curated the highly acclaimed centenary exhibition *The Art of Lee Miller* at London's Victoria and Albert Museum, with versions of the show touring to the Jeu de Paume in Paris, the Philadelphia Museum of Art, and San Francisco's Museum of Modern Art the following year. The tireless efforts of Antony Penrose and the devoted staff at the Lee Miller Archives can only mean that Lee Miller's reputation as a world-class photographer—of war and of fashion—will continue to flourish in the years to come.[6]

NOTES

Bibliographical references given in abbreviated form in the notes are given in full in the bibliography.

PREFACE

1 Burke, *Lee Miller*, xi.

2 See Chase, *Always in Vogue*; Man Ray, *Self-Portrait*; Yoxall, *A Fashion of Life*; as well as Bourke-White, *Portrait of Myself*. Miller's friend the Surrealist Eileen Agar wrote her memoir, *A Look at My Life*, in 1988.

3 A. Penrose, *Lives of Lee Miller*, 209; One exception to Miller's denial of all requests for photographic loans was when she allowed a photograph of her infant son (page 184) to be included in the "Family of Man" blockbuster exhibition, curated by Edward Steichen at New York's Museum of Modern Art in 1955. The exhibition was eventually seen by nine million people in thirty-eight countries. However, a mother's photograph of her son is much less conspicuous than a series of photographs of German concentration camps. Other photographs did also appear in print at various times. In 1958 Miller's photographs of Picasso, his work, and his studio were published in Roland Penrose's *Picasso: His Life and Work* (New York: Victor Gollancz), and new photographs accompanied the second edition, published as *Portrait of Picasso* (London: Lund Humphries) in 1971. In 1966, the year that her husband Roland Penrose was knighted and Miller became Lady Penrose, British *Vogue*'s Golden Jubilee issue carried an excerpt of her 1944 article on Saint-Malo. For further details, see the chronology in Scottish National Gallery, *Roland Penrose, Lee Miller*, 173–74.

4 Bettina McNulty, interview with Carolyn Burke, August 8, 1997; cited in Burke, *Lee Miller*, 340.

5 A. Penrose, *Lives of Lee Miller*, 8.

6 Scherman, foreword to *Lee Miller's War*, ed. Antony Penrose, 13.

CHAPTER 1

1 Nast, quoted in Caroline Seebohm, *The Man Who Was Vogue*, 156.

2 Ibid.

3 Ibid.; cited in Burke, *Lee Miller*, 57.

4 Miriam "Minnow" Hicks Feierabend (a childhood friend in Poughkeepsie), interview with Carolyn Burke, February 9, 2000; cited in Burke, *Lee Miller*, 61.

5 Scherman, foreword to *Lee Miller's War*, ed. A. Penrose, 8.

6 A. Penrose, *Lives of Lee Miller*, 8.

7 For a discussion of Theodore's 1915 photograph of Lee nude in the snow (which he titled *December Morn*, after Paul Chabas's painting *September Morn*, first shown in New York in 1914) see Burke, *Lee Miller*, 18–19. Theodore's beautiful photograph of Lee in the bath is more troubling, as it was taken when they were staying in a Stockholm hotel together in 1930, when Lee was twenty-three years old.

8 Livingston added: "The closeness between them, especially when Lee was in her early twenties, may have bordered on an unhealthy intimacy. In any event, Lee Miller would always have difficulty in establishing long-term relationships with other men." *Lee Miller: Photographer*, 27.

9 Burke, *Lee Miller*, 34.

10 Ibid., 39.

11 A. Penrose, *Lives of Lee Miller*, 13; Burke, *Lee Miller*, 40.

12 Miller, quoted in Arthur Gold and Robert Fizdale, "The Most Unusual Recipes You Have Ever Seen," American *Vogue*, April 1974, 161; cited in Burke, *Lee Miller*, 40.

13 Miller, quoted in Brigid Keenan, *The Women*, 63; cited in Burke, *Lee Miller*, 40.

14 Burke, *Lee Miller*, 40–41.

15 Crowninshield, quoted in Hallie Flanagan, *Shifting Scenes* (New York: Coward-McCann, 1928), 276; cited in Burke, *Lee Miller*, 41.

16 Lee Miller Diary, entries of March 8 and 21, 1926; cited in Burke, *Lee Miller*, 43.

17 Burke, *Lee Miller*, 43.

18 Ibid.

19 Theodore Miller Diary, February 1926; cited in Burke, *Lee Miller*, 43.

20 Burke, *Lee Miller*, 45–46.

21 Ibid., 46–47.

22 Ibid., 50. George Gershwin got his start composing for the Scandals; Louise Brooks began her acting career as one of the George White Girls.

23 "Seven Deaths Reported in Upstate New York," *Springfield Republican*, July 11, 1926, 2; see also Burke, *Lee Miller*, 51.

24 Ibid., 51.

25 Ibid., 53.

26 Lee Miller Diary, 1926 notebook (misdated 1927 according to Burke); cited in Burke, *Lee Miller*, 21.

27 See Burke, *Lee Miller*, 381, "damaged goods" note.

28 Burke, *Lee Miller*, 28.

29 Peiss, "Girls Lean Back Everywhere," in *The Modern Girl Around the World: Consumption, Modernity and Globalization*, ed. Alys E. Weinbaum et al. (Durham, NC: Duke UP, 2008), 352.

30 See, for example, J. Anderson Black and Madge Garland, *A History of Fashion* (New York: Morrow, 1980); and James Laver, *The Concise History of Costume and Fashion* (New York: Abrams, 1979). See also Macy's 1927 advertisement for vacuum cleaners, available on YouTube.

31 Bliven, "Flapper Jane," *New Republic*, September 9, 1925, 65–67.

32 Mackay, "Why We Go To Cabarets," *The New Yorker*, November 28, 1925, 7–8. Interestingly, Mackay indicates that debutantes, even naughty ones, did not think of themselves as flappers. She writes: "What does it matter if the flapper and her fattish boy friend are wriggling beside us as we dance?"

33 See Michael Lerner, *Dry Manhattan: Prohibition in New York City* (Cambridge, MA: Harvard UP, 2007), 136–37; see also Albin Krebs, "Ellin Berlin, 85, a Novelist, Dies," *New York Times*, July 30, 1988.

34 Mackay, "The Declining Function: A Post-Debutante Rejoices," *The New Yorker*, December 12, 1925, 15.

35 Baskerville, *The New Yorker*, June 13, 1925, 20; cited in Lerner, *Dry Manhattan*, 137.

36 Lerner, *Dry Manhattan*, 3.

37 Vreeland, *D.V.*, 56.

38 Michael Callahan, "Ladies in Waiting: Sorority on East 63rd Street," *Vanity Fair*, April 2010, consulted online; see also Sarah Kershaw, "Big Deal: Landmark Status Weighed for Barbizon," City Room Blog, *The New York Times*, consulted online.

39 Burke, *Lee Miller*, 57.

40 For a visual, see Todd Brandow and William A. Ewing, *Edward Steichen: In High Fashion* (New York: W.W. Norton & Co., 2008).

41 Most mental health professionals consider dissociation a common response to abusive situations such as rape and incest. They define dissociation as a mental process in which a person's thoughts and feelings become separated from his or her immediate reality.

42 Burke, *Lee Miller*, 55. Antony Penrose first used the term "disassociation" in connection with Miller's relationship to her body as a result of her traumatic experience of rape. See A. Penrose, *The Home of the Surrealists*, 46.

43 Vreeland, *D.V.*, 48.

44 Tanja Ramm to A. Penrose, June 9, 1984; cited in Burke, *Lee Miller*, 61.

45 Burke, *Lee Miller*, 61–63.

CHAPTER 2

1 Horst P. Horst quoted in Valentine Lawford, *Horst: His Work and His World* (New York: Knopf, 1984), 60; cited in Burke, *Lee Miller*, 85.

2 A. Penrose, *Lives of Lee Miller*, 22; Livingston, *Lee Miller*, 28; Burke, *Lee Miller*, 74.

3 Miller, quoted in Nancy Osgood, "Accident Was the Road to Adventure," *St. Petersburg Times*, October 5, 1969; cited in Burke, *Lee Miller*, 74.

4 Miller, quoted in Keenan, *The Women*, 136; and quoted in Amaya, "My Man Ray…," 59. New evidence unearthed by the Canadian scholar Steven Manford in Man Ray's date books, after their acquisition by the Getty Museum, Los Angeles, suggests that Miller and Man Ray may not have actually become lovers until mid-September 1929, rather than immediately that summer. See Manford, "Day One: Lee Miller, Man Ray, and the Fabled Meeting at Le Bateau Ivre," delivered at the Man Ray/Lee Miller Symposium as part of the opening celebrations of the *Man Ray/Lee Miller: Partners in Surrealism* exhibition at the Legion of Honor, San Francisco, July 14, 2012. Talk available online: http://legionofhonor.famsf.org

5 Miller, quoted in Amaya, "My Man Ray…," 58.

6 Ibid., 58 and 54.

7 Ibid., 55.

8 Ibid., 57.

9 Haworth-Booth, *Art of Lee Miller*, 39.

10 Miller, quoted in Amaya, "My Man Ray…," 57.

11 Vicki Goldberg, "Photography Review: Get a Great Image? Easy. Just Edit Out Those That Aren't," *New York Times*, February 5, 1999, consulted online.

12 Burke, *Lee Miller*, 79.

13 Miller, quoted in Amaya, "My Man Ray…," 59–60.

14 Ibid., 58.

15 Ibid., 56–57; A. Penrose, *Lives*, 30; Burke, *Lee Miller*, 93.

16 Burke, *Lee Miller*, 93.

17 Ibid., 75.

18 Ibid., 83.

19 Miller, "I Worked with Man Ray," *Lilliput*, October 1941, 316; cited in Burke, *Lee Miller*, 79.

20 Miller, quoted in Amaya, "My Man Ray…," 59–60.

21 Horst, quoted in Michael Gross, *Model: The Ugly Business of Beautiful Women* (New York: HarperCollins, 1995), 51.

22 Gross, *Model*, 39.

23 Although in New York City the first modeling agency had been established in 1921 by John Robert Powers, in Paris no modeling agencies existed until the mid-1950s. The first was to be established by the former top American model Dorian Leigh, who had to change French law to do so. In 1946 or 1947, in an attempt to shut down all of Paris's brothels, a law was passed that made it illegal to take a portion of someone else's wages. This had a knock-on effect. Susan Train, bureau chief of American *Vogue* in Paris from 1951 until quite recently, explained that this meant that modeling agencies, as well any other agency, were against the law. In 1955, however, Leigh moved to Paris determined to start a modeling agency. Susan Train, interview with author, Paris, March 20, 2008. See also Gross, *Model*, 81–82; and Jean-Noel Liaut, *Models and Mannequins, 1945–1965* (Paris: Filipacchi, 1994), 36–37.

24 Staffers also playfully referred to British *Vogue* as "*Brogue*." A. Penrose, *Lives of Lee Miller*, 28–29.

25 Gross, *Model*, 39. (see Ch. 2, n. 21).

26 Hoyningen-Huene, quoted in Keenan, *The Women*, 136.

27 French *Vogue*, October 1929, 76 and 78; Burke, *Lee Miller*, 83.

28 Hoyningen-Huene, unpublished memoirs; cited in William A. Ewing,
The Photographic Art of Hoyningen-Huene (New York: Rizzoli, 1986), 98; cited in Burke, *Lee Miller*, 84.

29 Jacqueline Barsotti Goddard, interview with Carolyn Burke, August 24, 1997; cited in Burke, *Lee Miller*, 80.

30 Beaton, quoted in A. Penrose, *Lives*, 29.

31 Martin, *Fashion and Surrealism* (London: Thames & Hudson, [1989] 1996), 9.

32 Ibid., 217.

33 R. Penrose, interview by Edward Lucie-Smith, 1980; cited in Slusher, *Green Memories of Desire*, 31.

34 A. Penrose, *Lives*, 50. Burke, *Lee Miller*, 85.

35 Ibid., 29; Ibid.

36 Horst, quoted in Lawford, *Horst*, 60; cited in Burke, *Lee Miller*, 85.

37 Poiret, *My First 50 Years* (London: Victor Gollancz, 1931), 151; cited in Whitney Chadwick, "Lee Miller's Two Bodies," in *The Modern Woman Revisited: Paris Between the Wars*, ed. Chadwick and Tirza True Latimer (New Brunswick, NJ: Rutgers UP, 2003), 212.

38 Livingston, *Lee Miller*, 35. Miller herself said of the photograph *Primat de la matière sur la pensée*, taken by her and Man Ray when they lived together in Paris, "I don't know if I did it but that doesn't matter. We were almost the same person when we were working." Miller, quoted in R. Penrose, *Atelier Man Ray 1920–1935* (Paris: Philippe Sers Éditeur 1982), 56; cited in Burke, *Lee Miller*, 94.

39 Man Ray, *Self-Portrait*, 168; cited in A. Penrose, *Lives*, 25.

40 Burke, *Lee Miller*, 101.

41 For more on Vionnet see: www. vionnet.com/about/; and Pamela Goblin, ed., *Madeleine Vionnet* (New York: Rizzoli, 2008). According to Jacqueline Demornex, *L'Art de la Mode* magazine proclaimed in 1926 that "Fashion lovers can recognize a particular couturier's style from fifteen paces: Vionnet's draping, Patou's chic, Lucien Lelong's fluidity"; cited in Demornex, *Lucien Lelong* (London: Thames & Hudson, 2008), 24.

42 Man Ray, *Self-Portrait*, 168; cited in A. Penrose, *Lives*, 24–25.

43 French *Vogue*, October 1930, 90–91.

44 Over twenty-five years later, Miller wrote of Cocteau in a *Vogue* article on
Surrealist cinema: "He himself, elegant, shrill, and dedicated, knew exactly what he wanted and got it. He screamed and cajoled. He electrified everyone who had anything to do with the film, from sweepers to tax-collectors. In a state of grace we participated in the making of a poem." British *Vogue*, August 1956, 98.

45 Chaplin, quoted in Burke, *Lee Miller*, 104.

46 Howard Barnes, quoted in "Praise is Paid to Miss Miller," *Poughkeepsie Evening Star*, December 5, 1933; cited in Burke, *Lee Miller*, 136.

47 Pony Simon, quoted in Burke, *Lee Miller*, 83.

48 Man Ray, letter to Lee Miller, n.d., Lee Miller Archives; cited in Burke, *Lee Miller*, 89.

49 Slusher, *Green Memories of Desire*, 32.

50 Amei Wallach, "Krasner's Triumph," American *Vogue*, November 1983, 501; cited in Ibid., 31.

51 For more on these sketches, see Haworth-Booth, *Art of Lee Miller*, 48–49; and Chadwick, "Lee Miller's Two Bodies," 214–15 (see n. 37).

52 Man Ray, quoted in *This Quarter* (1932), 55; cited in A. Penrose, *Lives of Lee Miller*, 44-2

53 Letter from Man Ray to Lee Miller, Lee Miller Archives; cited in A. Penrose, *Lives of Lee Miller*, 38.

CHAPTER 3

1 Miller, quoted in "Cargo of Celebrities That Was Brought Here by the Île de France," *New York World Telegram*, October 18, 1932; cited in Burke, *Lee Miller*, 128.

2 Vreeland, *D.V.*, 56–57.

3 Burke, *Lee Miller*, 128 (see n. 1).

4 Miller, quoted in Julia Blanshard, "Other Faces Are Her Fortune," *Poughkeepsie Evening Star*, November 1, 1932; cited in Burke, *Lee Miller*, 128.

5 Burke, *Lee Miller*, 128.

6 A. Penrose, *Lives*, 44.

7 Christian R. Holmes IV, quoted in P. Christiaan Klieger, *The Fleischmann Yeast Family* (Mount Pleasant, SC: Arcadia Publishing, 2004), 7.

8 A. Penrose, *Lives*, 44; and Haworth-Booth, *Art of Lee Miller*, 92.

9 Burke, *Lee Miller*, 129.

10 American *Vogue*, November 1932, tearsheet.

11 Burke, *Lee Miller*, 129; and Haworth-Booth, *Art of Lee Miller*, 101.

12 A. Penrose, *Lives of Lee Miller*, 44. Horn hailed from Heidelberg and had moved to New York in 1923 at the suggestion of Otto Kahn, a Mannheim-born industrialist and patron of the arts, who invited her to photograph his 443-acre estate on Long Island. While in New York, she met Frank Crowninshield of *Vanity Fair*. Impressed with her portfolio, he encouraged her to stay and make a career in New York. She initially established her portrait studio on West Fifty-Second Street. The year that Miller opened her studio, Horn moved hers to Tudor City; www.vonhornphoto.com

13 Ibid.

14 Erik Miller, July 1974, quoted in A. Penrose, *Lives of Lee Miller*, 45.

15 A. Penrose, *Lives of Lee Miller*, 44.

16 Lee Miller, quoted in Seinfel, "Every One Can Pose"; cited in Burke, *Lee Miller*, 129.

17 A. Penrose, *Lives of Lee Miller*, 44; Burke, *Lee Miller*, 134.

18 Miller, quoted in *Poughkeepsie Evening Star*, November 1, 1932; cited in A. Penrose, *Lives of Lee Miller*, 54.

19 John Berger, *Ways of Seeing* (London: Penguin, 1972), 45 and 47.

20 Haworth-Booth, *Art of Lee Miller*, 97.

21 For example, "Jungle Gardenia," introduced in 1932 by New York's Tuvache.

22 Erik Miller, quoted in A. Penrose, *Lives of Lee Miller*, 55; and Haworth-Booth, *Art of Lee Miller*, 110–11.

23 Lee Miller, quoted in Seinfel, "Every One Can Pose"; cited in Burke, *Lee Miller*, 129. See also Mark Haworth-Booth, *Art of Lee Miller*, 53–55.

24 A. Penrose, *Lives of Lee Miller*, 46.

25 Crowninshield, quoted in A. Penrose, *Lives of Lee Miller*, 46; and Haworth-Booth, *Art of Lee Miller*, 103. The announcement is preserved in the Lee Miller Archives.

26 E. A. Jewell, "Two One-Man Shows," *New York Times*, December 31, 1932; cited in Burke, *Lee Miller*, 132; and Haworth-Booth, *Art of Lee Miller*, 103.

27 I would like to thank Carole Callow, curator and photographic fine printer at the Lee Miller Archives, for first bringing these self-portraits to my attention.

28 Haworth-Booth, *Art of Lee Miller*, 108–9. See also Conekin, "Lee Miller's Simultaneity."

29 Livingston, *Lee Miller*, 43; Burke, *Lee Miller*, 135–36.

30 Houseman, *Run-Through: A Memoir* (New York: Simon & Schuster, 1972), 96; cited in Burke, *Lee Miller*, 138.

31 Jessye, quoted in Steven Watson, *Prepare for Saints* (New York: Random House, 1998), 245; cited in Burke, *Lee Miller*, 138.

32 Burke, *Lee Miller*, 137–38.

33 Ibid., 139.

34 "Thus do Tastes Differ," *Vanity Fair*, May 1934, 52.

35 Burke, *Lee Miller*, 135–36.

36 Penn, quoted in Jane Kramer, "The Life of the Party," *The New Yorker*, February 6, 1995, 65.

37 Magdi Wahba, "Cairo Memories," in *Studies in Arab History*, ed. Derek Hopwood (Oxford: Macmillan, 1999), 107; cited in Burke, *Lee Miller*, 148.

38 Eloui Bey, letter to Florence and Theodore Miller, August 26, 1934; cited in Burke, *Lee Miller*, 146.

39 Miller, quoted in Arthur Gold and Robert Fizdale, "The Most Unusual Recipes You Have Ever Seen," *American Vogue*, April 1974, 186; cited in Burke, *Lee Miller*, 149.

40 Burke, *Lee Miller*, 151–54.

41 Ibid., 150.

42 Livingston, *Lee Miller*, 48; Haworth-Booth, *Art of Lee Miller*, 141.

43 Burke, *Lee Miller*, 163.

44 Slusher, *The Green Memories of Desire*, 10.

45 R. Penrose, *Scrapbook 1900–81* (London: Thames & Hudson, 1981), 104; A. Penrose, *Lives of Lee Miller*, 74.

46 A. Penrose, *Lives of Lee Miller*, 74.

47 Ibid. Ali Smith writes eloquently on the photograph "Four Women Asleep" (page 72), shot in Cornwall that summer, and about the lives and work of its "sleeping" women, see *Artful*, (NY: Penguin, 2013) 112–117 and 227–228.

48 R. Penrose, *The Road is Wider Than Long: An Image Diary from the Balkans July–August 1938* (London: London Gallery Editions, 1939).

49 R. Penrose, "The Road *was* wider than long ***," epilogue to *The Road is Wider Than Long*. Facsimile edition. (Los Angeles: J. Paul Getty Museum, 2003). n.p.

50 Ibid.

51 Miller, letter to Roland Penrose, n.d. (May 1939); cited in Burke, *Lee Miller*, 193.

52 A. Penrose, *Lives of Lee Miller*, 96.

53 Burke, *Lee Miller*, 200. In 1938 the British Balloon Command was established to protect cities and key targets, such as industrial areas, ports, and harbors. Balloons were intended to defend against "dive bombers," flying at heights of 5,000 feet, by forcing them to fly higher and into the range of concentrated anti-aircraft fire. See Franklin J. Hillson, "Barrage Balloons for Low-Level Air Defense," *Airpower Journal* (Summer 1989), available online.

CHAPTER 4

1 "Here and now resolve to shop courageously to look your best," British *Vogue*, September 1939, 44.

2 Miller, quoted in Gold and Fizdale, "The Most Unusual Recipes You Have Ever Seen," American *Vogue*, April 1974, 186; cited in Burke, *Lee Miller*, 154.

3 A. Penrose, *Lives of Lee Miller*, 99.

4 On her love of cooking and spices from her "Egyptian period," see Miller, quoted in Ninette Lyon, "Lee and Roland Penrose: A Second Fame," American *Vogue*, April 1965.

5 Lee Miller, letter to Erik and Mafy Miller, August 25, 1942; cited in Burke, *Lee Miller*, 201. See also Conekin, "'Another Form of Her Genius.'"

6 Burke, *Lee Miller*, 200.

7 A. Penrose, *Lives of Lee Miller*, 98.

8 When Withers attended Oxford, her degree course was known as Modern Greats. Drusilla Beyfus, "Audrey Withers," Obituaries, *Guardian*, October 31, 2001, consulted online.

9 A. Penrose, *Lives of Lee Miller*, 98; Haworth-Booth, *Art of Lee Miller*, 152.

10 Haworth-Booth, *Art of Lee Miller*, 152.

11 Ibid.

12 Blanch, "W.R.N.S. on the Job," British *Vogue*, November 1941, 92; cited in Burke, *Lee Miller*, 209.

13 The ATS had its origins in the Women's Auxiliary Army Corps (WAAC), which was formed during World War I but later disbanded. WAAC veterans over the age of fifty were allowed to join the ATS.

14 For more on British women's official war work, see Shelford Bidwell, *The Women's Royal Army Corps* (Barnsley: Pen and Sword Books, 1997); Eileen Bigland, *Britain's Other Army: The Story of the A.T.S* (London: Nicholson and Watson, 1946); Jeremy A. Crang, "'Come into the Army, Maud': Women, Military Conscription, and the Markham Inquiry," *Defence Studies* 8, no. 3 (November 2008): 381–95; and Dorothy Brewer Kerr, *Girls Behind the Guns: With the Auxiliary Territorial Service in World War II* (London: Robert Hale Ltd, 1990)

15 Lee Miller, letter to Florence and Theodore Miller, n.d. (probably December 1940); and E. Murrow, *This is London* (New York: Schocken, 1985), 145. See also Burke, *Lee Miller*, 197–219.

16 See also "Remembering the Blitz," www.museumoflondon.org.uk; Paul Addison, *The Road to 1945: British Politics and the Second World War* (London: Cape, 1975); Anthony Calder, *The People's War: Britain 1939–1945* (London: Cape, 1969); and idem, *The Myth of the Blitz* (London: Pimlico, 1991).

17 Liberman, interview with Carolyn Burke, June 14, 1996; cited in Burke, *Lee Miller*, 294.

18 Nast, quoted in Seebohm, *The Man Who Was Vogue*, 354.

19 Lee Miller, letter to Erik and Mafy Miller, date; cited in A. Penrose, *Lives of Lee Miller*, 109.

20 Blanch, "Living the Sheltered Life," British *Vogue*, October 1940, 47 and 96.

21 Anonymous, "Here is *Vogue* in spite of it all," British *Vogue*, November 1940, 19.

22 Beyfus, "Audrey Withers" (see n. 8); see also J. Muylagh, "Obituary: Audrey Withers," *The Independent*, November 2, 2001.

23 Titmuss, *Problems of Social Policy* (London: HM Stationery Office, 1950), 322–23.

24 Lee Miller, letter to Florence and Theodore Miller, n.d. (probably December 1940), Lee Miller Archives. See also Burke, "London in the Blitz," in *Lee Miller*, 197–219.

25 Haworth-Booth, *Art of Lee Miller*, 153.

26 Burke, *Lee Miller*, 201.

27 A. Penrose, *Lives of Lee Miller*, 99.

28 The viaduct had been opened by Queen Victoria in 1869, and sits at the edge of the City of London, an area of about one square mile and home to Britain's financial services.

29 Designed by the sculpture firm Farmer & Brindley during the 1860s, each of the lions rests its left paw on a globe. Benedict Read, *Victorian Sculpture* (New Haven: Yale UP, 1982), 240.

30 Iona and Peter Opie, *The Oxford Dictionary of Nursery Rhymes*, 2nd ed. (Oxford: Oxford UP, 1997), 442–43.

31 "Tonic Tweeds," British *Vogue*, September 1940, 42 and 43.

32 R. Penrose, *Scrapbook*, 102.

33 Ibid.

34 A. Penrose, *Lives of Lee Miller*, 76–77.

35 Burke, *Lee Miller*, 198.

36 See Stephen Broadberry and Peter Howlett, "Blood, Sweat and Tears: British Mobilization for WWII," in *A World at Total War: Global Conflict and the Politics of Destruction, 1937–1945*, ed. Roger Chickering and Stig Förster (Cambridge: Cambridge UP, 2004), 157–76.

37 British *Vogue*, September 1939, n.p. and 23.

38 British *Vogue*, September 1939, 44.

39 "Power Behind the Throne," British *Vogue*, September 1939, 26.

40 See, for example, Sonya O. Rose, *Which People's War?: National Identity and Citizenship in Wartime Britain, 1939–1945* (Oxford: Oxford UP, 2003); and Jo Spence, "What Did you Do in the War Mummy? Class and Gender in the Images of Women," *Photography and Politics*, ed. Terry Dennett et al. (London: Photography Workshop, 1977).

41 Lucy Noakes, *War and the British: Gender and National Identity, 1939–91* (London: I. B. Tauris, 1997), 64.

42 Pat Kirkham, "Keeping Up Home Front Morale: 'Beauty and Duty' in Wartime Britain," in *Wearing Propaganda: Textiles on the Home Front in Japan, Britain and the United States, 1931–1945*, ed. Jacqueline Atkins (New Haven: Yale UP, 2005), 207.

43 "Thumbs Up, Thumbs Down," British *Vogue*, November 1939, 19.

44 Public Record Office, RG 23/17, Wartime Social Survey: Retail Services and Shortages, May 1942 to May 1943; cited in Ina Zweiniger-Bargielowska, *Austerity in Britain: Rationing, Controls and Consumption, 1939–1955* (Oxford: Oxford UP, 2000), 91.

45 British *Vogue*, February 1942, 38.

46 Ibid., 38–39.

47 "Problem Hands," British *Vogue*, February 1944, 34.

48 Kirkham, "Keeping Up Home Front Morale," 205–27.

49 "Make a Habit of Beauty," British *Vogue*, August 1944, 41.

50 Mass-Observation, Clothes Rationing Survey: An Interim Report Prepared for the Advertising Service Guild, London, 1941, 7–8; cited in Zweiniger-Bargielowska, *Austerity in Britain*, 88.

51 See, for example, Zweiniger-Bargielowska, *Austerity in Britain*; Helen Reynolds, "The Utility Garment: Its Design and Effect on the Mass Market 1942–45," in *Utility Reassessed: The Role of Ethics in the Practice of Design*, ed. Judy Attfield (Manchester: Manchester UP, 1999), 125–143; and Lisa Jardine, "A Point of View: Dazzling in an Age of Austerity," *BBC News Magazine*, December 31, 2011, available online.

52 Zweiniger-Bargielowska, *Austerity in Britain*, 50–51.

53 Jardine, "A Point of View."

54 "Smart Fashions for Limited Incomes," British *Vogue*, March 1942, 59.

55 "Today's Standard," British *Vogue*, April 1943, 30–35 (final ellipsis in the original).

56 Kirkham, "Keeping Up Home Front Morale," 209.

57 Scott-James, "The Taking of a Fashion Magazine Photograph," *Picture Post* 26 (October 1940): 22–25.

58 British *Vogue*, May 1941, 52.

59 Ruth Brown, "AIM Report" on the conservation of Norman Hartnell dolls' dresses (Staffordshire University, March 2010), available online.

60 Michael Pick, *Be Dazzled!: Norman Hartnell, Sixty Years of Glamour and Fashion* (New York: Pointed Leaf Press, 2007), 122.

61 "Elephant Grey," British *Vogue*, January 1944, 42.

62 "They Have Been Here Before," British *Vogue*, October 1941, 33; cited in Burke, *Lee Miller*, 209.

63 "Make a Habit of Beauty," British *Vogue*, August 1944, 41.

64 Yoxall, *Fashion of Life*, 153; cited in Burke, *Lee Miller*, 209.

65 "Accessory Factors," British *Vogue*, May 1942, 50 and 51.

66 "Headgear is coupon-free, but scarves made into headgear require coupons." Board of Trade Document, "Clothing Coupon Quiz" (Her Majesty's Stationery Office, September 1941), xiv. Nadia Woolf writes: "For some unknown reason women's hats were still plentiful; for many women sporting a smart new hat was their sole fashion note." Woolf, "Making do: Rationing in Britain During the Second World War," *The Jewish Magazine*, August 2009, consulted online.

67 Katharina Menzel-Ahr, *Lee Miller: Kriegskorrespondentin fur Vogue, Fotografien aus Deutschland 1945* (Marburg: Jonas Verlag, 2005), 36. Menzel-Ahr reproduces the playing card with Nusch's image and the September 1942 spread from British *Vogue*.

68 "In Town This Summer," British *Vogue*, July 1943, 50 and 51.

69 Carol Dyhouse, *Glamour: Women, History, Feminism* (London: Zed Books, 2010), 37.

70 A. Penrose, *Lives of Lee Miller*, 102–4.

71 Julian Trevelyan, *Indigo Days: The Art and Memoirs of Julian Trevelyan* (London: MacGibbon & Kee, 1957), 121.

72 Slusher, *Green Memories of Desire*, 57; Peter Forbes, *Dazzled and Deceived* (New Haven: Yale UP, 2009), 37–38, 143, and 150–51.

73 "Startle slide" seems to be a term conceived by Forbes in *Dazzled and Deceived*, caption for plate 18.

74 Slusher, *Green Memories of Desire*, 58; Forbes, *Dazzled and Deceived*, 151.

75 Scherman, interview by Carolyn Burke, May 28, 1996; Burke, *Lee Miller*, 210.

76 Scherman, quoted in John Loengard, *Life Photographers: What They Saw* (Boston: Little, Brown, 1998), 113; cited in Burke, *Lee Miller*, 211.

77 For more on her "beautiful navel," see Burke, *Lee Miller*, 124. For more on

champagne glass, see A. Penrose, *Lives of Lee Miller*, 32.

78 Dupain, quoted in Ann Elias, "Camouflage and the Half-Hidden History of Max Dupain in War," *History of Photography* 13, no. 4 (November 2009): 370–82, 373.

79 R. Penrose, *Picasso: His Life and Work* (New York: Harper & Row, 1973), 205. See also Chapter Five of Gertrude Stein's *The Autobiography of Alice B. Toklas* (New York: Vintage, 1961) in which she discusses the influence of the Cubists, especially Picasso, on developments in camouflage during World War II.

80 R. Penrose, cited in Tim Newark, "Now You See It … Now You Don't," *History Today* 57, no. 3 (March 2007): 4–5; see also Tim Newark, *Camouflage* (London: Thames & Hudson, 2009).

81 "Evolution in Embroidery," British *Vogue*, January 1943, 74.

82 "At the Other End of the Lens," British *Vogue*, January 1943, 70 and 74.

83 See, for example, Robin Derrick and Robin Muir, *Unseen Vogue: The Secret History of Fashion Photography* (London: Little Brown, 2004).

84 "Model Posture," British *Vogue*, February 1942.

85 Haworth-Booth, *Art of Lee Miller*, 59.

86 "Contrast in Checks," British *Vogue*, April 1944, 37.

87 Haworth-Booth, *Art of Lee Miller*, 168. "Cover Coats" appears on page 167, and one of Miller's portraits of Humphrey Jennings is reproduced on page 169.

88 Haworth-Booth, *Art of Lee Miller*, 168.

89 A. Penrose, *Lives of Lee Miller*, 114–16; see also Haworth-Booth, *Art of Lee Miller*, 168.

90 Miller, "Citizens of the World—Ed Murrow," British *Vogue*, August 1944.

91 Letter from Miller to Withers in 1944, quoted in A. Penrose, *Lives of Lee Miller*, 116.

CHAPTER 5

1 H. W. Yoxall, speech at gala luncheon thrown in Miller's honor in July 1945; cited in *Facing the Front*, a small brochure published to accompany an exhibition of the same name at the Barnsley Design Centre, curated

by Anne McNeill, September 12 to October 24, 1998.

2 Lee Miller, letter to Florence and Theodore Miller, December 14, 1941; cited in Burke, *Lee Miller*, 208–9.

3 Scherman, unpublished memoirs, 1983; cited in A. Penrose, *Lives of Lee Miller*, 109.

4 Scherman, foreword to *Lee Miller's War*, ed. A. Penrose, 9.

5 Lee Miller, letter to Florence and Theodore Miller, May 3, 1943; cited in Burke, *Lee Miller*, 213.

6 Miller's wartime pieces receive serious attention in the book *Lee Miller's War*, edited by her son, Antony Penrose, and with a foreword by David E. Scherman.

7 Withers, *Lifespan*, 92.

8 Withers, quoted in A. Penrose, *Lives of Lee Miller*, 118.

9 A. Penrose, *Lives of Lee Miller*, 118.

10 Myers, interview with author, Collinsville, North Carolina, June 21, 2003. Mr Myers passed away in 2007.

11 Ibid.

12 See also pages 50 and 51.

13 Miller, "Unarmed Warriors", British *Vogue* (September 1944), 36.

14 Eileen M. Sullivan, cited in Paul Fussell, *Wartime: Understanding and Behavior in the Second World War* (New York: Oxford UP, 1989), 95.

15 Withers, *Lifespan*; cited in Burke, *Lee Miller*, 222.

16 Miller, "The Siege of St. Malo," British *Vogue*, October 1944, 51. American *Vogue* contains a slightly different version of this piece: "'France Free Again.' St. Malo," American *Vogue*, October 15, 1944, 92 and 129.

17 Miller, "The Siege of St. Malo," 84.

18 Ibid., 86.

19 Martin Blumenson, "World War II: The Liberation of Paris," *World War II*, September 2000, consulted online at www.historynet.com.

20 Miller, letter to Audrey Withers, n.d.; cited in A. Penrose, ed., *Lee Miller's War*, 65.

21 Miller, "Paris is free … cables its joy," American *Vogue*, October 1, 1944, 148.

22 The exact date of Lee Miller's arrival in Paris is unknown. Burke believes that "she probably arrived on August 27." Burke, *Lee Miller*, 394 (footnote).

23 Miller, "Paris ... its joy ... its spirit ... its privations," British *Vogue*, October 1944, 78; and Miller, "Paris," American *Vogue*, October 15, 1944, 148; cited in A. Penrose, *Lee Miller's War*, 70.

24 Ibid.

25 Ibid.

26 In February 1947, Christian Dior made his name with his first collection of full-skirted dresses. Fashion magazines in Europe and America quickly dubbed Dior's debut collection, "The New Look." For more information see www.designmuseum.org/design/christian-dior.

27 Miller, "Paris ... its joy," British *Vogue*, 78; and Miller, "Paris," American *Vogue*, 148; cited in A. Penrose, *Lee Miller's War*, 69.

28 François, quoted in Dominique Veillon, *Fashion Under the Occupation*, trans. Miriam Kochan (London: Berg, 2002), 14.

29 Miller, "Paris ... its joy," 78; and Miller, "Paris," 148; cited in A. Penrose, *Lee Miller's War*, 69.

30 Miller, "Paris ... its joy," 78 (This sentence is edited out of the American *Vogue* version); cited in A. Penrose, *Lee Miller's War*, 71.

31 Miller, "Paris ... its joy," 78; and Miller, "Paris," 147–48; cited in A. Penrose, ed., *Lee Miller's War*, 69.

32 Miller, service letter to Audrey Withers, October 10, 1944; cited in Burke, *Lee Miller*, 235.

33 Benito, "High Hat Resistance," British *Vogue*, October 1944, 36 and 98; and Benito, "Milliners at Work, High Hat Resistance," American *Vogue*, November 1, 1944, 124–25 and 172–73.

34 Benito, "Milliners at Work," 125.

35 As Caroline Weber has wonderfully explained, Marie Antoinette's signature pouf "was a thickly powdered, teetering hairstyle that re-created elaborate scenes from current events ... or from imaginary country idylls." Weber, *Queen of Fashion: What Marie Antoinette Wore to the Revolution* (New York: Henry Holt, 2006), 5.

36 Benito, "Milliners at Work," 172.

37 Ibid., 172–74.

38 Ibid., 174.

39 Miller, service letter to Withers, Paris, misdated August 18, 1944; and in British *Vogue*, November 1944.

"Neuralgia" is a "sharp, shocking pain that follows the path of a nerve and is due to irritation or damage to the nerve"; see www.ncbi.nlm.nih.gov.

40 Miller, "Paris ... its joy," 27 and 78.

41 Ibid., 78 (ellipsis in the original).

42 Vreeland, *D.V.*, 114.

43 Miller, service letter to Withers, misdated August 18, 1944; cited in Burke, *Lee Miller*, 229; and Ali Smith, "The look of the moment," *Guardian*, September 7, 2007, consulted online.

44 Miller, "Paris Fashions" letter to Withers, n.d., Lee Miller Archives (ellipsis in the original), LMA reference for photograph: 5958–62.

45 Ibid., photocopies relating to LMA contact sheet: 5900.

46 Three recent biographies of the fashion designer Coco Chanel all agree that she was a collaborator in Nazi-occupied France—with "collaborator" defined by one reviewer as "a loaded wartime term for a citizen who cooperated with the enemy." The extent of Chanel's collaboration does not, however, create consensus. Lauren Lipton, "The Many Faces of Coco," *The New York Times*, December 4, 2011.

47 Miller, "Paris Fashions" letter to Audrey Withers, n.d. (see Ch. 5, n. 44)

48 Lucien Lelong, interview in *Votre Beauté*, September 1939; cited in Veillon, *Fashion Under the Occupation*, 6; and Demornex, *Lucien Lelong*, 81. (Note: translation reproduced here comes from combining both sources.)

49 Rhonda Garelick quotes an unidentified French fashion journalist from the early 1940s as stating that "Frenchwomen are the repositories of chic, because this inheritance is inscribed in their race," and also writes that there are "deep and unsettling parallels" between the European fashion industry and "fascist ideas." If so, Lelong's arguments may have resonated with the Germans. Garelick, "High Fascism," *The New York Times*, March 6, 2011.

50 Linda Grant, "Lucien Lelong: The Man Who Saved Paris," *The Telegraph*, November 21, 2008. Consulted online.

51 Miller, "Paris Fashions," British *Vogue*, November 1944, 36.

52 Miller, "Paris Fashions" letter to Audrey Withers, n.d. (see Ch. 5, n. 44).

53 Burke, *Lee Miller*, 232.

54 Miller, "Paris Fashions," British *Vogue*, November 1944, 36.

55 Miller, service letter to Withers, October 10, 1944; cited in Burke, *Lee Miller*, 235.

56 Miller, "Paris Fashions," British *Vogue*, October 1944, 36.

57 Miller, quoted in A. Penrose, *Lee Miller's War*, 84.

58 Veillon, *Fashion Under the Occupation*, 99.

59 Cited in A. Penrose, *Lee Miller's War*, 84.

60 Miller, service letter to Withers, October 4, 1944; cited in Burke, *Lee Miller*, 234.

61 Withers, telegram to Miller, October 13, 1944; cited in A. Penrose, *Lee Miller's War*, 80.

62 Miller, service letter to Withers, October 1944; cited in A. Penrose, *Lee Miller's War*, 83–4.

63 Miller, quoted in A. Penrose, *Lee Miller's War*, 72.

64 Burke, *Lee Miller*, 231.

65 Miller's photographs of Marlene Dietrich and Fred Astaire were published in French *Vogue* months after they appeared in the other two editions. The first liberation issue of French *Vogue* was not published until January 1945.

66 Picasso, cited in A. Penrose, *Lives of Lee Miller*, 122.

67 "Within...," British *Vogue*, October 1944. For tomato story, see A. Penrose, *Lee Miller's War*, 73; Burke, *Lee Miller*, 231.

68 "Pattern of Liberation," British *Vogue*, January 1945, 80.

69 Miller, letter, censor date December 7, 1944; cited in A. Penrose, *Lee Miller's War*, 92–93.

70 Miller, "Luxemburg Front: Vogue's correspondent, Lee Miller reports on the Western Front," American *Vogue*, January 10, 1945, 58–61; cited in A. Penrose, *Lives of Lee Miller*, 130.

71 Cited in A. Penrose, *Lives of Lee Miller*, 130; Burke, *Lee Miller*, 236.

72 Miller, quoted in A. Penrose, *Lives of Lee Miller*, 130.

73 Miller, "Luxemburg Front," 58; cited in A. Penrose, *Lives of Lee Miller*, 130.

74 Miller, "GI Lingo in Europe," American *Vogue*, April 1, 1945, 131.

75 Calvocoressi, *Lee Miller*, 103.

76 "Schiaparelli," entry in *The Fashion Book*, Richard Martin et al. (London: Phaidon, 1998), 414.

77 Schiaparelli, *Shocking Life: The Autobiography of Elsa Schiaparelli* (London: V&A Publishing, [1954] 2012), 156.

78 Miller, "Germany—The War that is Won," British *Vogue*, June 1945, 84, 85, 87, and 89.

79 Ibid., 41.

80 Ibid.

81 Ibid., 42 and 84. Note that Miller does not mention Jews in this piece. Janina Struk has written that in the summer of 1945 little was known "about the genocidal Nazi policies which had led to the Final Solution and the extermination of the Jews, and about the terror unleashed on the Slavic people of Eastern Europe." Struk, *Photographing the Holocaust: Interpretations of the Evidence* (London: I. B. Tauris, 2004), 133.

82 Liberman, interview by Carolyn Burke, June 14, 1996; cited in Burke, *Lee Miller*, 294.

83 Miller, British *Vogue*, June 1945, 42.

84 Miller, "'Believe It': Lee Miller Cables from Germany," American *Vogue*, June 1, 1945, 103–5.

85 Withers, interview with Carolyn Burke, May 5, 1996; cited in Burke, *Lee Miller*, 265.

86 Miller, "Hitleriana," British *Vogue*, July 1945, 36–37 and 74.

87 Zox-Weaver, "When the War Was in *Vogue*: Lee Miller's War Reports," *Women's Studies* 32 (2003): 131–63, 137.

88 Ibid., 156.

89 Miller, "Hitleriana," British *Vogue*, July 1945, 37.

90 Miller, letter to Withers, n.d. (probably May 3, 1945); cited in A. Penrose, *Lee Miller's War*, 188.

91 Miller, "Hitleriana," British *Vogue*, July 1945, 37.

92 Miller, letter to Withers; cited in A. Penrose, *Lee Miller's War*, 198–99; and Burke, *Lee Miller*, 264.

93 Zox-Weaver, "When the War Was in *Vogue*," 157 (see Ch. 5, n. 87).

94 Miller, "Hitleriana," British *Vogue*, July 1945, 74. One wonders how much Miller had her friend Charlie

Chaplin's 1940 film *The Great Dictator* in mind when she wrote the final words of this moving piece. In the film Chaplin plays Adenoid Hynkel, the ruthless dictator of the fictional nation of "Tomainia," who is determined to persecute Jews throughout the land. Hynkel becomes obsessed with the idea of being Emperor of the World, dancing at one point with a large inflatable globe to the tune of the Prelude to Wagner's *Lohengrin*.

95 Miller, "Denmark," American *Vogue*, August 1945, 138–41; see also Burke, *Lee Miller*, 268–69.

96 British *Vogue*, July 1945.

97 Yoxall, July 1945 (see Ch. 5, n. 1)

98 Withers, *Lifespan*, 53.

CHAPTER 6

1 Withers, unpublished lecture, Institute of Contemporary Arts, London, 1992.

2 Withers, interview with Carolyn Burke, October 6, 1997; cited in Burke, *Lee Miller*, 269.

3 Miller, letter to Aziz Eloui Bey, n.d. (1945); cited in Burke, *Lee Miller*, 269.

4 Woolman Chase, quoted in Withers, July 25, 1945, Audrey Withers Papers, Condé Nast UK, *Vogue* House, London; cited in Burke, *Lee Miller*, 269.

5 Miller, cited in A. Penrose, *Lives of Lee Miller*, 168.

6 Miller, letter to R. Penrose, September 30, 1945; cited in Burke, *Lee Miller*, 273.

7 Livingston, *Lee Miller*, 92.

8 Miller, "Report from Vienna", British *Vogue*, November 1945, 40.

9 Lee Miller, "Hungary," original manuscript for articles, British *Vogue*, April 1946, 52–55; and American *Vogue*, April 15, 1946, 164–5; cited in Burke, *Lee Miller*, 279.

10 A. Penrose, *Lives of Lee Miller*, 166–67; Burke, *Lee Miller*, 281.

11 Cited in Burke, *Lee Miller*, 282.

12 A. Penrose, *Lives of Lee Miller*, 273.

13 Miller, "Romania," original manuscript; printed in A. Penrose, *Lives of Lee Miller*, 171–72; see also Burke, *Lee Miller*, 285–87.

14 The same controversial sculpture discussed in Chapter 4, page 98.

15 "Candid Camera With Lee Miller," Pathé Newsreel, 1946, available online at www.britishpathe.com.

16 Miller had known and disliked Beaton for decades. John Phillips, the *Life* photographer who lived next door to her in Budapest in the fall of 1946, and with whom she sometimes collaborated, wrote in his memoir that Beaton "was a pure social climber, someone who would knife you in the back if it served his purpose." Phillips, *Free Spirit in a Troubled World* (Zurich: Scalo, 1997), 402; cited in Burke, *Lee Miller*, 281.

17 Burke, *Lee Miller*, 294–95.

18 Ibid., 298.

19 Ibid., 299.

20 See, for example, Peter Clarke, *Hope and Glory: Britain 1900–1970* (London: Penguin, 1996), 243.

21 "Vogue televises a basic wardrobe," British *Vogue*, January 1947, 50–52.

22 For more on Bernier, see Calvin Tomkins, "The Artistic Life: Last Lecture," *The New Yorker*, March 17, 2008, consulted online.

23 Miller, letter to Roland Penrose, January 1947; cited in A. Penrose, *Lives of Lee Miller*, 182–83.

24 A. Penrose, *Lives of Lee Miller*, 183.

25 *Vogue* photographers interpret Christmas," British *Vogue*, December 1947, 53.

26 Theodore Miller Diary, 1948; cited in Burke, *Lee Miller*, 308.

27 Cited in A. Penrose, *Lives of Lee Miller*, 188.

28 Miller, "The High Bed," British *Vogue*, April 1948, 83 and 111.

29 Charles Castle, *Model Girl* (Newton Abbot: David and Charles, 1977), 33–34; and Barbara Goalen, "Obituary," *The Telegraph*, June 19, 2002.

30 A. Penrose, *Lives of Lee Miller*, 186–88.

31 Burke has written that in the early 1960s Chiddingly was "parochial and 'upright,'" and that the villagers viewed Farley Farm's inhabitants as having "dubious morals" that were "artistic or foreign, or both—neither term being complimentary." Burke, *Lee Miller*, 349.

32 In the Lee Miller Archives the photographs are listed as *Glamour* collections and marked as having been sent to America.

33 See, for example, British *Vogue* Export 1949 Magazine taken near their South Kensington apartment.

34 Morgan, interview with Carolyn Burke, 1996; cited in Burke, *Lee Miller*, 329. On Miller's creative life after she gave up photography, see Conekin, "Another Form of her Genius"; and "'She did the cooking....'"

35 Burke, *Lee Miller*, xiii and xiv.

36 Miller, letter to Roland Penrose, n.d. (attributed by Burke to spring 1949); cited in Burke, *Lee Miller*, 310.

37 "Boutiques in London," British *Vogue*, January 1950, 68–69.

38 On the 1951 Festival of Britain, see Becky E. Conekin, *The Autobiography of a Nation: The 1951 Festival of Britain* (Manchester: Manchester UP, 2003).

39 "Looking to 1951," British *Vogue*, October 1950, 110–13.

40 R. Penrose, letter to Audrey Withers; cited in A. Penrose, *Lives of Lee Miller*, 193.

41 A. Penrose, *Lives of Lee Miller*, 124–25.

42 Miss Hill to Audrey Withers, Vogue Inter-office Memorandum, April 12, 1949, *Vogue* Archive, *Vogue* House, London.

43 Reid, interview with author, London, May 12, 2004.

44 Miller, "Bachelor Entertaining," British *Vogue*, March 1949, 68–69 and 114–16.

45 Miller, "Working Guests," British *Vogue*, July 1953, 54.

46 A. Penrose, *Lives of Lee Miller*, 209.

47 Ibid.

48 Anonymous, telephone interview with author, August 10, 2002.

49 Withers, unpublished lecture, ICA, 1992 (see Ch.6, n.1).

50 Scherman, interview in *Lee Miller through the Mirror*, a film by Sylvain Roumette, 1995.

51 "Narvik" is the name of a battle fought in April 1940 between the German and British navies in the Norwegian sea near the city of Narvik.

52 Miller, letter to Alison Settle, summer 1951. Alison Settle Archive, University of Brighton Design Archives, England.

53 Withers, quoted in A. Penrose, *Lives of Lee Miller*, 118.

54 David E. Scherman stated in an interview "If something wasn't fun, [Miller] didn't want to do it." (*Lee Miller through the Mirror*, 1995.)

By the mid-1950s photography was no longer fun for Miller and so she turned to cooking, which she did enjoy. Patsy Murray, Miller's housekeeper and Antony Penrose's nanny, said in the same film that she thought Miller used cooking to "relax" and "forget everything else," and that it was a way for her to "hide herself away." Bettina McNulty does not entirely agree, nor would the male chefs and artists who came to Farley Farm to hear Miller's stories and cook with her. See, for example, John Caxton, quoted in Burke, *Lee Miller*, 338.

55 Burke, *Lee Miller*, 329.

56 Ibid.; and A. Penrose, *Lives of Lee Miller*, 196.

57 Jacobs, quoted in Burke, *Lee Miller*, 345.

58 A. Penrose, *Lives of Lee Miller*, 196.

59 Bettina McNulty, interview with author, London, August 13, 2002.

60 John Loring, interview by Carolyn Burke, April 30, 1998; cited in Burke, *Lee Miller*, 361.

AFTERWORD

1 Dolly Jones, "Fashion Shows: Autumn/Winter 2007 Gucci," consulted online at: www.vogue.co.uk.

2 Keenan, *The Women*, 136.

3 Prose, *The Lives of the Muses* (London: Aurum, 2003), 230.

4 David Hare, "Lee Miller: Perhaps You Haven't Noticed," in Calvocoressi and David Hare, *Lee Miller Portraits* (London: National Portrait Gallery, 2005), 21.

5 See *Toni Frissell: Photographs 1933–1967* (New York: Doubleday, 1994); Becky E. Conekin and Robin Muir, *Eugene Vernier: Fashion, Femininity & Form* (Munich: Hirmer, 2012); Robin Muir, ed., *Clifford Coffin: Photographs from Vogue 1945 to 1955* (New York: Steward, Tabori & Chang, 1997). For more on Traeger, see Becky E. Conekin, "From Haughty to Nice: How British Fashion Photography Changed from the 1950s to the 1960s," *Photography & Culture* 3, No. 3 (November 2010): 283–96 and "Fashioning Mod Twiggy & the Moped in 'Swinging' London," *History & Technology*, (June/July 2012).

6 See Martin Harrison, *Young Meteors* (London: Jonathan Cape, 1998).

SELECT BIBLIOGRAPHY

What follows is intended as an indicative list of the contemporary publications and major sources consulted during my research. Works quoted in the text that do not appear below are cited with full publication details in the Notes.

PRIMARY SOURCES

Agar, Eileen. *A Look at My Life*. London: Methuen, 1988.

Bourke-White, Margaret. *Portrait of Myself*. New York: Simon and Schuster, 1963.

Chase, Edna Woolman. *Always in Vogue*. London: Victor Gollancz, 1954.

Man Ray. *Self-Portrait*. New York: Little Brown, 1963.

Penrose, Roland. *The Road is Wider Than Long: An Image Diary from the Balkans July–August, 1938*. Facsimile. Los Angeles: J. Paul Getty Museum, [1939] 2003.

Vreeland, Diana. *D.V.* Edited by George Plimpton and Christopher Hemphill. New York: Knopf, 1984.

Withers, Audrey. *Lifespan: An Autobiography*. London: P. Owen, 1994.

Yoxall, H. W. *A Fashion of Life*. London: Heinemann, 1966.

SECONDARY SOURCES

Amaya, Mario. "My Man Ray…." *Art in America* 63, no. 3 (May–June 1975).

Burke, Carolyn. *Lee Miller: On Both Sides of the Camera*. London: Bloomsbury, 2005.

Calvocoressi, Richard. *Lee Miller: Portraits From a Life*. London: Thames & Hudson, 2005.

Chadwick, Whitney, and Tirza True Latimer, eds. *The Modern Woman Revisited: Paris Between the Wars*. New Brunswick and London: Rutgers University Press, 2003.

Conekin, Becky E. "Lee Miller's Simultaneity: Photographer & Model in the Pages of Inter-War *Vogue*," in *Fashion as Photograph*, Eugenie Shinkle, ed. London: I. B. Tauris, 2008. 70–86.

– "'She did the cooking with the same spirit as the photography': Lee Miller's life after photography," *Photography and Culture* 1, no. 2 (November 2008): 145–64.

– "'Another Form of Her Genius': Lee Miller in the Kitchen," *Gastronomica: The Journal of Food & Culture* 10, no. 1 (Winter 2010): 50–60.

Haworth-Booth, Mark. *The Art of Lee Miller*. New Haven: Yale University Press, 2007.

Keenan, Brigid. *The Women We Wanted to Look Like*. London: Macmillan, 1977.

Livingston, Jane. *Lee Miller: Photographer*. London: Thames & Hudson, 1989.

Penrose, Antony. *The Lives of Lee Miller*. London: Thames & Hudson, 1985.

– *The Home of the Surrealists: Lee Miller, Roland Penrose and their circle at Farley Farm*. London: Frances Lincoln, 2001.

–, ed. *Lee Miller's War*. London: Thames & Hudson, 2005.

Scottish National Gallery of Modern Art. *Roland Penrose, Lee Miller: The Surrealist and the Photographer*. Edinburgh: Scottish National Gallery of Modern Art, 2001.

Seebohm, Caroline. *The Man Who Was Vogue: The Life and Times of Condé Nast*. New York: Viking, 1982.

Slusher, Katherine. *Lee Miller, Roland Penrose: The Green Memories of Desire*. Munich and London: Prestel, 2007

ACKNOWLEDGMENTS

Although this book has only been in the works for a year and a half, I have been researching and writing about Lee Miller for over a decade. Any research of so long a duration incurs many, many debts. My former employer the London College of Fashion (LCF) funded my initial research in the form of a Senior Research Fellowship, granted by Elizabeth Rouse and Christopher Breward, and renewed by Helen Thomas. That fellowship was for some years partially funded by the Fashion & Modernity Project, an initiative headed by Breward and Caroline Evans, funded by the Arts and Humanities Research Board, and involving numerous colleagues at LCF and Central Saint Martins College of Art and Design.

Thanks are owed to friends and colleagues who commented on my early research, articles, and talks on Lee Miller: Christopher Reed, Carolyn Steedman, the late Don LaCoss, Laura Lee Downs, Christopher Breward, Caroline Evans, Leslie Harris, Sonia Ashmore, Ludmilla Jordanova, Clare Pettitt, Stephen Brooke, Deborah Cohen, Craig Koslofsky, Antoinette Burton, Marilyn Booth, Amy de la Haye, Janine Furness, Carol Tulloch, Eugenie Shinkle, Annalisa Zox-Weaver, and Bettina McNulty. More recent talks and articles have benefited from feedback from many of the same individuals, as well as Annie Janowitz, Darra Goldstein, Emily Orr, Anna Arabindan Kesson, Vanessa Schwartz, and Laura Wexler. I am grateful to those who invited me to lecture on Lee Miller, as well as those editors who published early versions of some of this material: Barbara Caine, Christiane Eisenberg, Mary Jacobus, Laura Lee Downs, Christian Huck, Valerie Steele, James Vernon, Mark Haworth-Booth, Vanessa Schwartz, Stephen Brooke, Darra Goldstein, Doug Duda, and Scott Givot. For research assistance relating to this book, performed at various points over the years, I thank Amber Jane Butchart, Lance Tabraham, Zephyrine Craster, Bonnie Robinson, Janine Button, then librarian at *Vogue* House, London, and Arabella Hayes, then of the Lee Miller Archives. Most recently, for extraordinary assistance and picture research in New Haven and London, and for her amazing eye and positive attitude, I thank my Yale research assistant, Loren Olson, without whom this book would not have seen the light of day.

For suggestions and support on this book specifically I thank many of the above, as well as Robin Muir, Mark Haworth-Booth, Alison MacKeen, BC Craig, Stephanie Browner, Terence Pepper, Ian

Shapiro, Tim Barringer, and Kishwar Rizvi. I very much appreciate my many new, encouraging friends in New Haven, including the graphic designers Jenny Chan and Angie Hurlbut, the artist Linda Lindroth, as well as Mercedes Carreras, Annie Murphy Paul, John Witt, Lauren McGregor, Iain York, Annie Wareck, and Scott Shapiro. For hospitality in the UK, I thank Sharon, Sean and John Tooze; Nicki, Gordon, Jessie and Alice Smith; and Dale and Steve Russell. Thanks to the Frederick W. Hilles Publication Fund of Yale's Whitney Humanities Center for a much needed grant in aid of permission and reproduction fees, and special thanks to the ever encouraging Ned Cooke, as well as to Susan Stout, the senior administrator at the Whitney Humanities Center. I am profoundly indebted to my agent, Sarah Chalfant of the Wylie Agency, and I want to also thank her right-hand woman in London, Alba Ziegler-Bailey, as well as Rebecca Nagel in the New York office.

It has been a pleasure to work with Thames & Hudson, from managing director Jamie Camplin, who commissioned the book to art director Johanna Neurath and the book's designer, Anna Perotti. My editor Laura Potter has been the definition of efficient while staying delightful and supportive throughout the entire process. Thank you all. This book is the result of close collaboration with the Lee Miller Archives and without their support would have been impossible. I would like to acknowledge its director Antony Penrose, as well as Ami Bouhassane, Lance Downie, Kerry Negahban, Tracy Leeming, Gabi Hergert, and Genevieve Steele. Finally, at the Lee Miller Archives, I must thank Carole Callow. The Archives' curator and photographic fine printer, she knows the most about Lee Miller's fashion photographs and spent many hours pouring over uncatalogued photographs with me and offering expert advice.

R. J. Horst was extremely generous in allowing me to reproduce George Hoyningen-Huene's photographs of Miller in this book, as was the fashion designer Ann Demeulemeester, who granted me permission to use the runway image in the Afterword. Thanks also to Caroline Berton of Condé Nast France and to Harriet Wilson, Brett Croft, Bonnie Robinson, and Ulrika Becker of Condé Nast UK. That London team, led by Wilson, is a historian's dream come true. They are always generous, upbeat, and thorough.

For inspiration, consultation, and hospitality, I thank Bettina McNulty, Lee Miller's best friend in the 1960s and 1970s, who opened her personal archives to me from the very start, shared many wonderful memories of her adventures with Miller, and even accompanied me on a research trip to the Lee Miller Archives, helping me to select the very best photographs of 1940s suits, hats, and furs. When we were there one evening, Antony Penrose said that being with Bettina is the closest you can get to being with Lee. I feel that knowing Bettina has helped me to get a better sense of Lee Miller and I am honored to call her my friend.

Because of their love of photography, or fashion, or perhaps just of me, my biggest cheerleaders for this book have been Adam Tooze, Annie Janowitz, Stephen Brooke, Loren Olson, and Edie

Conekin-Tooze, as well as Bettina. All of them have commented on versions of the text and on the choice of photographs. As always, Adam, my rock and my best critic, has read and made suggestions on every word. His enthusiasm for this project remained unflagging, even when at times my own was waning. Edie almost certainly does not remember a time when I was not working on Lee Miller. I dedicate this book to her. I hope that she is inspired by Lee Miller's strength, intelligence, beauty, creativity, and humor. I like to think that Lee would have appreciated Edie too.

ILLUSTRATION CREDITS

INDEX